SHOCKING PARIS

ALSO BY STANLEY MEISLER

United Nations: The First Fifty Years
(Reissued in revised and expanded edition
as *United Nations: A History*)

Kofi Annan: A Man of Peace in a World of War

*When the World Calls: The Inside Story of
the Peace Corps and Its First Fifty Years*

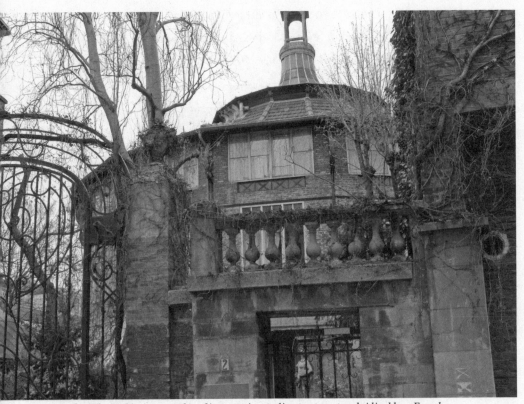

La Ruche (The Beehive), a complex of inexpensive studio apartments subsidized by a French sculptor, was the first stop for Soutine, Chagall and scores of other foreign artists who arrived in Paris in the early years of the twentieth century. Photo © Michel LeBrun-Franzaroli.

SHOCKING PARIS

SOUTINE, CHAGALL AND THE OUTSIDERS OF MONTPARNASSE

STANLEY MEISLER

St. Martin's Press　New York

SHOCKING PARIS. Copyright © 2015 by Stanley Meisler. All rights reserved. Printed in the United States of America. For information, address St. Martin's Press, 175 Fifth Avenue, New York, N.Y. 10010.

www.stmartins.com

Designed by Letra Libre, Inc.

Library of Congress Cataloging-in-Publication Data

Meisler, Stanley.
 Shocking Paris : Soutine, Chagall and the outsiders of Montparnasse / Stanley Meisler.
 p. cm.
 ISBN 978-1-137-27880-7 (hardcover)
 1. Soutine, Chaim, 1893–1943. 2. Painters—France—Biography. 3. École de Paris. I. Title.
 ND553.S7M45 2015
 759.4—dc23
 [B]
 2014030853

Our books may be purchased in bulk for promotional, educational, or business use. Please contact your local bookseller or the Macmillan Corporate and Premium Sales Department at (800) 221-7945, extension 5442, or by e-mail at MacmillanSpecialMarkets@macmillan.com.

First published by Palgrave Macmillan, a division of St. Martin's Press LLC

First edition: April 2015

10 9 8 7 6 5 4 3

To the memory of

Joyce and Matthew

Soutine and a Dead Chicken. The dealer Léopold Zborowski rented a house in the small town of Le Blanc in central France in the late 1920s and invited all his painters including Soutine to spend time there. The dealer encouraged the painting of landscapes, but Soutine was far more interested in still lifes of dead poultry. Private collection/Bridgeman Images.

CONTENTS

SHOCKING PARIS

INTRODUCTION

WHEN I GRADUATED FROM THE CITY COLLEGE OF NEW York in 1952, my uncle Morris had words of avuncular wisdom for me. Now that I had a degree, he admonished me, I must work hard, get a steady job and not spend the rest of my life struggling in a Paris garret like his cousin Soutine. "Chaim Soutine, the painter?" I asked. "You mean you've heard of him?" replied Uncle Morris.

I don't want to exaggerate my ties to the painter. Uncle Morris was married to my mother's sister. I cannot claim any blood relationship to Soutine. But the little lecture aroused my interest in the dark, enigmatic artist. Whenever I came across a painting by Soutine in a museum from then on, I gave it a second or even a third look.

When the *Los Angeles Times* assigned me to Paris as its correspondent in the 1980s, it was natural that I would get deeper into the world of Soutine. He is much more celebrated and understood there than in the United States, and I could easily find his statue, his cafés, his homes, even his grave. And, most important, the Orangerie museum on the Place de la Concorde displayed a room full of color-drenched, stunning canvases by Soutine all the time. It was there that I first seemed to see little houses arched and ready to leap from one landscape onto another, a demonstration that this man painted like no one else.

My interest in Soutine led to allied interests, to contemporaries like Chagall and Modigliani and Jules Pascin, to the outpouring of Russian Jewish artists from the Pale of Settlement to Paris, to the Beehive that housed them, to the cafés that fed them, to Dr. Barnes who discovered Soutine, to the School of Paris that comprised these outsiders of Montparnasse and to the critics who castigated them. I wrote about some of these subjects in a small way for both the *Los Angeles Times* and *Smithsonian* magazine. It was only in recent years, however, that I understood how all these parts were interrelated, how Dr. Barnes's championship of Soutine, for example, led to a new gush of contempt for the East European Jews in France. With this understanding came the feeling that it now made sense to write a book connecting many dots of the story.

What I have tried to do in this book is tell the story of the foreign-born immigrant painters in Paris in the 1920s and 1930s. Most came from the Russian empire, almost all were Jewish, and they made an impact on the history of art before most Parisians realized they were there. When Parisians did realize it, they were shocked that so much of their cherished world of painting was now in the hands of immigrants. The artists became known as the School of Paris, but they were not a school or a movement in the usual sense. They did not try to produce a certain kind of art. Nor can an art historian discern one characteristic or another that defined them. They were simply a phenomenon of history.

I have tried to tell much of the story through biography, mainly of Soutine with a good deal about Marc Chagall and somewhat less about Amedeo Modigliani and others. Both Soutine and Chagall were Jews who left the Russian empire, but they had nothing else in common. No one could ever mistake the fury of a Soutine painting for the intricate nostalgia of a Chagall. Moreover, their personalities were opposites: Soutine was shy, innocent and often helpless; Chagall was social, savvy and sometimes manipulative. But both were

distinguished artists of the twentieth century, and we need to study both to understand the School of Paris.

One of the kindest compliments that I have ever received as a writer came from the late Don Moser. When he retired as editor of *Smithsonian* magazine, he sent me a note saying that he always had admired my ability to write about art "without the usual flapdoodle." By that he meant the opaque jargon and theorizing that often mar the pages of exhibition catalogues and drive readers away from the prose. But there is a danger in turning your back on all jargon and theories, for some opaque prose may contain important issues and insights. On occasion I have felt the need to decipher some opaqueness and translate it into clear sentences for the book. But the result, I hope, is still free of flapdoodle.

Soutine is the key artist in the book, and that creates a temptation. He left no writing—no letters, diaries, notebooks—about his art, his personal problems, his feelings about Paris or, in fact, anything else. In her 1993 book on Soutine, French biographer Clarisse Nicoïdski lamented the difficulty of sorting out the truth when the handful of witnesses contradict each other. "The difficulty with Soutine," she wrote, "stems from the fact that every testimony, even the most sincere, even the most impartial, is immediately put in question by a detail, an anecdote, another testimony. And that happens not only when it involves setting down the narrative of his life but even more so when describing his way of thinking." That can tempt writers to flights of conjecture. There is an awful lot of prose in art history about what Soutine must have, could have, should have, would have done. I was determined not to follow this lead in the book or, at least, to follow it only rarely. I have avoided conjecture as much as possible.

Finally, the story of the School of Paris, of the foreign immigrant artists of the Russian empire, is part of a much greater story of mass migration from the Russian empire because of religious persecution, political oppression and economic hardship. Many millions were

uprooted to America or other parts of Europe. My father's brother Hona, faced with the draconian quota against Jews in Russian medical schools, left Bialystok (in what is now Poland) to study and then practice medicine in Paris. When he married, he married a doctor in Paris who also came from the Russian empire. One of the official witnesses who signed their certificate was a journalist who knew many artists of the School of Paris. My uncle, my aunt and the reporter all died in Auschwitz. My own father, six years younger than Soutine, left the Russian empire in 1913, the same year as the artist. But my father landed in New York, not Paris.

So there are other migration stories at work here. But they are for other books. Here we are concentrating on the phenomenon of the immigrant artists of Paris, a wondrous but little-told story.

ONE

IN 1913, CHAIM SOUTINE, A YOUNG MAN BARELY 20, WITH thick lips, a bulbous nose and slightly slanted, Tartar-like eyes, arrived at the Gare du Nord in Paris after a long and arduous rail trip from Vilna in what is now Lithuania. He soon headed for a building at 2 passage de Dantzig in the 15th Arrondissement on the Left Bank of the Seine River. At 2 A.M., with a sack on his back, he banged on the door of Pinchus Krémègne. Krémègne, an older student at the school of fine arts in Vilna, had reached Paris a year before and settled immediately at that address. Like many other youths of the era, Krémègne believed he could never succeed as an artist unless he studied and worked in Paris, whose fabulous museums and ubiquitous galleries and learned teachers and passionate critics and generous collectors and renowned artists made it the world's center of art.

Soutine and another classmate, Michel Kikoïne, had decided to follow their upperclassman's example. Kikoïne made the trip first. Then Soutine arrived in Paris intent on finding his two schoolmates

in the same building. Krémègne for many years liked to joke or boast that he had arrived in Paris speaking only three words of French: "passage de Dantzig." It is doubtful that Soutine, like the others a native Yiddish speaker schooled in Russian, knew any more French than that.

The passage de Dantzig address was vital, especially to newcomers, for it marked the site of a unique French institution, La Ruche (the Beehive), which provided cheap housing to young painters, sculptors and poets. The residence, a polygonal structure of 16 sides, comprised 50 small but amply windowed studio apartments with large public rooms for the artists to meet each other. Nearby buildings housed the overflow in another 50 studios. La Ruche was the creation of Alfred Boucher, a prominent and wealthy sculptor honored and prized by the government and fellow artists during a long career. He also was a footnote to a tragic scandal, having introduced his student Camille Claudel to his friend the renowned sculptor Auguste Rodin, thus igniting a long and tormented love affair that eventually led to her madness and destruction of many of her works.

La Ruche was an act of pure philanthropy on the part of a successful artist who knew what it was like to start out with meager resources. Boucher bought some cheap land not far from the abattoirs on the Left Bank and put together La Ruche largely with materials dismantled from the 1900 Paris World's Fair. The bulk of the building came from the Médoc wine pavilion designed by the firm of Gustav Eiffel, the art nouveau wrought iron gate in front of La Ruche came from the Palace of the Woman and two caryatid statues guarding the front door came from the British India pavilion. Although a private project, the residence, which opened in 1902, was blessed by the French government. La Ruche served both as an affirmation of Paris's role as the center of world art and as an iconic and practical welcome to poor artists who came to bask in this artistic wonder of Paris.

La Ruche, which still houses artists in the twenty-first century, was an extraordinary success. Its alumni included French painter Fernand Léger and French writer Max Jacob and Swiss poet Blaise Cendrars and, among its foreign painters and sculptors, Soutine, Modigliani, Marc Chagall, Jacques Lipchitz, Diego Rivera, Tsuguharu Foujita, Jacob Epstein, Ossip Zadkine and Moïse Kisling. Chagall had already lived there for a couple of years when Soutine arrived looking for his Vilna schoolmates. "These ateliers were occupied by artistic Bohemians from all over the world," Chagall wrote in a memoir, describing the atmosphere of La Ruche. "While an offended model sobbed in the Russian ateliers, the Italian studios rang with songs and the sound of guitars, the Jewish ones with discussions."

Boucher had toyed with a more classic and academic name for his building but finally settled on the more commonplace and symbolic La Ruche. Boucher, who maintained a studio in the building, wanted the young artists to work as hard together as bees in a hive. He set aside a large room where most of the poor artists could draw a model that he paid for. He even incorporated a small theater in La Ruche for plays and concerts.

There is no doubt that lasting friendships were forged in La Ruche. Modigliani painted or sketched portraits of Soutine, Rivera, Foujita, Zadkine, Kisling, Jacob, Krémègne, Lipchitz and Cendrars, all friends from La Ruche. Chagall found himself drawn not to other painters but to the poet Blaise Cendrars. Cendrars provided Chagall with titles to several paintings and wrote several poems about him. The poet said the poems were as fanciful as a Chagall painting. One, "Portrait," closes with these lines:

He kills himself every day
Suddenly he does not paint anymore
He was awake
Now he sleeps

He strangles himself with his tie
Chagall is astonished to still be alive.

IF ARTISTIC SUCCESS DEPENDED on appearance, manners, geniality, hygiene, training and outside support, Chaim Soutine would surely have been voted least likely to succeed by the other residents of La Ruche. Yet no painter is now more identified with the movement that came out of La Ruche known as the School of Paris.

In interviews years afterward, friends and associates often referred to Soutine as "sauvage" (wild) or even "fou" (mad). But neither word seems to capture his personality. No single word, in fact, could.

Soutine was extraordinarily shy, so shy that no friend ever testified to watching him paint. He was obsessed by his work, so obsessed that he would slash his canvases with a knife if they failed, as they often did, to fulfill his hopes. He also looked on himself as the eternal outsider, too poor at first to feed and clothe and house himself. He seemed to ignore everything besides his work, anything else about himself, appearing as disheveled and unwashed as a shtetl bumpkin, at least in his early years in Paris. And he felt no compulsion to explain his work or himself. He wrote no memoir or any other book or article. Only a few letters have survived, and they reveal almost nothing.

Even the simplest facts about his life often depend on what others remember that he told them, and their memories are sometimes in dispute. Soutine was born in 1893 (the day is unknown) in the shtetl (Jewish market village) of Smilovitchi, about a dozen miles from the town of Minsk, now the capital of Belarus. The territory was part of the Russian empire in those days, but the area had belonged to old Lithuania, and many art monographs refer to Soutine as Lithuanian even though his citizenship was Russian. Smilovitchi was well within the Pale of Settlement—the vast area of Poland, Lithuania, White Russia and the Ukraine in which the czars allowed Jews to

live. Jews could work or study in St. Petersburg, Moscow and the other cities of Russia itself only with special permission.

Soutine never showed any nostalgic love for the shtetl of his childhood. At the turn of the twentieth century, the Russian government reported that only 3,100 people lived in the nondescript village of gray wooden shacks. It had a small wool factory, some home distilleries, a few stores, an abandoned monastery, three churches for the peasant farmers in the area and a synagogue. "When you live in a dirty hole like Smilovitchi," Soutine once told a friend, "you can not imagine that cities like Paris exist." As an adult, Soutine learned to cherish the music of Bach, but, he said, "in my village I did not even know that a piano existed."

Chaim was the tenth of 11 children born to Saloman and Sarah Soutine. Saloman was a tailor, mainly a mender of old clothes, and there is no doubt that the family, living in the market square of Smilovitchi, was very poor. Kikoïne, Chaim's boyhood friend, described life in the impoverished Soutine family as extremely hard and sad with the father opposed to Chaim's plan to spend a lifetime painting pictures. Kikoïne said Chaim made several abortive attempts to run away and enroll in an art school outside of town.

The Russian Polish painter known as Marevna, the mistress of Diego Rivera, elaborated on this in a memoir written in the 1970s. Based on conversations with Soutine, she wrote that he was "an ugly, sickly child, who was disliked by his father who often singled him out for beating." "He went to bed hungry at night," she said, and "was often ill for lack of food." All in all, she wrote, his "childhood world was a Grand Guignol world of nightmarish shapes, grimaces, cries of protest and rebellion."

Yet Schraga Zarfin, another painter from Smilovitchi, six years younger than Soutine, downplayed the force of the family opposition to a career in painting and cast doubt on the harshness of life for Soutine. While Saloman discouraged Soutine's hopes of life

as a painter, Zarfin said, he did not forbid the idea and, in fact, proudly displayed some of Soutine's drawings on a wall of the family house. Zarfin insisted that life was not "particularly miserable" in Smilovitchi.

The Soutine family, in fact, helped Chaim enter art school. When the teenager Soutine sketched a likeness of the rabbi in Smilovitchi, his son, a butcher, beat Soutine because of the supposed ban on drawing a thing or a person by the Torah's Ten Commandments. The blows were so severe that Soutine's mother filed an official complaint with the justice of the peace. The butcher paid compensation of 25 rubles (some accounts say 12), which Soutine's mother used to send Chaim to art school in Minsk.

A few years later, he and his classmate Kikoïne moved on from Minsk to an advanced art academy in Vilna. Enrollment was not easy. Soutine was so nervous that he showed up for an 8 A.M. entrance examination at dawn and spent several hours pacing the sidewalk waiting for the school to open. Soutine was asked to draw a cone, a cube and a pitcher. His fraught nerves made him flub perspective. The examiners rejected the tearful Soutine at first and then accepted him out of pity. In the end, according to Kikoïne, Soutine proved one of the most brilliant students at the academy, producing sketches that "always carried a suggestion of morbid sadness." Soutine and Kikoïne met Krémègne at the academy and plotted their future as artists in Paris.

When Soutine and the others arrived, Paris was one of the great cities of the world with a population of almost 3 million, grand boulevards, bustling department stores, elegant restaurants and an underground subway matched only by those of London and New York. The subway—known as the Metro—had drawbacks. The platforms and cars were bare and dreary, the narrow corridors for changing trains were lengthy and, ever since completion in 1900, the Metro emitted a strange metallic and acidic odor. But it was a cheap and fast

way for Parisians to make their way through a vast city. Moreover, the Metro's wonderful entrances on the street were designed by the great art nouveau architect Hector Guimard. In the art nouveau style, he lavished the entrances with glass and iron coverings that looked like dragonflies and with giant metallic tendrils that held up lamps. A couple of years before Soutine's arrival, Guimard had completed a synagogue on the rue Pavée in the old Marais neighborhood. The synagogue featured an undulating facade with long slim windows and an interior graced with intricate grillwork and curving lamps. It had been commissioned by a congregation of Russian-born Jews who had emigrated to France decades earlier.

Soutine and the other immigrant artists could not escape the sight of the Eiffel Tower hovering over the Left Bank of the Seine. The tower had been erected more than 20 years earlier for the 1889 world's fair that celebrated the hundredth anniversary of the French Revolution. The tower had no function except to demonstrate the engineering skills of the French, a fact that encouraged a committee of 300 writers, painters, sculptors and architects to try to prevent its construction. In their unheeded letter of protest, they derided the proposed tower as "useless and monstrous." Bitterness simmered after the construction—Guy de Maupassant insisted he often ate in the restaurant within the tower so he could avoid looking at the monstrosity itself—but, by the time Soutine arrived in Paris, the Eiffel Tower, then the tallest man-made structure in the world, had become a symbol of Paris.

Soutine's friends later liked to relate anecdotes about his odd behavior during his first years in Paris. These anecdotes, comic yet painful, reflected mainly on his extreme poverty, worsened by his insistent indifference to how he looked and what others thought of him. A doctor's daughter had begged enough funds from other Jews in Vilna to finance his trip to Paris, but Soutine, unlike Chagall and others who had small stipends from sponsors, had no money at all

to spend. He tried odd jobs as a day laborer but was hampered by stomach ulcers that would weaken him his entire life and by his lack of a working knowledge of French.

Soutine was so poor, in fact, that it is doubtful that he ever registered for a studio at La Ruche. Instead, he shared space in the apartments of Kikoïne, Krémègne and others. Later, when Kikoïne married and moved out of La Ruche, his daughter remembered a hungry Soutine bursting into their home and rushing to the kitchen to gorge on leftovers. Soutine marred his appearance by wearing the same paint-smeared jacket at all times.

His impoverished condition was hardly hygienic. Krémègne recalled finding Soutine and Modigliani leaning against the wall of a studio in the Cité Falguière, a neighborhood of cheap artist studios regarded as a step above La Ruche. The studio was shared by Soutine and the Russian sculptor Oscar Miestchaninoff. Soutine and Modigliani were surrounded by a trench that Miestchaninoff had molded out of clay and filled with water. Modigliani was reading Dante, Krémègne said, while Soutine was trying to read a tabloid newspaper. The barrier was supposed to protect them from advancing bedbugs. But it failed. An insect lodged in Soutine's ear and had to be removed by a doctor.

Marevna, describing Soutine in the early years, wrote, "He was not good looking. He had a short neck, high shoulders, and he stooped. . . . His thatch of coarse, dark hair was cropped like a Russian peasant's, but a fringe came down to his eyebrows and concealed his large protruding ears and low forehead. . . . He smacked his thick lips when he talked, and flecks of white foam gathered at the corners of his wide mouth." His most attractive feature was "a charming smile, which involved his whole being, drawing one closer to him." But this attractive smile also exposed unhealthy and stained teeth and gums. "His hands," she went on, "were his most striking feature—small, pink and soft as a child's."

On arrival in Paris, Soutine enrolled in the classes of Fernand Cormon in the École Nationale des Beaux-Arts. Cormon had established a reputation as the teacher of Vincent van Gogh and Henri de Toulouse-Lautrec and other painters of Montmartre in the late nineteenth century. After trying to interview Soutine, Cormon sent a note to the administration: "Please enroll M. Soutine in the class. He is Russian and does not understand a single word of French."

Whenever Soutine attended a live modeling session in school or at La Ruche, he sat along the wall so no other student could see his work from behind. There is a photograph of Cormon posing in his atelier with two hundred or so students. The shy Soutine is so far back in the last row that his head is barely perceptible. Soutine dropped out of the classes in a few months, deciding he could learn far more by haunting the Louvre.

Soutine's shyness and loneliness were so pronounced in his early Paris years that they became almost clichés. Lunia Czechowska, who sat for some of Modigliani's most striking portraits, said, "Soutine was never really part of the group. He kept himself hidden in a corner, like a frightened animal." Marevna, who bedded Soutine one night, described him as "a poor lover, perhaps because of shyness."

These kinds of anecdotes lessened as Soutine matured and slowly lifted himself out of extreme poverty. We do not know much about how his art progressed because there are no paintings or drawings from his boyhood in czarist Russia or his first years in Paris. The earliest work in his catalogue raisonné is dated 1915. He evidently destroyed his immature efforts.

IN ONE REGARD, Soutine was not alone in his first years in Paris. He found compatriots all around him, men and women who spoke his native language and shared his heritage. One of the great surprises of La Ruche when Soutine arrived in 1913 was the predominance

of Jewish artists from the towns and shtetls of the czarist Russian empire.

At the start of the twentieth century, Boucher, the founder of La Ruche, did not expect that Yiddish-speaking painters and sculptors would contribute much to the contemporary art scene. They never had before. Orthodox Jews, in fact, believed for centuries that the painting or sculpting of realistic life was forbidden by the second commandment's injunction against making "for yourself a carved image, or any likeness of what is in heaven above or on the earth beneath or in the water under the earth." There were no magnificent works by Jewish Leonardos and Michelangelos in the synagogues of Europe. Although this strict interpretation of the Torah was dying out in the nineteenth century, Soutine, as we noted, was a victim of it in Smilovitchi. Similarly, when Marc Chagall's great-uncle Israel found out that his young relative was drawing pictures of people, he became so agitated and fearful of God's wrath that he dared not shake hands with Chagall.

Jewish artists in Eastern Europe were hampered by more than the Torah. Until the nineteenth century, Jews could not belong to the guilds that trained artists and produced painting and sculpture. Even afterward, the best art schools of Russia were closed to Jews or allowed admission to only a few. Despite these obstacles, a vibrant Jewish art scene developed in the Russian empire in the last half of the nineteenth century, with a large number of artists painting wonderful realistic scenes of Jewish life. But the artists who went to Paris did not identify as traditional genre painters. Not even Chagall did. Like most artists in Paris, Chagall, Soutine and the other Jewish artists looked on themselves as an avant-garde searching for new and modern ideas in the glow of the new twentieth century.

Most of the Jewish artists who went to Paris turned their backs on their homelands and settled in France. They arrived in Paris during a time of great migration. From 1880 to 1914, in fact, 2 million East

European Jews emigrated to the United States. They were driven away by poverty, new ideas and fear. The Pale of Settlement had become too limiting. Schooling in the Russian language and fat new newspapers and magazines brimming with images had carried some of the great ideas agitating Western Europe—like equality and justice and nationalism and socialism and secularism and modernism—to the Jewish towns and shtetls of the Pale. Young people with ambition like Soutine and Chagall now found their homelands stultifying. They yearned to leave and seek their futures elsewhere. Others simply headed toward the New World in their flight to escape poverty.

Fear in the first years of the twentieth century intensified the rush to departure. From 1903 to 1905, there were reports of almost 300 pogroms or attacks by Christian toughs, unimpeded by the police and probably orchestrated by the Russian government, on Jews in towns of the Pale. More than 800 Jews died in the Ukrainian port of Odessa in October 1905, and 200 died in the Polish town of Bialystok in June 1906. Chagall's hometown of Vitebsk was the scene of lesser attacks. While Soutine's shtetl of Smilovitchi was spared a pogrom, violence flared in the neighboring town of Minsk and other nearby market villages.

To make matters worse, the czar's government put a Jewish superintendent of a brick factory in Kiev on trial in 1913 for the ritual murder of a 12-year-old Christian boy. This revived the hoary medieval libel that Jews used the blood of murdered Christian children to make matzo on Passover. The defendant, Mendel Beilis, was acquitted, but the jury ruled that a ritual murder had indeed taken place although some other unknown Jew was the murderer. It was not a good time for Jews in czarist Russia.

Yet in some ways, it was a propitious time for a Jewish immigrant to arrive in Paris. At the least, the most virulent anti-Semitic commentators in France had eased their spews of venom. The Dreyfus case, which had convulsed France for a dozen years, finally limped to

an official end in 1906. Soutine, Chagall and most of their colleagues arrived at a time when many French felt enervated after too many years of political and social conflict over the case of a Jewish officer convicted of treason.

The young Jewish artists probably did not have Dreyfus in mind when they showed up at La Ruche. Chagall does not even mention the case in his memoir of his early years in Paris. But the Dreyfus affair, even when quiescent, hung over France for many years and influenced attitudes toward the Jewish painters and sculptors who arrived in Paris after the case closed.

The case began in 1894, when the army unjustly accused Captain Alfred Dreyfus, the only Jewish officer on the general staff, of passing military secrets to the German government. Since their evidence was weak, the prosecutors fabricated more incriminating evidence. Dreyfus was sentenced to life imprisonment on Devil's Island, the French penal colony in French Guiana in South America. When generals received new evidence proving they had convicted the wrong man, they refused to acknowledge it, insisting that any exoneration would dishonor the army. The honor of the army was far more important than the fate of a Jewish officer.

Supporters of the convicted officer called themselves Dreyfusards; his vilifiers were known as anti-Dreyfusards. The controversy was so divisive that one anti-Dreyfusard family dug up the bodies of their closest relatives and buried them elsewhere so they would not have to lie near the relatives of Dreyfusards. The painters Camille Pissarro, whose father was Jewish, and Edgar Degas, a militant anti-Dreyfusard, stopped speaking to each other. The lineup among artists in France put the Dreyfusards Claude Monet, Paul Signac and Mary Cassatt against the anti-Dreyfusards Paul Cézanne, Auguste Rodin and Pierre-Auguste Renoir.

For the most part, the Dreyfus affair pitted the right, Catholic militants, the army, monarchists and anti-Semites against Socialists,

liberals, intellectuals, and republicans. Dreyfus's most important champion was the novelist Émile Zola, who filled up the entire front page of the newspaper *L'Aurore* on January 13, 1898, with his famous J'accuse letter to the French president. The letter laid bare the true story of the unjust condemnation of Dreyfus and the despicable cover-up that followed. That page, with the headline "J'accuse" in enormous type, is surely the most famous front page in European history. It would take another eight years before the French High Court of Appeals threw out the conviction.

European Jews differed in their reaction to the Dreyfus affair. Theodor Herzl, who covered the case for a Vienna newspaper, soon wrote his book calling for a separate state for the Jewish people. If even France, the most enlightened country in Europe, reeked of anti-Semitism, he reasoned, there was no sanctuary anywhere for Jews. Herzl is now regarded as the father of the Zionist movement.

In Lithuania, in contrast, Emmanuel Levinas's father urged his son to emigrate to France. "A country that tears itself apart to defend the honor of a small Jewish captain is somewhere worth going," he said. Lévinas followed his father's advice and became one of France's most influential philosophers.

The Jewish immigrant painters and sculptors who filled many of the rooms of La Ruche when Soutine arrived in 1913 would gradually leave and, as they began to earn some income from their painting, make their way to the studios and apartments of Montparnasse, meeting each other from time to time for a drink or snack at the Café Rotonde or Le Dôme, which served as neighborhood anchors. By 1925, they would take on the form of an unofficial association of foreign artists known as the School of Paris.

Cosmopolitan Paris had many artistic and literary groupings of foreigners in the early decades of the twentieth century. There were Ernest Hemingway and his Lost Generation and Picasso and his entourage and the Steins with their salons and Sergei Diaghilev and his

Ballets Russes and many members of the Dadaists and the Surreal-
ists. Memoirs of this era make much of almost all these bands. Yet,
while individuals like Chagall and Soutine maintain their place in
art history, the School of Paris itself seems somehow to have slipped
from most memories, especially outside France, a fascinating, forgot-
ten tale.

TWO

MODI, MONTPARNASSE, NETTER AND ZBO

MOST FRIENDS IN PARIS KNEW AMEDEO MODIGLIANI AS Modi, a nickname that has the same sound in French as *maudit,* or "cursed." That confusion did not seem to matter, for most friends feared that he was, in fact, cursed. He led a life of operatic tragedy. A handsome Italian artist weakened by too much hashish and alcohol, Modigliani died of tuberculosis in 1920 at the age of 35. His young love, pregnant with their second child, leapt to her death from a fifth-story window a day later. While alive, he managed to exist on the subsidies of a kindly collector. But no matter how much came his way, his forays to the cafés of Montparnasse usually left him penniless. His paintings barely sold at the time of his death. Yet in 2010, ninety years later, his "Nude Sitting on a Divan" sold for $61.5 million at auction at Sotheby's.

There is no doubt about Modigliani's popularity with the public and with rich collectors. But aficionados of his works fear that the bohemian clichés of his life get in the way when art historians and

critics assess his accomplishments, that the lurid details of his down-fall overshadow his paintings, that, as an important exhibition put it a few years ago, it is difficult for the art establishment to get "beyond the myth" of Modigliani and realize that he truly was an innovative and significant painter. The sensational anecdotes may also get in the way of understanding the depth of his encouragement of the young and little-known East European Jewish painters of Montparnasse, especially Chaim Soutine. Modigliani died before talk began of a School of Paris, but there is no doubt that he served as a kind of pa-tron of the group and a good friend to many of its members.

Modigliani was born in Livorno (known to many English speak-ers as Leghorn) on the western coast of Tuscany on July 12, 1884. His parents were Sephardic Jews, descendants of Jews expelled from Spain in 1492. His wealthy father, Flaminio, helped manage family-owned zinc and coal mines and lumber forests, but a series of failures wiped out the family holdings in the 1880s and forced him into bank-ruptcy. Amadeo's mother, Eugenia, who had been born in Marseille in France and was fluent in English and French as well as Italian, opened a small private language school to help support the family.

As a boy, Modigliani was sickly, subject to attacks of pleurisy and typhoid and finally diagnosed with tuberculosis at the age of 16. De-spite these illnesses, he studied painting and sculpture in Florence, Rome, Carrara and Venice and finally, in 1906 at the age of 21, ar-rived in Paris, wearing a broad-brimmed hat, a red scarf and an Ital-ian corduroy suit with flaring sleeves. At first he alternated living in Montmartre and Montparnasse but, like most young painters in the new twentieth century, finally settled in Montparnasse.

THE ART SCENE WAS literally changing in Paris. In the nineteenth century, artists had congregated around the hill of Montmartre in the north of the city on the Right Bank of the Seine. This world came alive in the work of Henri de Toulouse-Lautrec and others who

painted the exuberance of the Moulin Rouge and the Chat Noir and all the other dance halls and cafés that brightened the area. It was the heartland of Parisian bohemian life. Even impressionists like Pierre-Auguste Renoir, Edgar Degas and Camille Pissarro, who did not often paint scenes of nightlife, had studios around Montmartre. And so did Pablo Picasso, Georges Braque and the other early twentieth-century cubists.

But the artists grew annoyed at the hordes of tourists streaming through the narrow streets of Montmartre looking for them. The nightlife also turned irksome as it became dominated by pimps and prostitutes. The artists started to gravitate to Montparnasse across the city in the south on the Left Bank of the Seine. Montparnasse offered relatively low rents for studios, commodious cafés, a lack of tourists and ease of living. Billy Klüver and Julie Martin, historians of this era in Paris, believe that the police decided to designate Montparnasse a "free zone"—a neighborhood where more "unconventional behavior and life-styles" were allowed than in the rest of Paris but brothels and crime were kept out.

Since La Ruche lay on the edge of Montparnasse, its graduates found it natural to look for new housing in the area. The death knell for Montmartre came in 1912 when Picasso and his friends decided to move out of their studios there, in the building known as Le Bateau-Lavoir, and head south to Montparnasse. Montparnasse was not as picturesque as Montmartre with its hill and funicular and narrow streets and outdoor portraitists and church on its summit, but, after the First World War, it was the real artist center of Paris.

Two cafés, the Dôme and the Rotonde, on the corners where the Boulevards du Montparnasse and Raspail cross, served as the social hubs of Montparnasse. Artists, writers and composers gathered there to break from their work, exchange ideas or meet newcomers to Paris. Since the presence of these intellectuals attracted other Parisians to the cafés, owners did not mind how long they stayed or how little they

ordered. A 20-centime cup of coffee guaranteed a seat for the afternoon. Michel Kikoïne said that when he ran out of francs, he would spend hours at one of the cafés hoping to find a fellow painter who would lend him money or at least pay for his food and drink.

The pattern was set by white-haired, heavily mustached "Papa" Victor Libion who bought the Rotonde in 1911, enlarged it and set up an outdoor café on the sidewalk. The Russian journalist Ilya Ehrenburg said that Russians, Spaniards, Latin Americans and other foreigners, "all exceedingly poor, oddly-dressed, and hungry," usually crowded into a smoke-filled back room and "argued about painting, declaimed poetry, discussed likely sources for borrowing five francs, quarreled and made up." Libion would throw out loud drunks but usually managed to quiet Modigliani before he became too noisy.

Ernest Hemingway, writing in the *Toronto Star*, had harsh words for both cafés. He said the Rotonde attracted the "scum of Greenwich"—presumably referring to the bohemian Greenwich Village in lower Manhattan—and that the Dôme attracted Americans who were "nearly all loafers expending the energy an artist puts into his creative work in talking about what they're going to do."

Nevertheless, Hemingway frequented the Dôme and wrote in *A Moveable Feast* that he sat down one evening in the early 1920s at a table there with the painter Jules Pascin and two models. Pascin, a wealthy Bulgarian Jew whose adopted name Pascin was an anagram of his family name Pincas, was regarded as one of the leading painters of the School of Paris. He usually wore a derby and liked to organize large parties, some with everyone in costume. There are photos of him dressed as a picador and in a fez and whiskers.

Pascin was drunk, and his vulgar talk sometimes made Hemingway and the models uncomfortable. Pascin persisted in insulting the models and then invited Hemingway to join them for dinner, but Hemingway declined. "Go on, then," Pascin said. "And don't fall in love with typewriting paper."

Pascin killed himself in 1930 at the age of 45. Hemingway, who himself committed suicide in 1961, regarded Pascin as a "lovely painter," very high praise in the writer's muted lexicon. "Afterwards, when he had hanged himself," Hemingway wrote, "I liked to remember him as he was that night at the Dôme.

"They say the seeds of what we will do are in all of us," Hemingway went on, "but it always seemed to me that in those who make jokes in life the seeds are covered with better soil and with a higher grade of manure."

UNLIKE THE RUSSIAN JEWISH PAINTERS of La Ruche who often struggled with the French language, Modi could easily have fit into French society as a sophisticated and assimilated artist. He spoke French fluently, dressed well, bore the stamp of some of the finest art schools of Italy, knew the greatest Italian works of art and enjoyed the handsome looks of a movie star. He basked in the special mood of Livorno, long regarded as a congenial town for an urbane Sephardic Jew. Unlike Venice, for example, it never had a ghetto. An ecumenical respect for all religions and their universality pervaded the city.

But Modi refused to assimilate and spent a good deal of his time with the Jewish artists who lacked his advantages. "Despite the invisibility of Modigliani's Jewishness," wrote Mason Klein, the organizer of the 2004–2005 exhibition in New York, Washington and Toronto titled *Modigliani: Beyond the Myth,* "he reclaimed it from beneath his Gentile mask." He sometimes introduced himself in cafés as "Modigliani: *je suis juif* (I am Jewish)."

Klein, an art historian and curator at the Jewish Museum in New York, believes that Modigliani's refusal to assimilate came from his self-image as an artist who was different and individualistic. In short, he wanted to feel alienated in Paris and could do so if he associated with the Jewish artists who, despite their numbers, were really outsiders. Whatever the reason, there is no doubt that Modigliani

embraced the new Jewish painters of Paris, especially Chaim Soutine, probably the least sophisticated of them all.

Jacques Lipchitz, a cubist sculptor born like Soutine in Lithuania in the Russian empire, introduced Soutine to Modigliani in 1915, in the midst of World War I. The war had decreased the number of foreign artists in Paris somewhat. It had, for example, trapped Marc Chagall visiting his family in his hometown in Russia. He would remain there through the Bolshevik Revolution and the first years of the Soviet Union. Since Moïse Kisling came from the Austro-Hungarian empire, at war with France, he was technically an enemy alien. But he fought for France by joining the French Foreign Legion. Jules Pascin, who came from Bulgaria, which was aligned with the enemy Germany, left for the United States and remained long enough to earn American citizenship before returning to Paris. The status of Italians like Modigliani and Russian citizens like Soutine remained unchanged since their countries were allies of France during the war. Both tried to join civilian brigades digging trenches in battlefields, but the work proved too arduous for them.

Despite diminished numbers of artists, shortened hours at the cafés and a notable lack of buyers of art, life continued much as before for both Soutine and Modigliani during the war, and a close friendship developed. The sight of the two, the handsome, sophisticated, friendly 31-year-old Modi shadowed by the unkempt and taciturn 22-year-old Soutine, became a mainstay of the scene at the Dôme and the Rotonde. Modi drank heavily, sometimes offering to sketch the likeness of a patron on a piece of paper for an absinthe.

The pairing was incongruous to all those who had a clichéd image of Soutine based on their first impressions. There is no record of what Modigliani and Soutine said to each other about their work, but the pairing is less surprising when you realize that both men were intent on fashioning a new kind of portraiture—a form of art ignored by most other avant-garde painters in the early twentieth century. No

one, of course, would ever mistake a Modigliani portrait for one by Soutine. With his penchant for triangular mouths, long slender necks and sculpted, eyeless heads, Modigliani endowed his subjects with a universal nobility. They did not look exactly alike—the haughtiness of the French writer Jean Cocteau (painted in 1916 and 1917 and now at the Princeton University art museum) was unmistakable, for example—yet some art historians believe that he and the other subjects share a common humanity imposed by the painter. There was hardly any universality in the portraits of Soutine. Almost all his subjects were caught in a swirling cascade of color and confusion that often distorted the size of their features. Few were flattering. Some looked decades older than their age. Soutine tried to capture the essence of the sitter. Neither he nor Modigliani was interested in producing a realistic, photographic likeness of the subject.

Modi painted several portraits of Soutine, the most significant (in the Jonas Netter collection in Paris) in 1916. Soutine looks quiet, gentle, shy with his eyes half closed yet watchful. He is wearing a clean, brown, buttoned jacket. There is nothing unkempt or soiled about him. His soft hands rest on his thighs. A gap separates two of the fingers of his right hand from the other three. Marc Restellini, the director of the Pinacothèque de Paris, a private museum, and the editor of several Soutine exhibition catalogues, believes the separation represents the difficult gesture of benediction that, according to Jewish folklore, is still possessed by Jews descending from the cohen (priests) of biblical times. That analysis probably stretches the evidence, but there is no doubt that Modi painted a serene and almost spiritual Soutine.

Another portrait was more notorious. Hanka Zborowski, the wife of Modi's dealer, did not like Soutine and showed her annoyance whenever Modi brought his young friend around to the Zborowski apartment. To spite her, Modigliani one day painted a full-length portrait of Soutine on a door in the apartment. When the Zborowskis

complained, Modi told them, "Someday you will be able to sell the
door for its weight in gold." Hanka replied in disgust, "But until then
we have to live with that portrait."

There are no known portraits of Modigliani by Soutine. If he
painted any, he must have destroyed them. But there are unusual self-
portraits. In 1918, Soutine painted himself as a young, innocent and
naive artist (now at the Princeton Art Museum). Soutine sometimes
liked to distort age, usually making his subjects look older. In this
case, he seems to have rendered himself ten years younger, as if he
were a bar mitzvah boy of 13 wearing his first suit. The tie and the
lapels of his jacket are askew.

Four years later, Soutine painted another self-portrait, more in
line with the kind that would mark his genius. In the portrait (now in
the Museum of Modern Art of the City of Paris), he painted an enor-
mity of nose, ears and bright red lips in distorted features pressed
onto a distorted body clothed in swirls of yellow, brown and green
fabric. It seems like a study in self-hate, and Soutine aptly titled it
"Grotesque."

Modi and later Soutine were rescued from hopeless poverty by a
little-known Paris collector named Jonas Netter. A Jewish business-
man born in Alsace, Netter admired the wonderful and popular im-
pressionists of the late nineteenth century, but they had become too
expensive in the early twentieth century, so he searched instead for
cheaper paintings by younger painters who might someday become
as wonderful as the impressionists.

He found them through an unusual guide, Léon Zamaron, the
police officer in charge of renewing the papers of foreigners living in
Paris. As part of their victory spoils after the Franco-Prussian war
of 1870, Germany had annexed the French province of Alsace, forc-
ing Alsatians like Netter to carry foreigner documentation. At police
headquarters, Netter struck up a conversation about paintings with
Zamaron, who knew the world of foreign painters through his work

and suggested that Netter call on a Polish dealer named Léopold Zborowski.

Zborowski, a Pole born in Warsaw and educated at Krakow University, had arrived in Paris the same year as Soutine. He regarded himself as a budding poet and intended to study French literature at the Sorbonne. But he was sidetracked into art, even taking the same art classes as Soutine, and tried to establish himself as one of the many art dealers of Paris. There were 130 in 1911, and the number kept growing. Zborowski bought and sold rare books, drawings and prints at first but soon gravitated toward oil paintings, the main attraction in the Paris art market. But the painter Kisling, who knew him well, said Zborowski remained "essentially the poet, always with his head in the clouds."

The wife of Tsuguharu Foujita, the Japanese painter who was an alumnus of La Ruche, introduced Modigliani to Zborowski in 1916. Other dealers had handled the works of Modi before but none with much enthusiasm. Zborowski, a handsome, dark-bearded man of considerable charm and intellect, showed a great deal of enthusiasm and served as Modi's dealer for the rest of the artist's short life. He told his wife that Modigliani was "twice as good as Picasso."

Modigliani was the first painter that Zborowski induced Netter to both buy and subsidize. The dealer had promised to support Modi but could come up with only inadequate and irregular payments. Netter filled the gap. He agreed to pay Modi 600 francs (the equivalent, when you account for inflation, of 768 euros, or $1,000, in 2011) a month to cover his rent, food and art supplies. This subsidy, regarded as generous in those days, would entitle Netter to take half the canvases Modi painted in a month.

The Netter-Zborowski partnership worked well. Netter was a busy and discreet businessman who felt no urge to involve himself in the world of artists, their models and their parties. He was interested only in their paintings. He admired and trusted Zborowski and

marveled at his exuberance. Netter remained in the background, and Modi and others, whether they knew the actual source of the money or not, usually acted as if they believed their subsidies came from Zborowski or, as they called him, Zbo.

Netter always sent the funds to Zborowski on time, but the dealer was sloppier about passing it all on to the artist right away. In a letter from Nice in 1918, Modi began in both French and English: "*Mon cher Zbo, Voila la question: ou:* that is the question (*voir* Hamlet) *c'est a dire* to be or not to be." Unlike Hamlet, Modi was not contemplating suicide but needed more money. He was "sliding into mud," he told Zbo, and unless the dealer sent him more funds, he would "remain immobilized with legs and fists tied."

Under pressure from Modi, Zbo reluctantly agreed to persuade Netter to supply Soutine with a monthly retainer, though far less than what Modi received. But the constant visits of the young uncouth Soutine with his awful accent in French continued to annoy Zborowski's wife. Her nagging finally pressured the dealer into sending Soutine off to the South of France to paint landscapes.

Besides Modigliani and Soutine, the French painter Maurice Utrillo also received subsidies from Netter. Zborowski searched the galleries of other dealers and the studios of other painters for works that might interest Netter. In a few years, the Alsatian assembled what was surely the finest private collection of the works of the School of Paris. They included Moïse Kisling, Michel Kikoïne and Pinchus Krémègne as well as Modigliani and Soutine and the lesser-known Henri Epstein, Aizik Feder, Jan Wacław Zawadowski, Eugène Ébiche, Zygmunt Landau and Isaac Antcher. But it did not include Marc Chagall. Chagall was visiting Russia when world war erupted in 1914 and did not return to Paris until ten years later.

MODI HAD A PROCESSION of lady friends, including the Russian poet Anna Akhmatova, but the liaisons usually did not last

very long. In 1914, however, he met Beatrice Hastings, a South African–born columnist for a British political and literary journal called *New Age*. Modi did not impress the green-eyed Hastings when they first met at the Café Rotonde because, she said, he reeked of hashish and brandy. "He looked ugly, ferocious, greedy," she said. But later, when he returned to the café, he was shaven and charming. Modi "raised his cap with a pretty gesture, blushed and asked me to come to see his work," she wrote later. Beatrice was soon taken with this "pale and ravishing villain," this "complex character," this "swine and a pearl," and they began a troubled affair that lasted a year. When Modi met Beatrice, he had just given up sculpting. The cost of marble and other stone had become prohibitive during the war, and the dust from the carving aggravated the weakness of his lungs. While holding on to his studio for work, he moved into her apartment in Montparnasse and with her to Montmartre when she rented a two-story, four-room house with a garden right on top of the hill.

The affair was not a tranquil one. The couple, especially when both were drunk, traded shouted insults, slapped each other and cheated. "Once, we had a royal battle, ten times up and down the house, he armed with a pot and me with a long, straw brush," she recalled. They finally broke up in August 1915.

After the breakup, Modi went on a drinking binge that finally left him unconscious in another painter's studio. Friends found him and tried to nurse him back to better health. For a few months, he moved into a small apartment with Soutine in an inexpensive artists' neighborhood known as the Cité Falguière.

In the last few years of his life, Modigliani painted some of the most extraordinary nudes in the history of art. Although he had spent several years trying to turn out sculptures, his painted nudes bore no resemblance to the idealized, classical women of most sculptors. Modigliani's nudes were aroused, ready for lovemaking, their

eyes feasting on their lovers, the colors of their bodies startling and feverish.

Since the handsome Modi had the reputation of a lothario, it was sometimes assumed that the nudes were portraits of his conquests. But he rarely painted any of his loves without clothes. He painted his nudes on order from Zborowski. Zbo set up a studio in the apartment above his own on rue Joseph Bara, supplied Modi with canvases and paints, hired several models, and ordered a batch of paintings. Since Zbo paid him a salary (mostly with Netter's money), Modi complied and completed 20 in a few days. Modi always finished his portraits in a single sitting.

In 1917, Zborowski persuaded Berthe Weill to stage a one-man Modigliani show in her gallery on rue Taitbout. Weill specialized in introducing young avant-garde painters and was widely known and respected as the dealer who sold the first Picassos in Paris. Although Zborowski included only a few (some witnesses say 4, others 7) of Modi's nudes in the show of more than 30 works, Weill brazenly placed one of the provocative nudes in the window of her gallery. She also featured a nude drawing by Modi on the poster advertising the show.

The local police station was across the street from the gallery, and the nude in the window upset the local police chief. Parisians, of course, were used to nudes in paintings. The Louvre was full of them. But Modigliani's nudes were different. He did not paint classical nudes of purity and innocence. His nudes displayed their pubic hair and beckoned for sex with big black eyes. The police chief summoned Weill to the station. "I order you to remove all this rubbish," he said. "And if my orders are not followed immediately, I will confiscate all of them." Weill pulled the offending painting from the window, and the show went on.

This incident has long been regarded as one of the most notorious in twentieth-century art, but the news about the police censorship

did not engender immediate sales. Weill sold only two drawings. She herself bought five paintings so that Zborowski would not be too discouraged.

In 1917, the same year as the Weill gallery exhibition, Chana Orloff, a Ukrainian-born sculptor and a close friend of the Hébuterne family, introduced 19-year-old Jeanne Hébuterne to Modigliani. Jeanne, whose father was an accountant for a perfume company, was a student at the Académie Colarossi, a private art school that, unlike the government's Beaux-Arts, accepted women. She also was enrolled in the National School of Decorative Arts. Orloff described her as akin to "a small gothic statue" with "something mysterious about her." The Hébuterne family never forgave Orloff for the introduction.

The meeting initiated a passionate, star-crossed, tense love affair. It was the first time Modi fell in love with a fellow artist, for she was far more than a fawning student. Jeanne, though only 19, was a superb draftsman and a painter of extraordinary promise. She loved to sketch the kind of streamlined curves and patterns that would become fashionable in the art deco era, and she also inspired some of Modi's finest work.

Modigliani painted a large number of portraits of Jeanne in 1918 and 1919. Judging by several photographs, she easily fit the stylized traits that he emphasized in his painting, for she had a long neck, thick lips and large nose with eyes that focused softly and dreamily. Although photos reveal a teenager of lively charm, she did not seem beautiful, and Modi did not paint her as such. At first, the portraits endowed her with a wonderful nobility. Later portraits showed a saddened and troubled young woman with a lovely neck, long nose and usually vacant eyes. Sometimes a slight double chin started to form. Even when a loose dress showed her pregnant, she betrayed no joy.

Zborowski was pleased with the new affair. Jeanne was quiet and reserved, even melancholy, but she obviously adored Modi. Zbo

hoped that she would impose some stability on him, discourage his drinking and carousing and nurse his weakened body. But Modi could not break old habits, Jeanne never denied him anything and his health continued to weaken. Despite an incessant cough, he never stopped smoking or drinking.

With Zbo's financial help, Modi moved into a large apartment on the rue de la Grande Chaumière, his last address in Paris. Zbo supplied a stove and some furniture; his wife, Hanka, and their friend Lunia Czechowska cleaned the apartment and Modi painted the walls ocher and orange. Jeanne spent most nights with Modi in the apartment but did not tell her parents. It was a remarkable subterfuge, for her parents, who also lived in Paris, assumed she was staying with them. But the family always allowed Jeanne a great deal of freedom, and she explained her many absences by claiming she was visiting relatives outside Paris or spending the night with the families of fellow students. Her mother did not figure out the truth until she realized Jeanne was pregnant.

In March 1918, Parisians could hear the thunder of enormous German cannons approaching the city. Zborowski assembled his main artists, Modi, Utrillo and Soutine, and led them far from the fighting to the Mediterranean city of Nice on what is now known as the Riviera. The Riviera has some of France's most spectacular vistas, for the last segments of the Alps approach the coast and then fall almost 2,000 feet to the beaches, seaports and capes below. It was a kind gesture by Zbo but not an extravagant one. The Riviera had not yet been discovered as a year-round resort. It was used mainly by the wealthy in the winters. In the 1920s, American expatriates like F. Scott Fitzgerald, Hemingway and the artist Gerald Murphy would help publicize it as ideal for summers as well as winters, making the Riviera fashionable year-round. But when Zbo's group arrived, winter was over, and hotels, apartments and restaurants were cheap. The group soon grew. Jeanne, no longer able to hide her affair from her

parents, left Paris to join Modi. Her mother, Eudoxie Hébuterne, accompanied her.

Eudoxie finally left the couple after several shouting matches with Modi. A child, also named Jeanne, was born in Nice on November 29, 1918, a little more than two weeks after the signing of the armistice that ended the world war. The depressed young mother seemed incapable of caring for the infant without help; she wanted as little to do with it as possible. Modigliani even had to ask Czechowska, Zbo's friend, to keep the baby in her apartment for several days. But Modi was ecstatic about his child and fatherhood. "The baby is well and so am I," he wrote his mother in Italy. "You have always been so much of a mother that I am not surprised at your feeling like a grandmother, even outside the bonds of matrimony."

Czechowska said, "Modigliani was absolutely thrilled. He adored this baby and nothing else in the world existed for him except her." The child Jeanne, when she grew up, talked to many of his friends and wrote a book about her father, concluding "Modigliani was touchingly proud of his wife and baby, but at the same time he seems to have been terrified of this new responsibility."

Once back in Paris, the birth of the baby inspired Modi to turn out more canvases in hopes of earning more. His work had started to sell, and he attracted notice at a London exhibition arranged by Zbo. Modi signed a statement that read "Today, July 7, 1919, I pledge myself to marry Mlle. Jane [sic] Hébuterne as soon as the documents arrive." Jeanne, Zborowski and Lunia Czechowska witnessed his signature. But the couple never managed to marry.

In a few months, Jeanne discovered that she was pregnant again. The health of Modi, who still tried to tour the Paris cafés every night even in the winter cold, continued to deteriorate. Zbo wanted him to go to a sanitarium in Switzerland, but Modi ignored that kind of advice. By the beginning of 1920, Modi was so sick that he stopped working and remained in bed. But he would not allow Jeanne to call

a doctor. Zborowski came by every day for ten days but was then felled by influenza and bedridden himself. A neighbor and old friend, the Chilean artist Manuel Ortiz de Zárate, usually checked on Modi daily, but he was out of town for more than a week.

News of the seriousness of Modi's illness spread through the community of dealers. Several, who had become interested in the painter recently and had bought canvases, put them aside to wait for his death. They guessed that their value would increase greatly as soon as his death evoked memorable tales of his wild bohemian life throughout Montparnasse. They even implored Zborowski in vain to stop selling Modiglianis for fear of flooding the market and decreasing the value of their hoards.

When Ortiz de Zárate returned from his trip, he found the apartment freezing, Modi unconscious in bed and Jeanne lying against him. Ortiz de Zárate called an ambulance that rushed Modigliani to Charity Hospital on the rue Jacob. He did not regain consciousness and died two days later on January 24, 1920, at 8 P.M. of tubercular meningitis. He was 35 years old.

Jeanne came to the hospital the next morning for a final farewell. Since she was in her ninth month of pregnancy and distraught, friends begged her to remain there for rest and tests. But she spent the rest of the day at her parents' apartment, sharing a bed with her brother André. During the night she got out of bed, opened the window of the fifth-story apartment and leapt to her death. She was 21. The unborn child died as well. The family rejected a proposal from Modi's friends that Jeanne be buried alongside him.

Modi was buried at Père Lachaise Cemetery where tourists usually looked for the graves of Frédéric Chopin, Jean-Baptiste-Camille Corot, Jacques-Louis David, Honoré de Balzac, Georges Bizet and other celebrities of Paris. The funeral was attended by many friends. Meryle Secrest, Modigliani's most recent biographer, lists Soutine on a long list of painters who "would have been" in the funeral

procession. Soutine, however, was painting on the Riviera when he received news of the two deaths, and there is no evidence that he left for Modi's funeral. In fact, the grieving Soutine became ill during the next few weeks, and Zborowski returned to the Riviera to fetch him back to Paris. The Modigliani family in Italy took custody of little Jeanne. Ten years later, the Hébuterne family finally agreed to allow the remains of their daughter to be buried alongside Modi.

Montparnasse was now without its Modi. Two days after he died, Zborowski wrote Modi's brother, "He was a son of the stars for whom reality did not exist." In one of the last meetings between the bedridden painter and Zborowski, he had told his dealer not to worry. "I'm going," he said, "but I am leaving you Soutine."

THREE

> **MIDI, LANDSCAPES
> IN TURMOIL, A PASTRY CHEF AND
> ASSAULTS ON THE CANVAS**

CHAIM SOUTINE DID NOT LIKE HIS EXILE IN THE MIDI. HIS dealer, Léopold Zborowski, paid him five francs a day so long as he painted in the South of France. The cost of living was far less in the countryside than in Paris, but five francs was not much, barely enough to buy paints for the day. To make matters worse, Zborowski was often late in sending the monthly allowance. Soutine knew that the dealer did not think much of his work, that he kept Soutine on the meager payroll only at Modigliani's insistence. Yet Soutine had no other regular source of income. He obeyed Zbo's demand and, with an occasional short foray back to Paris, remained in the South, mainly in the town of Céret, for three years. Despite all the grumbling, the stay proved crucial to his development as an artist.

Even before leaving Paris, Soutine was in anguish. An anonymous accuser had complained to the police that Soutine had made anti-French remarks during the world war that had just ended.

Soutine denied the accusation, and a police investigation turned up no such evidence. The complaint was dismissed as baseless, but it put Soutine through several frightening weeks.

The trip to the South had been devised by Zborowski mainly to placate his wife, who did not like Soutine. Soutine's first stop was at Cagnes-sur-Mer just outside Nice on the Mediterranean coast. Cagnes was a suburb with more than 5,000 people crowded into homes built into the hill that climbed from its beach. As an artist, Soutine felt no enthusiasm for its sand and sea and occasional palm tree. He wanted to paint landscapes, not seascapes. He wanted bands of trees surrounded by thick vegetation. His frustration there provoked a desperate letter to Zbo. "It is the first time that I have found myself unable to do anything," he wrote. "I am in a bad state of mind and demoralized, and that affects my work. . . . I want to leave Cagnes. I cannot bear the scenery." He tried moving to another Mediterranean port, Cap Martin outside Monaco, but that did not change his mood. "I did not like it," he went on. "I was forced to wipe out the canvases that I started. Now, against my liking, I am back in Cagnes where, instead of landscapes, I will be forced to turn out some miserable still lifes." Warning that he had felt several times like giving it all up and returning to Paris, Soutine implored Zbo to propose another site. The dealer finally sent Soutine off to Céret, a town in the Catalan country of southwestern France in the foothills of the Pyrénées just north of Spain.

Céret was a small town of 4,500 that seemed ideal for landscapes: forested hills and a nearby stream and orderly white stucco homes under ocher-tiled rooftops. Most residents, though schooled in French, spoke Catalan to each other. They clasped arms and formed huge circles on Sunday to dance the traditional Catalan *sardanas* and hosted an afternoon of bullfights from time to time. The town had a tranquil orderliness that vanished in the wild turmoil of Soutine's painting. The artist created his finest landscapes there and

painted unusual portraits that would attract great attention later. But he was never content with his stay in Céret, for he looked on it as no more than forced exile from Paris.

Céret already had a significant role in art history. A couple of Picasso's friends—French artist Frank Burty Haviland and Spanish sculptor Manolo—had started an art school in an abandoned monastery there and invited Picasso to visit them. Picasso, who delighted in small Catalan towns where he could practice the language he had learned as a student in Barcelona, went there in the summer of 1911. Georges Braque joined him, and the two honed their new art form known as cubism. The two artists competed with each other, trying to outdo each other with a more perfect cubist masterpiece. As a result, the critic André Salmon liked to describe Céret as "the mecca of cubism."

When Soutine arrived in Céret in 1919, the art school was closed, but Haviland and Manolo still lived in the town. There were younger artists as well, including Pinchus Krémègne, Soutine's old schoolmate from the art school in Vilna. The harshest assessment of Soutine's behavior in Céret came from Krémègne. Soutine had trouble keeping friendships throughout his life, and their relationship had soured soon after Soutine's arrival in La Ruche. Speaking to a local journalist decades later, Krémègne said, "He was raving mad, constantly drunk and dirty. People took him for the village idiot. He was impossible for the whole two years he spent there. He always hated Céret. When anyone would ask him how old he was, he'd say that his two years in Céret didn't count."

The memories of the townspeople were more measured. Pierre Camo, a well-known poet from Céret, wrote that Soutine "was completely unapproachable. . . . He was touchy and unsociable. I guess he must have been very shy. He basically lived alone and apart. He was always careful to hide his paintings and could not bear being seen while he worked, even from a distance. I never had a chance to say a single word to him."

André Masson, the cubist and later surrealist painter working in Céret at the same time, did have a word with Soutine. They argued about van Gogh. "He was against Van Gogh," Masson recalled. "He said, 'Van Gogh is an old maid knitting.' When I asked him whom he did like, he said Rouault."

Soutine was an outsider in a town of few outsiders, and he still mispronounced French words, often confusing the sound of the *e* and the *i,* so that the word "étude" came out of him as if it were spelled "itude." To complicate matters, he did not understand Catalan, the language often spoken all around him. He did not have a friend like Modigliani to encourage him. His shyness made it difficult for him to make new friends, and his volatility made it difficult for him to hold on to old friends.

Soutine's working habits in Céret surely struck many as odd. Zborowski, who wrote a friend about a visit to Céret, described some of Soutine's landscape binges. "He goes off to the countryside," Zbo said, "and lives like a pauper in a shed for pigs"—it was actually a tool shed in a vineyard—and "gets up at four in the morning, walks twenty kilometers with his canvases and paint to find a site that pleases him, and comes back to sleep without thinking about eating.

"I found three hundred paintings piled one on top of the other in his wretched hole, which stank to heaven because he never opened the window for fear of damaging the canvases," Zborowski went on. "While I was out getting some food for him he set fire to them, giving as his excuse that he wasn't satisfied with them. However, I managed to save a few, but only after a knock-down fight with him."

Soutine had tranquil leisure time in Céret as well. In an article published more than a half century later, the son of the local barber said Soutine would come into the shop for a shave without greeting anyone. Then he would walk across the street to the Grand Café and order a coffee and a brandy. "With delicate movements," the writer

recalled, "he would savor one and then the other, all the time totally absorbed in himself."

Soutine moved several times during his stay, living in a hotel, an apartment and in rooms with families. He always had difficulty paying his rent. This problem was solved, however, when his benefactor, the collector Jonas Netter, visited Céret and paid all his bills.

Despite his shyness, his difficulty with the French language, his lack of any Catalan, his oddness and his unsocial attitude, Soutine managed to persuade a pastry chef, a widow in mourning, a former army officer, and a couple dozen other Céret townspeople to pose for his portraits for a few sous a sitting. Since a sitting took three or four hours, it is doubtful that they posed for the money. Despite Soutine's social ineptness and unhappiness in the town, he clearly had enough good manners and charm to persuade some townsfolk to pose when he needed them.

There is, in fact, a great irony about Soutine's professed distaste for Céret, for his time there was surely the most productive of his career. He painted and did not destroy about 200 canvases, developing a unique style in landscapes and portraiture that stamped his work forever. He lavished drippings of color together that anticipated the great abstract expressionists who followed him decades later. Never again would he turn out a series of paintings so vital to his career. One canvas alone, a portrait of a pastry chef, would prove the most important of his life.

There is not enough evidence to trace how Soutine evolved as an artist. Few paintings exist from the era before Zborowski, at Modigliani's insistence, agreed to pay Soutine a stipend of five francs a day. This lack stems partly from Soutine's penchant for destroying canvases that he deemed failures, partly from stretches when, his energy sapped from hunger or from working as a day laborer, he did not paint at all.

At most, we can find an early hint. In 1915 or 1916, for example, he painted "The Artist's Studio, Cité Falguière" (now in a private collection), a picture of the building in which he and the sculptor Oscar Miestchaninoff shared a studio after they left La Ruche. The walls billow outward as if the structure has some strange life within. Yet this does not prepare us at all for the turmoil, exuberance and pulsating power of the landscapes he painted soon afterward in Céret.

In the year 2000, the Museum of Modern Art of Céret published a catalogue for an exhibition of the landscapes painted by Soutine during his stay in the town. Many landscapes in the catalogue were accompanied by photographs of the scenes Soutine painted. The photos showed an orderly town of two- to three-story homes, some in white stucco, the others in beige stone, all with ocher roof tiles. Ravines curved beyond the homes. Tall cork and plane trees stood upright and well spaced out. The streets, some opening into plazas, seemed tranquil and near empty of people. Forested hills cropped up here and there. Soutine devoted many canvases to a stone church with a bell tower and to the abandoned monastery.

Soutine's paintings barely resembled the photos. The paintings created a world in utter turmoil, in frightening rebellion, like a tsunami in wondrous and terrible color. But more than trees and bush swirled across his paintings. He charged the inanimate with life, and homes stretched and reached high, like great birds of prey, set to leap away from the canvas. When three or four of his landscapes hang side by side in a gallery, they seem part of the same story, rushing into each other, like sections of a Chinese scroll. "Everything dances around me," Modi once said in a night of drinking, "as in a landscape by Soutine."

Soutine's Céret landscapes were surprising, unique and uncanny.

Two masterpieces, now in the Orangerie museum in Paris, illustrate the maddening movement of the Céret landscapes. In "The Great Blue Tree," the world is caught turning upward and around.

The tree, reflecting the blues in a storm-churned sky, is bending in vain against a force that is drawing almost all things upward. Yet two tiny human figures are taking their place in the lower left corner of the canvas as if they have come without panic or fear to observe the upending of the world.

In "Houses," Soutine has taken the tranquil, residential Avenue of the Republic in Céret and distorted it completely. The houses have all come alive and are stretching, bundling, twisting, moving continually leftward. They are rushing over a road that is made up of thick streams of many colors, greens and blacks and browns and yellows and more. These convoluted mixtures of color in Soutine's works would prompt the art critic Harold Rosenberg to say in the 1950s that abstract action painters could have learned their craft by examining a square inch of a Soutine canvas under a microscope.

The figures in Soutine's Céret portraits are less distorted than the landscapes, but these canvases are still special and unique. The portraits have led some critics to describe Soutine as an expressionist in the manner of van Gogh or the avant-garde German painters of the 1920s. But Soutine's work looks so different that classifying him with them seems inadequate. Like expressionists, Soutine refuses to paint the objective reality of his subject. But it is not clear what he wants to show: the psychological inner reality of the subject, his own emotional reaction to the subject or, since he ages so many, his vision of what they will become some distant day. Perhaps he wants to show all three. It is obvious, in any case, that he wanted to paint the turmoil beneath an ordered world and the fear behind some ordinary people.

Soutine never helped others understand what he was trying to do. He once told a girlfriend that he could not discuss his work because he did not speak French or Russian well enough to express his ideas on the subject. That was, of course, a disingenuous excuse. He was surrounded by Yiddish speakers all his life, and none ever reported him talking about his art in his native language.

Soutine did not paint portraits of fellow artists or of civic leaders in Céret. Instead, he sought out ordinary townspeople, attracted largely by the color of their clothing or perhaps a special aspect of their features. Each portrait is different, of course, but there are elements that unite them. None smiles, and all seem filled with anxiety.

For its Soutine exhibition, the Museum of Modern Art of Céret found some family photographs of Rémy Zocchetto, the 17-year-old apprentice chef at the Garetta hotel in Céret who served as the model for Soutine's 1919 painting "The Pastry Chef" (now in the Barnes Foundation in Philadelphia). The likeness is actually very close to the photo with only one major distortion—an enormous reddened right ear. The man's gaze in the painting is firm yet fearful without the slightest hint of a smile. It is the coloring that makes this portrait distinctive, for the young chef, all dressed in white smock and hat, is kneading a contrasting deep red kerchief. The large expanses of white are highlighted with rivulets of blue, pink, brown, yellow and orange, and the model sits in a dark black chair that seems to bend to fit his body. The paint of his multihued face looks as if it were molded in clay.

A vital trait of the Céret paintings—and, in fact, of all Soutine's work—was the thickness of the paint with its dynamic swirls, bolstering the belief that the artist must have attacked the canvas in some kind of frenzy. Ellen Pratt, a Guggenheim Museum conservator, led a team that studied evidence of his technique in two dozen canvases loaned to the Soutine retrospective at the Jewish Museum in New York in 1988. "Soutine didn't just apply paint to the canvas," she concluded. "He worked it, sculpted it, manipulated it. His paint functions as color, as substance, as texture." His application of the pigment, she said, fell "firmly in the category of the three dimensional."

Soutine employed several tools. He painted with a brush but also used the pointed end to scratch into the pigment. He wielded

a palette knife, both to apply paint and to scrape some of it away. When necessary, he leaned into the canvas and twisted the paint with his hand. The research team discovered his fingerprints on some canvases.

After X-raying a dozen of the canvases, Pratt's research team found that Soutine had painted two on top of other paintings. That reflected one of Soutine's oddities. He liked to go to the Paris flea market and buy seventeenth-century paintings for use as canvases for his own work. At the time, 300-year-old paintings cost less than new canvas. But Soutine did not buy them solely to save money. He sought antique paintings in the flea market even after he could afford new blank canvases. According to the sculptor Chana Orloff, Soutine felt that the old layer of paint helped the new paint stick to the canvas. He also liked the feel of the old painting after he cleaned it. "I like to paint on something smooth," he said. "I like my brush to slide."

Soutine was still in exile in the Midi when he received the shocking news that Modi had died and that Jeanne had killed herself and her unborn child. He had seen the couple whenever he could in the last few years. They had even visited him in the Midi, and Jeanne had painted a wonderful, tough portrait of him. Now Soutine had suddenly lost the only painter in Paris who had embraced him fully with friendship, respect and practical help. Without Modi, he would not have had a dealer. He would not have had a sponsor like Netter. As Pierre Courthion, a sensitive and painstaking critic, put it, "The death of his comrade, and the dramatic circumstances around it, would leave a great void in his existence. . . . Soutine would never again find a companion more faithfully devoted than the Italian who had helped him leave his extreme misery."

In the years afterward, many acquaintances noticed that Soutine never again toured the cafés of Montparnasse in drunken spectacles. It was widely assumed that the death of Modi had frightened him

away from the alcohol that could tear apart his weak insides. But that assumption surely misunderstood Soutine. He was too shy and inward to ever savor making a spectacle of himself in the cafés. He had followed Modi like a shadow to support the only real friend he had. With Modi gone, the shadow vanished.

FOUR

DR. ALBERT COOMBS BARNES OF PHILADELPHIA MADE HIS
first art-buying trip to Paris in 1912, a year before Soutine arrived.
Barnes returned year after year until he finally amassed the great-
est private collection of modern art in America. While doing so, he
cultivated a reputation as imperious, contemptuous, irascible and
unconventional. But he also demonstrated a magnificent eye for the
color and form that distinguished the finest of avant-garde painting.

Dr. Barnes was both a medical doctor and a chemist, and his
wealth came from the discovery of Argyrol, an awful-smelling potion
that millions of mothers used to swab the throats or drip into the
nostrils of children with sore throats and running noses in the days
before antibiotics. Argyrol, an antiseptic with a silver protein base,
was also used in different strengths to alleviate the symptoms of gon-
orrhea. Barnes did not invent Argyrol, but he theorized that a work-
able cold remedy could be created if one could find a way of denuding

silver protein of its caustic qualities while still retaining its power as
an antiseptic. His partner, Hermann Hille, a German chemist, came
up with the right formula, and Barnes mastered the promotion and
marketing of the medicine. After a few years, Barnes, who did not
like to share power, bought out his partner, and Argyrol became the
property of Barnes alone.

Barnes had long shown an amateur interest in painting and might
have tried a career in art if that prospect did not seem so impractical
for a poor boy in need of a steady salary. His father, who had lost an
arm during the Civil War, supported the family on odd jobs and a pen-
sion of eight dollars a month. Barnes attended Central High School,
known as Philadelphia's elite school for poor boys, and then, with
the help of his earnings as a semiprofessional baseball player, earned
his medical degree from the University of Pennsylvania. Since there
were many jobs in the pharmaceutical industry, Barnes, who received
his medical degree at age 20, headed to Germany for postgraduate
studies in chemistry. He returned to a job with a Philadelphia phar-
maceutical firm and eventually moved on to the discovery of Argyrol.

A wealthy man by 1911, when he was 39 years old, Barnes de-
cided to return to his old interest and, while still in charge of the
company producing Argyrol, embarked on a second career in art
collection and education. He asked an old friend and Central High
classmate, the Ashcan School realist painter William Glackens, to
explain the latest trends in modern art and make a trip to Paris to buy
samples of some of the finest work for Barnes. Glackens returned in
1912 with paintings by Renoir, Degas, van Gogh, Manet, Gauguin,
Cézanne and others.

Barnes studied them carefully and then set off later the same year
on the first of many trips to Paris to buy paintings on his own. He
was enthralled by his meetings with European artists and critics,
listening to their views on art and sometimes even expounding his
own newly developing theories. He attended some of the salons of

Gertrude and Leo Stein at 27 rue de Fleurus. Paul Guillaume, the dealer, served as his guide elsewhere. Barnes called Guillaume "a creator in the greatest of arts, life itself" and often visited his gallery at 59 rue de la Boétie on the Right Bank. On one visit he found Guillaume and the British critic Roger Fry discussing African art. "I listened for a while," Barnes recalled, "and then took possession of Roger Fry and had a talk on Renoir and Cézanne that I shall remember for the rest of my life." A friendly argument with the French critic Waldemar George in the gallery one day lasted all afternoon. "Before it was finished," Barnes wrote, "I had learned something about one phase of modern art that I had never been able to understand from volumes of writing." On another afternoon he and the sculptor Jacques Lipchitz sat on the floor of the gallery engrossed in a conversation despite the difficulty of communicating. Lipchitz spoke Yiddish and Barnes, German.

In late December 1922, Barnes arrived in Paris for one of his most momentous shopping sprees. By then, dealers and artists had learned to anticipate the excitement and profits of these visits. The magazine *Montparnasse* proclaimed his presence: "*Hallo,* Boys. Cheer Up. *M. Barnes est dans nos murs*" (Mr. Barnes is within our walls).

According to Paul Guillaume, Barnes, studying the wares in Guillaume's gallery soon after his arrival, noticed a striking painting by an artist he did not know. It was the portrait of the pâtissier Rémy Zocchetto by Soutine. "It's a peach," said Barnes. Guillaume had purchased the painting after noticing it at the home of an unnamed artist. The unusual painting attracted him, Guillaume wrote, as the portrait of "a pastry chef, unheard of, fascinating, real, truculent, afflicted with an immense and superb ear, unexpected and true—a masterpiece."

In his account of the discovery, Guillaume, writing in *Les Arts a Paris,* a journal published by his gallery, could not resist repeating the scuttlebutt about Soutine from the cafés of Montparnasse. "It is

no secret to anyone that Soutine is no fan of hydrotherapy," Guillaume wrote. "His very appearance protests against all the vain hygienic practices favored by our century. It is an article of faith to him that ablution is a heresy, changes of clothing a sacrilege."

Guillaume's account of the discovery (and his description of Soutine's aversion to bathing) has been generally accepted, but his reporting was disputed by Barnes more than a quarter of a century later. In a 1950 letter to the Museum of Modern Art (MOMA) in New York, Barnes wrote that he first spotted the Soutine portrait in a small bistro in Montparnasse, not in Guillaume's gallery.

This version, recalled so many years later, effectively deprived Guillaume of even the smallest role in the discovery of Soutine. Barnes did not enjoy sharing credit, and his chagrin over giving some to Guillaume may have clouded his memory. The Barnes letter has not proved persuasive, for most art histories still follow Guillaume's account.

In any case, Barnes, after finding the portrait, insisted on seeing more by this unknown Soutine. Guillaume led him to Zborowski's apartment on the rue Joseph Bara in Montparnasse. Zbo laid before Barnes all he then had of Soutine—more than 50 canvases, including more portraits, many tumultuous Céret landscapes, a few still lifes of flowers. They included 5 canvases that Zbo's 17-year-old assistant, Paulette Jourdain, had saved from burning and hidden in her room. She brought them out only on her boss's insistence. Barnes spent two days examining all the paintings and then bought 52. "Leave us at least one Soutine," said Paulette. Barnes invited her to see them in Pennsylvania.

"The main reason I bought so many of the paintings," Barnes wrote in his letter to MOMA, "was that they were a surprise, if not a shock, and I wanted to find out how he got that way. Besides, I felt he was making creative use of certain traits of the work of Bosch,

Tintoretto, Van Gogh, Daumier and Cézanne, and was getting new effects with color."

The prices were very low. In the same 1950 letter to MOMA, Barnes said he paid only $15 to $30 for a painting. That sounds like an attempt to exaggerate his prowess as a bargain hunter. Most sources estimate he paid $3,000 for the batch, more than twice what he claimed, yet still an incredibly low cost. At the January 1923 exchange rate of 7 cents to a French franc, Barnes spent almost 43,000 francs to buy the whole batch. (Adjusted for inflation, that would amount to 42,500 in 2011 euros, the equivalent of about $55,000 in US dollars.)

Barnes wanted to meet Soutine, and Zbo persuaded his artist to put on a suit and come to the dealer's apartment the next morning. It was not a pleasant meeting. Another painter—someone like Marc Chagall—would have been ambitious and grateful and sophisticated enough to try to impress and engage with his new benefactor. But Soutine was too shy, too tense, too lacking in social grace, too disdainful of acclaim to try to ingratiate himself. It did not help that Barnes, now 51, a little more than 20 years older than Soutine, was a formidable figure. Photos of that era show a stern man with homburg, high collar, rimless glasses and pudgy yet unsmiling features. Nor did it help that Soutine still spoke French with a heavy Yiddish accent.

Barnes began by saying "Ah, Soutine. Good." But little conversation followed. Years later Soutine pronounced Barnes a boor and complained of having to dress up for him. "I'll never forgive myself for having been an idiot enough to go to such trouble," he told the Ukrainian-born sculptor Chana Orloff. Though Barnes never dropped his admiration of Soutine as an artist, he showed disdain for Soutine as a person after their meeting. Barnes told a friend years later, "I caught him when he was drunk, sick and broke and took the

contents of his studio for a pittance." The artist and his great benefactor never met again.

Barnes's regard for the paintings never wavered. "It is fairly certain that the dealers here who have connections in Paris will start to buy Soutines," he wrote Guillaume later in 1923. "I hope the prices do not go too high before you get all the good ones to be bought. In my mind there is no doubt that he will rank higher than any painter since Van Gogh, and I believe a fortune can be made out of those paintings bought at several times the price I paid."

Barnes's purchase turned Soutine's life as topsy-turvy as one of his landscapes. Word spread through the Rotonde and other cafés that the great Dr. Barnes had discovered Soutine and purchased scores of paintings. Some gossipers guessed 100. The shy taciturn Soutine found himself hailed as a celebrity, even a trend setter. When they heard that his favorite author was Dostoevsky, art students showed up at the cafés with copies of *Crime and Punishment* and *The Brothers Karamazov*. Collectors began hunting for the Soutines that Barnes had left behind. "Everyone is running after Soutine," said the envious French painter Maurice Loutreuil.

A new image of the artist emerged. Orloff, one of the few women artists in Paris, met Soutine after the purchases by Barnes. "I was very frightened of him at first," she recalled. "But I later discovered that he was a very subtle man. Despite his reputation as a madman, I found that Soutine was very polite, normal and delicate."

Fanciful stories made the rounds—the kind that jokesters like to make up about well-known characters. The periodical *L'Europe Nouvelle* reported that a woman asked Soutine to postpone painting her portrait because she had an abscessed tooth. But Soutine refused because the abscess was distorting her face just the way he liked.

The surest stamp of celebrity came in 1924 when director Jean Epstein used Soutine in a cameo role in his movie *Le Lion des Mongols*.

Soutine, his thick hair flapping up and down, is dancing alongside the famous model Kiki in the midst of a wild, gyrating crowd in a scene at the Jockey nightclub.

Soutine enrolled in French classes in hopes of shedding his accent. With more money than he had ever imagined he could have, he decided to vacation in Nice and hired a taxi to take him there. His friend the sculptor Oscar Miestchaninoff presented him with a book on personal grooming, *L'Homme du Monde*. Soon Soutine and Zborowski (who now had enough cash to open a gallery of his own) clothed themselves in silk ties, silk shirts, British suits and fedoras. When Chana Orloff invited him to dinner, Soutine came in a suit and insisted that she and another guest wear evening dresses. Hardly anyone sneered at him as unkempt and dirty anymore. A few now sneered at both Zbo and him as dandies. Friends of Soutine dated themselves by whether they had met him before or after the grand purchases of Dr. Barnes.

Barnes helped Soutine by deciding not to hoard all the purchased paintings. He immediately sold a dozen at cost to Guillaume and another dozen at a small profit to a second dealer a couple of years later. This meant there were prized Soutines in the art market at the height of the artist's celebrity. By 1926, according to the dealer René Gimpel, "his canvases . . . are sold these days in the ten-thousand bracket and are going up every day." Gimpel described Soutine as "a star rising in the firmament of modern painting."

During the weeks in Paris, Guillaume led Barnes to the works of other foreign Montparnasse artists, and the doctor bought paintings by Modigliani, Jules Pascin and Moïse Kisling as well as sculptures by Lipchitz. Barnes also commissioned Lipchitz to sculpt five reliefs for the mansion going up in Merion outside Philadelphia to house his holdings. Nor did Barnes neglect to buy more Matisses to augment his grand collection of Cézanne, Renoir, Seurat, Matisse, Corot and other giants of French painting.

After Barnes departed, Guillaume hailed the visit in a message addressed to "Painters of the Rotonde." Writing in his gallery's newsletter, Guillaume told them, "You've lived through feverish weeks. You've had the feeling that a golden prince was, benignly, sharing your destiny, and you were right. He bought works from many of you. . . . That's not all. This distinguished ambassador of French art will fight for you . . . against those who laugh, the imbeciles, the ignorant, the impotent of the New World. . . . Dr. Barnes is gifted with a prodigious faculty of judgment; he will use it to help you over there."

This was a special moment in the history of art in the twentieth century. Not only had Dr. Barnes discovered Soutine, but he had recognized that a special group of painters and sculptors, all foreign, were now at work in Paris, and he planned to exhibit his latest purchases to Philadelphia, highlighting the young foreigners as contemporary artists who deserved to be studied together. Barnes was too astute to label them as a movement of any kind, but he knew something unusual was afoot in Paris. His recognition was surely the first by a major collector, critic or institution.

The triumph of Soutine and the others, however, caused a good deal of resentment among some French artists and critics. Louis Vauxcelles, the acerbic art critic credited with coining the names cubism and fauvism (though he had intended his labels to insult the artists rather than identify or explain them), described the young Montparnasse painters purchased by Barnes as "Slavs disguised as representatives of French art." "Slavs" sounded like a euphemism. Soutine, Modigliani, Pascin, Kisling and Lipchitz did not regard themselves as Slavic, but all were Jewish.

It was hard, however, to accuse Vauxcelles of anti-Semitism. Vauxcelles was actually a Jew born in Paris with the name Louis Meyer. His anger seemed to reflect two sides of the denigration of the foreign artists of Montparnasse. On the main issue, he and others resented the attention showered on the foreigners while French

artists were ignored. But Vauxcelles also reflected the embarrassment and even alarm of some French-born Jews over the failure of many foreign-born Jews to assimilate French culture fully. Most of the Jewish painters and sculptors neither talked nor acted like Frenchmen. Later, when the immigrant painters became recognized as the School of Paris, some Jewish critics would object, insisting that the immigrants like Soutine must not separate themselves from French-born painters.

Vauxcelles, in his attack on the artists favored by Barnes, repeated a false rumor that Soutine and the others had somehow pushed aside a French painter named Jean Marchand while Barnes mulled over purchases. "If this is true," Vauxcelles went on, "I believe Monsieur Soutine and his comrades blundered painfully."

This resentment over Barnes's purchases of Soutines figured in a brouhaha over the placement of art in the prestigious fair called the Salon des Indépendants. In 1924, the salon began grouping painters by their nationality, provoking a great deal of protest. The well-known painter Paul Signac, president of the salon, said he was trying to prevent clusters of works from painters allied in movements. He could not ban the individual painters because the Salon des Indépendants, unlike the official salons of the government, had no screening committees; it accepted all painters who wanted to exhibit. Separating painters by nationality prevented movements with several nationalities from exhibiting together.

Signac insisted that his new policy had nothing to do with the painters purchased by Barnes. It was evidently aimed mainly at Dada artists who had infuriated Signac with their wild, aggressive, revolutionary ideas in the last few years. Some antics were quite comical. Marcel Duchamp, for example, probably the best-known Dada artist, had purchased a urinal, called it a work of art and named it "Fountain" (the original is lost). He also had taken a reproduction of the "Mona Lisa," drawn a mustache under her nose and, in an old

schoolboy joke, labeled it "L. H. O. O. Q." (now in a private collec-
tion). If you read those letters in French, the sounds form a sentence
that means, in English, "She has a hot ass."

But much of Dada was far more offensive. Francis Picabia titled
a drawing "The Blessed Virgin" (Doucet Library in Paris) that was
made up of splashes of ink blots as if she had been deflowered. Some
of Dada's performances of plays were so nasty that they ended with
the audience pelting the stage with vegetables and the actors throw-
ing things back at the crowd. Signac did not want the Dadaists to
pack one of the salon's galleries with all their iconoclastic stuff, stuff
that in Signac's view did not qualify as art. Although many Dadaists
in Paris were French, others were Romanian, Swiss, Belgian, Ger-
man, American and Czech. Signac derided them as "the *métèques* of
Montparnasse," using a French slang word that demeans foreigners.
Signac said the new arrangement would keep most of them apart.

Whatever Signac's motivation, his policy was looked on as a
great triumph by those resentful over Barnes purchasing so many
works from foreign painters. The new salon arrangement would
make clear that painters like Soutine were not French. There was
great irony in this, for Soutine never entered paintings in this salon
or any other. The division of salon space by nationality also led to
some absurd labeling. The Bulgarian-born Jules Pascin, a longtime
resident of Montparnasse, was classified as an American because he
had obtained U.S. citizenship while spending the years of the world
war in New York.

Vauxcelles was mocking and triumphant as he celebrated this
victory over the foreign painters of Montparnasse. When Kisling,
Lipchitz and Ossip Zadkine joined French artists Picabia and Fer-
nand Léger and others in withdrawing from the salon, their protest
unleashed more fury from Vauxcelles. "It seems the decision has
caused the central European high society of Montparnasse to rise in
indignation," the critic wrote. "And I hear that the Rotonde, where

all the dialects of the earth are spoken, sometimes even French, will be the site of a large demonstration followed by a meeting of protest against the nationalist committee of the Indépendants." Actually no such demonstration was planned.

Vauxcelles went on to describe his solution to the problem of so many foreign painters in Montparnasse. "It isn't a question of chauvinist politics, of expulsion or other pogroms," he said, adding quickly, in an allusion to his Judaism, "A pogrom decreed by me would be quite a piquant idea." What was needed instead, he said, was "a simple matter of hygiene, of sanitation, aimed at achieving the proper behavior in Paris" of the Montparnasse painters. In short, they must learn to assimilate and make themselves more French than foreign. "And, if I am accused of being reactionary," he concluded, "too bad." The venomous diatribe of Vauxcelles was the most extreme form of the demand by French-born Jews that immigrant Jews assimilate to French ways.

The controversy over display arrangements at the Salon des Indépendants led critic Roger Allard to suggest a solution to the issue of nationality. In Allard's view, France should regard a group of foreign-born artists who spent so many years in Paris not as foreigners but as residents associated with the French school of art. He proposed calling them the "School of Paris." Although barely noted at the time, this term, as we will see in chapter 6, gained popularity in a couple of years and would be used for at least the next two decades to describe Soutine and the other foreign-born artists of Montparnasse.

Barnes had no time for squabbles over nationality. He understood, of course, that a painting would be influenced by the biography of a painter or the history of his or her era. But none of this was as important, he insisted, as the painting itself and how it measured up to his own criteria for the greatness of art. He was very proud of his purchases during this Christmas–New Year holiday trip. He had returned to the United States with a number of first-rate paintings

from little-known artists in Paris. One painter was not even known at all, and he counted as a Barnes discovery. Barnes intended to show him and the others off right away.

In April and May 1923, Barnes mounted an exhibition of his recent acquisitions at the Pennsylvania Academy of Fine Arts in Philadelphia. There were 19 paintings by his discovery, Soutine, the largest number in the show, as well as works by the little-known Lipchitz, Modigliani, Pascin, Kisling, Maurice Utrillo and Giorgio de Chirico and by the well-known Picasso, Matisse and André Derain.

Barnes anticipated that the Philadelphia art establishment would have difficulty appreciating the work of the younger contemporary artists, so he asked for understanding in the catalogue of the show. "Most of the exhibit is the work of artists now living in Paris but who were born and spent their youth in other countries," he wrote. " . . . These young artists speak a language which has come to them from the reaction between their own traits, the circumstances of the world we live in, and the experience they themselves have had. . . . To quarrel with them for being different from the great masters is about as rational as to find fault with the size of a person's shoes or the shape of his ears. If one will accord to these artists the simple justice of educated and unbiased attention, one will see the truth of what experienced students of art all assert: that old and new art are the same in fundamental principles."

The reaction, however, was more hostile than Barnes expected, instilling in him a contempt for the art academics, curators and critics of Philadelphia, a contempt that he harbored for the rest of his life. Edith A. Powell of the Philadelphia *Public Ledger* described Soutine's paintings as "portraits of the dregs of humanity" and doubted whether the public was ready to pay careful attention to his "diseased and degenerate" world. In the contemptuous view of Edward Longstreth of *Art News,* Soutine "glorified the ugly." C. H. Bonte

of the *Philadelphia Inquirer* derided Modigliani as a "compression-ist" since the heads of his subjects were flattened "as if some frightful pressure had been applied to the skull." Most of the paintings sickened Dorothy Grafly of *The North American* "as if the room were infected with some infectious scourge." Summing up his feelings, Francis Z. Ziegler of the *Philadelphia Record* declaimed, "It is hard to see why the Academy should sponsor this sort of trash."

None of this weakened Barnes's faith in the artistic worth of his purchases. He fired back angry and insulting letters at all these tormentors and barred most from ever seeing any part of his collection again—even as it was widely hailed as the finest private collection of modern art in America.

The doors of the new mansion of the Barnes Foundation opened in 1925, but not to everyone. Dr. Barnes conceived of his collection not as the holding of a public museum but as the curriculum for special courses in the understanding of art. Two hundred students a year could contemplate these masterful paintings as objects of learning. But outsiders could not see any part of the collection—which contained more Renoirs and Matisses and Cézannes than any museum in the world—without writing Barnes for special permission.

Barnes did not grant permission automatically. A solicitor's best chances came from lack of any celebrity at all and lack of any link to the art establishment. Barnes, for example, refused to allow the Nobel Prize–winning poet T. S. Eliot, the architect Le Corbusier and the celebrated critic Alexander Woollcott to see the collection. It was often impossible to fathom the reason for Barnes's decision. Even when it was possible, the decision seemed petty. Jacques Lipchitz had once asked Barnes to buy a painting from an impoverished artist to keep him from starvation. Barnes did so but then broke with Lipchitz for confusing philanthropy and art. He would not allow Lipchitz to enter the mansion even though his sculptures were prominently displayed there.

The paintings were displayed far differently than in a museum. Barnes did not arrange them by painter, nationality, movement or era. The works of art were set up to illustrate themes in the art course. Paintings were hung on the same wall because they illustrated the use of color or throbbed with power and passion or demonstrated the importance of simplicity or illustrated some other pedagogical aspect of art. One wall displayed only paintings by Renoir, just to show that the usual wall in a museum was boring. Another was covered only by American paintings to prove that works by artists of the same nationality often have nothing in common. On top of all this, Barnes did not display the titles of any paintings. He insisted that a title might get in the way of the real meaning of a painting.

Over the years, the capricious admission policy, the odd arrangement of the paintings, the refusal to loan even a single painting to any exhibition elsewhere, the insistence that his collection was not for display but only for education, his ban on color reproductions and his ferocious and lusty attacks on critics all conspired to make the public look on Barnes as some kind of cantankerous crank. Yet that reputation was unjust or, at least, inadequate. Barnes put together an enormous collection of great works of art, and it was hard to argue with his core belief that the configuration of paint on a canvas counted far, far more than an artist's history and biography. Moreover, his method of education, though its various ways of arranging art confused outsiders, had the full support of John Dewey, the illustrious philosopher regarded as a founder of progressive education in America. Dewey, in fact, served as the director of education for Barnes's classes. The classes, though limited in size, were evidently open to anyone willing to spend an academic year listening to lectures about the collection. Barnes also offered to allow University of Pennsylvania students to study the collection, but the plan fell through in the 1920s when some Penn faculty objected to his "Bolshevist art."

Barnes published his credo *The Art in Painting* in 1925 and revised it every few years afterward. Though turgid and soporific, it was a thoughtful attempt to set down his beliefs without any of the negative and outrageous outcries that often filled his letters. His comments on Soutine, for example, sound pertinent and reasonable—though somewhat dependent on jargon. Barnes wrote, for example:

> Soutine occupies a distinctive position in modern painting because of his achievements in the use of solid, deep, rich, juicy, and variegated color. The paint is laid on the canvas very heavily, much in the manner of van Gogh, with ribbonlike strokes which are longer than van Gogh's, more varied, more dynamic, and more suggestive of power. . . .
>
> No contemporary painter has achieved an individual plastic form of more originality and power than Soutine. But extreme preoccupation with color, absence of the deep space required for monumental effects, and his inability to organize the plastic units, exclude all but a few of his best pictures from the highest range of art.

Barnes died in an auto collision outside Merion on July 24, 1951. He was 79 years old. His will made it clear that he had turned his back completely on the Philadelphia art and academic establishment. He ignored all the institutions of the city and instead bequeathed eventual control of the board of the Barnes Foundation and his collection of art to Lincoln University, an African American school 30 miles from Philadelphia in mushroom country near the Maryland border. Barnes's choice was not capricious. Long known as the Black Princeton, Lincoln was run by a prominent educator, Horace Mann Bond, father of the future civil rights leader Julian Bond. Supreme Court justice Thurgood Marshall, poet Langston Hughes, President

Kwame Nkrumah of Ghana and President Nnamidi Azikiwe of Nigeria were among Lincoln's most distinguished graduates.

For almost four decades, close associates of Barnes kept control of the board, stubbornly resisting attempts to change its character. Lincoln appointees did not assume majority control until 1988. Lincoln management, however, had trouble raising enough money to run the collection, and the university eventually ceded control to several rich foundations. Intent on making these great works of art easily available to many people and on enlivening the cultural life of Philadelphia, the new board transferred all the paintings and sculptures to a new building in the heart of the city near the Philadelphia Museum of Art. Amid great protest from admirers of the old suburban mansion, the new building opened its doors in 2012, and the Barnes Collection became a museum like most others. Albert Barnes would have been appalled.

The foreign artists of Paris paid little attention to the peculiar ways Barnes organized his collection and then kept it largely out of public view, even if the doctor's enthusiasm for a painter could occasionally cause some harm. In 1937, the wife of William Glackens complained that Barnes's large holding of his paintings kept the work of her husband largely hidden in America. But if that troubled painters like Pascin and Kisling, they did not complain about it. No matter how odd Barnes may have seemed in the United States, he had an enormous impact on the young foreign painters of Paris. His purchases of their works, amplified by exhibition and discussion of them as a group, had given them a new identity. The foreigners had become a kind of brand. Other collectors now sought them out. Barnes was even more significant, of course, for Soutine. The drama of Barnes's discovery of Soutine and his purchase of the bulk of his canvases established Soutine as a salable artist for the rest of his life. Montparnasse owed a great deal to the stubborn and autocratic Dr. Barnes.

FIVE

MARC CHAGALL,
THE GREAT BAKST, PARIS AND
THE OCTOBER REVOLUTION

NO TWO RUSSIAN JEWISH PAINTERS ON MONTPARNASSE were as different as Marc Chagall and Chaim Soutine. Their canvases, of course, looked nothing alike. Soutine did not engage with symbols and delve into the wealth of Jewish folklore in the Pale of Settlement. Chagall never painted portraits with distorted features or landscapes of churning earth or still lifes of bleeding beef. Although he painted celebrated scenes of the crucifixion of Christ, almost all of Chagall's protagonists, including Christ, were noticeably Jewish, and Chagall would go on to become the most beloved modern Jewish master of the twentieth century. Although Soutine, unlike Chagall and other Montparnasse painters, never changed his name, an art historian has to stretch evidence to extraordinary fineness to catch any hint of Jewishness in Soutine's work.

Their personalities were just as different. Chagall was ambitious and knew how to cultivate friends with influence and how to make

the most of good fortune. He came to Paris with plans and a link, however tenuous, to a celebrated Russian artist in Paris, Léon Bakst, designer of the fabulous costumes and sets of the Ballets Russes. Chagall came from a small town that was much larger than the usual shtetl. He had studied in the great city of St. Petersburg, the capital of the Russian empire, and, though he had all the self-doubts and fears of youth, when he showed up in Paris, he had some grasp of how to fend for himself. Unlike Soutine, he was smart enough to submit his paintings to the annual competition of the Salon des Indépendants. No one would look at Chagall as a bumpkin. If Dr. Barnes had discovered him, the young Chagall, unlike Soutine, would have tried to maintain a connection to his benefactor.

One other difference needs emphasis. Soutine hid himself from all but a few intimate friends. He did not write long, revealing letters or submit to continual interviews. Chagall, who lived until the age of 95, was a prolific letter writer. His son-in-law played Boswell, interviewing the master and everyone in his life, and wrote an enormous biographical tome. Chagall even wrote an autobiography, *My Life,* when he was only 35. More is known about Chagall than any other foreign painter of his generation in Montparnasse.

On the celebrated trip when he discovered Soutine, Barnes did not buy any Chagalls. There weren't any to buy. The world war, the Bolshevik Revolution, the false promise of the new Soviet Union had kept Chagall away from Paris for more than nine years, and he did not return until a few months after Barnes left in 1923. Barnes, of course, had many years afterward to buy Chagalls, but he never did. He does not even mention the Russian in his book, *The Art in Painting.* Judging by the rest of his collection, Barnes was not attracted to canvases brimming with symbols. His was a minority view in an era of accelerating Chagall popularity.

Despite their many differences, Chagall and Soutine had one trait in common. Both were pillars of the School of Paris, two of the

best-known and most accomplished artists of the group. The fact that both can be included demonstrates how tortured it can be to depict the foreign painters of Montparnasse as a movement with shared goals and techniques.

Moyshe Chagall, six years older than Soutine, was born on July 7, 1887, in the town of Vitebsk, a river port of 60,000 people in the Pale in what is now Belarus. A little more than half the residents were Jewish and spoke Yiddish as their native language. Vitebsk never lost its hold on Chagall. In his autobiography, he calls it "my sad, my joyful town!"

The Chagall family was poor but not impoverished. The elder Chagall worked in a herring storage house. He may have had some supervisory duties, but most of his work was hard labor. "He lifted heavy barrels," his son wrote, "and my heart used to twist like a Turkish pretzel as I watched him carrying those loads and stirring the little herrings with his frozen hands." His mother opened a small grocery and earned enough to build and rent four wooden shacks to tenants.

When he was a boy, Chagall showed his mother a drawing. "Look, Mamma, how do you like that?" She peered at it and finally said, "Yes, my boy, I see; you have talent. But listen to me, child. Perhaps you ought to be a clerk." But Chagall persisted, and the word spread among relatives that he planned life as a painter. His uncle Israel would no longer shake his hand. "My uncle is afraid to offer me his hand," Chagall wrote in his autobiography. "They say I am a painter. Suppose I were to sketch him. God forbid. A sin."

His mother bribed Chagall's way into the Russian high school, which had only a few seats for Jews, and then years later led him to Yuri Pen, the head of the only art school in Vitebsk. Pen was Jewish, and Chagall's mother, speaking in Yiddish, handed him samples of her son's work and explained, "He wants to be a painter. He must be mad. Please look at his drawings. If he has any talent, then it would be worth taking lessons. But otherwise . . . Let's go home, my son."

Pen leafed through the drawings and finally muttered, "Yes, he has some ability." For Chagall, as he put it, "that was enough." He studied with Pen for several months before deciding it was time to move on to St. Petersburg.

Since St. Petersburg, a city of more than 1.2 million, was in Russia itself and therefore outside the Pale, it was officially off limits to Jews, but 20,000 lived there, owners of special passes and permits. Chagall arrived with a temporary pass to pick up goods for a shopkeeper friend of his father but soon enrolled in an art school, which allowed him to stay on.

The key event of his stay in St. Petersburg was his meeting with the 43-year-old Léon Bakst, the renowned art nouveau painter of Russia and the designer of sets and costumes for Serge Diaghilev's Ballets Russes in Paris. Chagall, half his age, arrived in Bakst's apartment with a portfolio of sketches and a letter of introduction from an art collector in Vitebsk. He arrived in 1909, just after the Ballets Russes opened their first season in Paris to great acclaim.

Bakst, born Lev Rosenberg in a town not far from Vitebsk, was Jewish too, and that calmed Chagall during the interview. "I haven't forgotten the smile, tinged with pity or perhaps kindness, with which he greeted me," he wrote in his autobiography. ". . . He is a Jew. Reddish curls clustered above his ears. He could have been my uncle, my brother. . . . He'll understand me; he'll understand why I stammer, why I am pale, why I am so often sad and even why I paint in lilac colors."

In the midst of his account, Chagall inserted a three-word paragraph signaling where the interview would lead him: "Bakst. Europe. Paris."

Bakst studied Chagall's portfolio and pronounced it "on the wrong track" and "spoiled" but added "not completely." Based on that hopeful phrase, Bakst proposed that Chagall enroll in his celebrated art school as a scholarship student, and Chagall eagerly agreed.

But the school did not work well for Chagall. He found Bakst too hard to please, at least at first. Although Bakst thought Chagall "walks on his head," he regarded the young man as one of his best students and finally made that clear toward the end of Chagall's six months there. Bakst reveled in bold color. "I myself am head over ears in color," he said, "and don't want to hear a word of black and white." Bakst also encouraged Chagall to dwell on the traditional Jewish life that he knew best. "What I like best in your work is the provincial life around you," he told his student.

Chagall did not expect much from the school, looking on it only as a gateway. "I can't be taught," he wrote. "I grasp nothing except by instinct . . . and scholastic theory has no hold on me. In short, my going to school had been more a matter of getting information, of communicating, than of being taught in the proper sense of the word." When Bakst decided to make a permanent move to Paris, there was no reason for Chagall to remain at the school.

Chagall hesitatingly told Bakst that he would like to go along with him to Paris. "Ah, if you like," Bakst replied. "Tell me, can you paint scenery?"

"Certainly," Chagall lied.

"Here's a hundred francs then. Learn the job properly, and I'll take you."

Chagall helped Bakst work on the set designs for the Ballets Russes' Narcissus, but his skill as a painter of scenery did not impress his teacher. Bakst departed for Paris without Chagall.

Chagall persisted, writing letters imploring Bakst for help in moving to Paris but vowing to go there even without help. Bakst ignored the letters at first but finally tried to divert the young man. "How crazy that you are going to go to Paris with 25 rubles," he wrote. "It's such a crazy thing that I wash my hands of this crazy idea. I will not give you a penny. . . . I have no money and I also have no job. I am a man who is very frightened and I have very bad nerves and if you

come I will cause you many troubles. . . . There are many Russians here who are dying from hunger. . . . If you come, because I have a feeling of self-protection, I will try to avoid you in Paris—you have to know this."

In May 1911, Chagall sold two paintings to a collector in St. Petersburg and, even more important, cajoled train fare to Paris and the promise of 125 francs a month from him. The 1,500-mile train trip to the Gare du Nord in Paris took four days. "Vitebsk, I am forsaking you," Chagall wrote in his autobiography. "Stay on your own with your herrings!"

He also left behind—but did not forsake—the love of his life, Berta Rosenfeld, the beautiful and well-educated youngest child of a wealthy jeweler in Vitebsk. Her family did not approve of marriage to an unknown and unsuccessful suitor, a painter without prospects, from the poorer part of town. The young couple decided they would marry as soon as Chagall achieved some measure of success.

A photo of the newly arrived Chagall in Paris shows a short but rather dapper young man in tie, long jacket and straw boater. All other photos of that era emphasize his handsome but unusual look, a shock of tangled, curly hair over sharp features. The features were so sharp, in fact, they seemed, especially when he offered the sliver of a smile, puckish, as if he were ready to sprinkle some kind of magic dust.

Chagall spent only three years in Paris in this early stage of his career. But it was a vital stage, noteworthy for his new friendships with influential contacts and for the creation of some of his most accomplished and arresting canvases. To make sure his foreign name did not confuse others, Chagall adopted "Marc," both simple and French, as his new first name. Berta, when she arrived in Paris years later, would call herself Bella.

Waves of homesickness engulfed Chagall at first. "I even wanted to invent a holiday of some kind, just as an excuse to go home," he

wrote. But the richness of the art in the great city soon warmed him. "It was the Louvre that put an end to all this wavering," he said. "When I walked round the Veronese room and the rooms where the Manets, Delacroix, and Courbets are, I wanted nothing more."

Chagall attended the Ballets Russes one night to see Bakst. They had not communicated since Bakst's letter imploring Chagall to stay away from Paris. "So you came, after all?" said Bakst. Chagall did not reply but wrote in his autobiography, "Well? Should I have stayed in Russia? There . . . I felt at every step that I was a Jew—people made me feel it." Bakst told him that he would call on him soon to see how he was doing. When Bakst did show up a few days later, he looked at Chagall's paintings and said, "Now your colors sing." The professor and his protégé never spoke again.

Chagall's stay in Paris troubled but did not end his love affair with Bella. He was an indifferent correspondent, failing to reply to her passionate letters. "Dearest," she wrote, "it hurts me not to know anything, which means communicating with me can't give you anything. And you remain alone. Sometimes I think otherwise." In another letter, she wrote, "You are so far away that, when I feel you are so dear to me, I hesitate and don't trust myself and I am afraid that I am so far away now that I have to pay for that maybe with my and your souls. . . . It is so difficult to be far away and I am so stretched to different corners and one side is so thin that it could be broken and I wouldn't be able to survive that."

Jackie Wullschlager, Chagall's biographer, says there were rumors of a couple of liaisons in Paris, but neither, whether true or not, was a threat to Bella. Wullschlager concludes that "Chagall was emotionally alone—but alone with painting. Bella had identified so passionately with his work that it never occurred to her to consider that painting was her rival."

Chagall, who had rented an apartment upon arrival in Paris, soon realized that the rent would exhaust his little stipend, so he

moved into La Ruche, paying only 100 francs a year. Russian Jewish sculptors such as Jacques Lipchitz and Ossip Zadkine were already there, and a host of Russian Jewish painters were on their way. The move to La Ruche led to a significant friendship. The Swiss poet and critic Frédéric-Louis Sauser, who used the nom de plume Blaise Cendrars, called on him there. Cendrars, who had lived in La Ruche, still kept watch on activities in the compound. He had no trouble communicating with Chagall, who did not speak French. A serendipitous traveler who had once worked in Russia for the rival of the Fabergé jewelry house, Cendrars spoke fluent Russian.

"He was the first to come and see me at La Ruche," Chagall recalled. "He read me his poems, looking out of the open window, smiled at my pictures to my face, and we both laughed."

Among the Russian Jewish painters in Paris was a young woman, Sonia Delaunay, who had been born Sarah Stern in the Ukraine. Sonia was married to the French painter Robert Delaunay, a cubist best known for his canvases deconstructing the Eiffel Tower. Sonia would later turn to design and attract attention for the exciting geometric patterns in her textiles. Diaghilev commissioned the Delaunays to design the sets and costumes for a new Ballets Russes production of Cléopâtre in 1918.

Sonia introduced Chagall to her husband, and Chagall would remain a close friend of the Delaunays for many years. This was surprising because the fiercely competitive Chagall generally shied away from relationships with potential rivals. When Soutine showed up in La Ruche, for example, Chagall dismissed him as "a morbid expressionist" and avoided any contact. Chagall biographer Wullschlager speculates that, although he studied some of Delaunay's cubist techniques, Chagall "may have sensed from the start that Delaunay, for all his vaunting ambition, would never be a great painter and was therefore no serious rival."

Chagall met the poet and critic Guillaume Apollinaire at the home of the Delaunays. Apollinaire was a nom de plume as well, for the man was born Wilhelm Kostrowitsky, the illegitimate son of a Russian woman living in Rome. The father was never publicly identified. The mother moved to Monaco and France, and Apollinaire was educated in Nice, Cannes and Paris. He became a literary combine, turning out plays and novels as well as poetry and criticism.

Chagall described the roundish Apollinaire as a "gentle Zeus" who "carried his stomach like a volume of collected works." The artist nervously led Apollinaire to his studio in La Ruche one day. "Apollinaire enters cautiously," Chagall wrote, "as if he were afraid the whole building might suddenly collapse and bury him in the ruins." He studied the works of Chagall and then, in great admiration, pronounced them *"surnaturel"* (supernatural). Later, Apollinaire decided that the word *surréel* (surreal) would fit the mood of paintings like those better. The expression was adopted a decade later by André Breton as the name for his surrealist movement. Chagall never identified himself as a surrealist, though he acknowledged such elements in the symbols that filled his canvases. But no matter what word Apollinaire used, his praise enhanced the reputation of the young Chagall. Apollinaire also helped Chagall by writing a poem dedicated to him.

Chagall bonded easily with Cendrars and Apollinaire, men of the same generation. Chagall arrived in Paris in May 1911 at the age of 22. Cendrars was 22 as well, and Apollinaire, only six years older. Judging by his autobiography, Chagall was clearly articulate about art in a way that Soutine was not. "Art seems to me to be a state of soul, more than anything else. . . . The soul that has reached the level that men call literature, the illogical . . . is the purest," Chagall wrote. Biographer Wullschlager says that Chagall also knew how to ingratiate himself with those who could further his career, and Cendrars

and Apollinaire, two of the most heralded young writers in France, were eager to do so.

They used their influence with a friend, Herwarth Walden, an avant-garde painter, the son of a German Jewish banker and, most important, the owner of an art gallery in Berlin. Walden, according to Chagall, was dozing in Apollinaire's apartment one day. The poet, with Chagall at his side, woke him. "Do you know what we ought to do, Monsieur Walden?" Apollinaire said. "We ought to organize an exhibition of this young man's work. Don't you know him?" Then he introduced Chagall to the sleepy Walden.

We do not know what other persuasion was required, but the Chagall exhibition, comprising 40 paintings plus a large number of drawings and watercolors, opened at Walden's Sturm Gallery in Berlin in June 1914. The show marked the climax of a significant year in Chagall's career. His exhibitions at the Salon des Indépendants had already drawn attention. Cendrars told him that "The Violinist" (now at the Stedelijk Museum in Amsterdam) was the most beautiful painting at the salon. "I want to cry," Cendrars said. That painting, showing a gigantic violinist dancing on the roofs of a Russian town, became the iconic inspiration for the title of *Fiddler on the Roof*, a 1960s Broadway musical that Chagall detested when he saw it. Cendrars then persuaded Paris dealer Charles Malpel to put Chagall on contract, paying him 250 francs a month as an advance covering future paintings.

Apollinaire and Cendrars wrote poems praising Chagall even before the Berlin exhibition opened. Another Apollinaire poem appeared in the catalogue. The show was a spectacular success: every painting was sold. According to biographer Wullschlager, "the show was the single most important exhibition of Chagall's life, the foundation of his worldwide fame."

The show included two of his best-known works, and both reveal a good deal about the kind of painting the young artist created during his first stay in Paris. "I and the Village" (a wonderful title conjured

by Cendrars), portrays the green head of a young peasant, with the sharply cut features of Chagall himself, staring at the white head of a cow, all against the distant background of a Russian town, presumably Vitebsk. The actions of the peasants play out in a cubist-like series of orbs and triangles painted in deep colors. This canvas, now in the permanent collection of the Museum of Modern Art in New York, probably betrays some of the influence of the Delaunays on Chagall's early work.

The second painting, "Paris Through the Window," is a prized holding of the Guggenheim Foundation in New York. Michael R. Taylor, the Philadelphia Museum of Art's former curator of modern art and now director at the Hood Museum of Art at Dartmouth College, calls it an "exuberant early masterpiece." The painting is a fanciful attempt to show what Chagall could see of Paris through his window at La Ruche. The canvas brims with the artist's personal iconography: floating figures, an upside-down train, a two-headed man, a parachutist, a puzzled cat. Like Apollinaire, who wrote poetry about it, and like Robert Delaunay, who painted a series about it, Chagall focuses on the Eiffel Tower (which he could not actually see from his window), bathing it in soft, atmospheric coloring. These two paintings are very different from the later work that ensured Chagall's worldwide popularity: the paeans of love to Bella, the nostalgic evocations of a fanciful Vitebsk and the crucifixions of a very Jewish Jesus Christ.

Buoyed by his success in Berlin, Chagall decided the time had come to return to Vitebsk for a while and persuade all doubters that he could now support Bella as a painter. But his timing was off. He arrived in Russia in late June. A week later, a Serbian nationalist in Sarajevo shot and killed Archduke Franz Ferdinand, the heir to the throne of the Austro-Hungarian empire. A month later, Austro-Hungarian troops fired on Serbia, snapping open a tangle of alliances that pulled most of Europe into the First World War.

Chagall did not pride himself on his grasp of international politics. "As I was in Berlin," he wrote, "I didn't realize that, within a month, the bloody comedy would begin that was to transform the whole world, and Chagall with it." The artist was trapped. France and Russia were allies, but he would have to cross the enemies Austro-Hungary and Germany to reach Paris. Even if he had wanted to try, he could not obtain the papers he needed to do so.

To make matters worse, Walden in Berlin could not or would not send him the proceeds from the sale of his paintings, so Chagall did not have the funds to prove that he could support a family on an artist's income. (When Walden did agree to pay, years after the end of the war, he insisted on using the old prices, despite the rampant inflation in Germany. Chagall finally sued and won increased compensation plus the return of those paintings Walden had bought for himself.)

As a Russian citizen, Chagall was subject to conscription into the Russian army, but he managed to avoid that fate when a brother of Bella hired him as a clerk in a military office in St. Petersburg. Chagall and Bella were married in the capital on July 25, 1915, despite her mother's warning: "You'll ruin yourself for nothing." Even at the wedding, relatives gossiped their disapproval. "He even gets paid for his pictures," Chagall overheard one say. Another replied, "All the same. That's no living." Marc and Bella's daughter, Ida, their only child, was born a year later.

The Bolshevik revolution in October 1917 shattered the Russian empire and brought forth a communist Soviet Union that led the country out of the war. "My Marxism was limited to knowing that Marx was a Jew, and that he had a long white beard," Chagall wrote in his autobiography. But, even when the world war ended in 1918, he remained in the Soviet Union. The revolution had unleashed euphoria over culture, with promises of government enthusiasm and funds for the arts, and Chagall wanted to take advantage of that.

Anatoly Lunacharsky, the Soviet Union's first commissar for enlightenment, had met Chagall when both lived in La Ruche in Paris, and he now appointed Chagall commissar of art in Vitebsk. In this post, Chagall exhibited his latest work, sold ten of his canvases to the government, designed sets for the Theatre of Revolutionary Satire and founded the Vitebsk People's Art College. But Chagall, who served as director of the college, found the last experience shattering and humiliating.

In the excitement of the revolution, the Bolsheviks favored a new abstract art. Kazmir Malevich, another teacher at the school, was a favorite of the government with such geometric abstract canvases as the 1918 painting "White on White" (now at the Museum of Modern Art in New York). The work of Chagall, though fantastic and fresh, was too representational for the new fashion. He lacked, as his biographer Wullschlager puts it, "revolutionary correctness." "Why is the cow green and why is the horse flying through the sky, why?" Chagall said he was asked by communist leaders. "What's the connection with Marx and Lenin?" The students, under pressure, gradually lined up with Malevich, forcing Chagall to resign and leave Vitebsk in June 1920, never to return. By then Malevich himself faced official dissatisfaction, for the Bolsheviks were starting to turn from abstract art in favor of social realism—representational art that glorified the state and the Communist Party.

Chagall and his young family moved to Moscow, where he painted murals and sets at the Moscow Jewish Theatre, taught drawing at a Jewish camp for war orphans in a village outside the city and wrote his autobiography in Yiddish. Finally it was time for him to end his Soviet interlude. His friend Lunacharsky obtained passports for Chagall, Bella and Ida. Another friend financed the trip. Chagall, after a long stay in Berlin, returned to Paris in August 1923, more than nine years after he had left. Bella and Ida arrived a couple of months later.

One of his two closest friends, Apollinaire, was gone. Wounded in the head while fighting in an artillery unit with the French army during the war, he never fully recovered and later succumbed to the worldwide influenza pandemic in 1918. Cendrars lost an arm while fighting for the French Foreign Legion, yet that did not diminish his activity or his influence. He immediately helped set up a meeting between Chagall and the dealer Ambroise Vollard to discuss a contract for the artist to illustrate expensive books with original etchings. But the friendship did not last long after Chagall's return to France. Chagall, still furious at the German dealer Walden, falsely accused Cendrars of encouraging Walden to deny him what he was owed for the sale of his paintings in the 1914 Berlin exhibition. The accusation ended the friendship.

Chagall had stayed away from Paris so long that at first he missed the recognition the foreign painters of Montparnasse were starting to receive. But the neglect did not last. Vollard contracted with Chagall to create 107 etchings to illustrate a special edition of Nikolai Gogol's *Dead Souls*. Lucrative contracts followed for etchings for editions of La Fontaine's *Fables* and the Bible. Vollard also introduced Marc and Bella into influential social circles that would enhance sales. Chagall had scores of paintings to sell from the days in Russia—fantasies about Bella and about Jewish life in Vitebsk—and he painted more canvases along the same lines. His work attracted notice worldwide, and soon Chagall would be considered Soutine's only rival among the young immigrant painters of Montparnasse.

SIX

ANDRÉ WARNOD, THE SCHOOL OF PARIS AND THE JEWS

ANDRÉ WARNOD WAS BORN TO A HUGUENOT FAMILY IN the town of Giromagny in northeastern France in 1885. He studied art in Paris as a young man but soon realized that he did not have the talent to match his contemporaries. He was drawn to them nevertheless and spent much of his time gossiping with the young painters and writers of Montmartre and later Montparnasse. This avocation turned into his calling in 1909 when the editor of the newspaper *Comœdia* agreed to hire him as the chronicler of the world of art. Warnod would mix with artists and writers in their studios, in cafés, at costume balls, during poetry readings and in galleries and turn out reports accompanied by his own sketches. The newspaper called him "the courier of arts and letters," and he became an influential figure in the art life of Paris.

Warnod was often troubled by the abuse heaped upon the foreign painters of Montparnasse by Louis Vauxcelles and other critics. He denounced these detractors as "ill-tempered spirits" who unfairly

condemned the artists of Montparnasse as "unsympathetic people, brawlers, insolent artists and junk dealers who speak in all the slangs of the world while creating a ghetto and a sanctuary for vagrants and coffee."

Warnod looked on the foreign artists as a tribute to and an honor for France. He saw them as the School of Paris—whose achievements owed far more to France than to their countries of birth. For many years, scholars credited Warnod with coming up with the name "School of Paris." The latest research now attributes that honor to another critic, Roger Allard. But if Warnod did not invent the term, he gave it meaning and popularized it in 1925 in a series of articles in *Comœdia* and in his book, *Les Berceaux de la Jeune Peinture* (The Cradles of the New Painting). The opening lines of his book, in fact, read like a rousing cry of pride for the young foreign artists:

> The School of Paris exists. Future art historians can define its character better than we can, and they can also study the elements that make it up, but we can affirm both its existence and the force of attraction that makes artists of the whole world come to us.
>
> How can we look on an artist as undesirable, if that artist looks on Paris as the Promised Land, a land blessed with painters and sculptors? They are drawn here for significant reasons. Our museums are justly famous, but even more than our artistic riches, these artists want to know the country where our great painters lived, breathe the air that they breathed, to be agitated by the arguments that agitated them, to feel the mildness of the climate, to admire the light, to finally know the happiness of enjoying and living in the liberty that art must have in order to blossom.

Warnod insisted that the French could not reproach foreign artists who "carry hardly anything else in their baggage but the will to

enrich their art with what they find among us." Moreover, he went on, there are great artists among them who give France far more than they take.

Warnod also made it clear that his praise of the School of Paris was not meant to belittle the work of the young French artists. They, too, were creating the finest paintings—though different from the work of the immigrants. He cited André Derain, Maurice Utrillo and Georges Braque as examples. The young French artists would be known as the French School, to make it clear that France had two very different schools of painting and sculpture.

Although Warnod left details about the makeup of the School of Paris to later generations, he confused the issue by including Pablo Picasso in the group. Since Warnod's book, historians have differed about whether or not he really belongs. Picasso was a few years older than the others: By the end of 1925, he was 44. Most members of the School of Paris were in their thirties. Chaim Soutine was 32, Jacques Lipchitz and Moïse Kisling were 34 and Marc Chagall 37. Even Amedeo Modigliani, who acted as a mentor to Soutine and died in 1920, would have been only 41.

By 1907, six years before Soutine had even arrived in Paris, Picasso had painted his great work "Les Demoiselles d'Avignon" (now in New York's Museum of Modern Art). With that painting, as his biographer John Richardson put it, Picasso "was finally ready to establish that he—as opposed to Matisse, who had dominated successive salons—would be the Mahdi of modern art." Soon Picasso and Braque invented cubism, the process of breaking up the natural forms of the objects in a painting into little squares and other geometric shapes. That was supposed to render the "truth" of a subject more faithfully than mere verisimilitude. Cubism had a sensational heyday, but it was no longer a breathtaking novelty by the time most immigrant painters reached Paris. In their eyes, Picasso, as great as he was, represented an older generation.

Picasso, moreover, had not renounced the land of his birth the way most of the others had. He looked on himself as part of some kind of Barcelona–Paris axis and liked to summer in Cadaqués on Spain's Costa Brava. According to biographer Richardson, Spain from time to time exerted "an atavistic tug" that made Picasso return "to his Spanish roots for sustenance." In a note to Guillaume Apollinaire, Picasso described Spain as "the beautiful country of my birth." He shut himself off from Spain only when the Spanish Civil War of the 1930s ended with the country under the yoke of the fascist dictator Francisco Franco.

In fact, the inclusion of Picasso distorts the meaning of the School of Paris. Picasso was an avant-garde master beyond imitation. He was almost always one of a kind. It is absurd to imagine a collector, finding the cost of a Picasso out of range, asking a dealer to show him something else from the School of Paris. But a collector, unable to buy a Soutine or a Chagall, might easily ask for others from the School of Paris. Warnod's boosting of the group surely helped painters like Michel Kikoïne and Pinchus Krémègne.

Who made up the School of Paris? An exhibition of the School of Paris at the Musée d'Art Moderne de la Ville de Paris in late 2000 and early 2001 displayed the works of 77 painters, sculptors and photographers. A show at the Jewish Museum in New York in 1985—called "The Circle of Montparnasse: Jewish Artists in Paris 1905-1945"—exhibited the work of 43 artists, including 15 not in the later Parisian exhibition. Nadine Nieszawer, a French dealer who specializes in the sale of School of Paris works, listed more than 150 painters and sculptors on her Web site in 2014. There may have been other students or amateurs who considered themselves School of Paris artists but never made an impression on the market.

Warnod had no doubt who typified the school. "If we had to designate a single painter capable of representing all the live forces that animate Montparnasse, we would not hesitate," he wrote in his

book. "We would nominate Pascin." Although he praises Jules Pascin's paintings and watercolors, he is just as impressed by his prowess at organizing fanciful festivities. "Pascin is a prodigious animator," Warnod wrote, "and when he lets himself be guided by his own imagination, the party is complete."

Warnod named and discussed the core group that most critics associated with the School of Paris. Aside from Pascin, these included Modigliani, Soutine, Chagall, Kisling, Ossip Zadkine (the 35-year-old sculptor from Smolensk in Russia), Lipchitz, and Léonard Foujita (the 39-year-old painter from Edogama City, Japan). Warnod made little attempt to evaluate the artists but simply described the traits of their work.

He paid tribute to Modigliani, noting that his nudes "often seemed to suffer until the extreme limit of sensations—emaciated figures with very long bodies and small heads inclining like a flower too heavy for its stem, a troubling reflection of the sensitivity and sexuality of the painter." The two most important living painters, Soutine and Chagall, did not receive special attention but were included in a section titled "The Russians." Warnod wrote that Soutine was "carried away by a sort of delirium that made his canvas surge with the jolt of a passionate world." Chagall, the critic said, was "a poet at the same time that he paints, an enthusiastic and exuberant visionary, spirited and full of tenderness and sensitivity."

Most attempts at definition since Warnod have only added more confusion. Unlike terms such as the sixteenth-century Venetian School of painting or the seventeenth-century Spanish School of painting, the phrase School of Paris fails to conjure up images of a style or kind of painting. It makes more sense to think of the School of Paris as a historical phenomenon—an unprecedented and unexpected migration of young artists, mostly Jewish, many from the Russian empire, to Paris in the early decades of the twentieth century.

No special kind of painting marked the School of Paris, though it is possible to discern some influences from one artist to another. Through his friendship with the artist Sonia Delaunay, Chagall began to add some interesting cubist touches to his early canvases. Like Soutine, Krémègne, who studied at the same school in Vilna, applied thick paint to his crowded landscapes. But what is amazing about these artists is the diversity of their work. Each seems to move in his own direction.

Moreover, the artists of the School of Paris were so intent on going their own way that they avoided popular movements of the 1920s like Dadaism and surrealism. The surrealists, mistaking his folkloric fantasies for dream sequences, tried to claim Chagall as one of their own, but he resisted. He totally rejected their idea of letting the subconscious dictate painting. "Fantastic or illogical as the construction of my pictures may seem," he said, "I would be alarmed to think I had conceived them through an admixture of automatism."

The Jewish character of the School of Paris provoked the most puzzlement and comment and rancor in the city. If the artists had all been Spaniards like Picasso and Joan Miró, no one would have been shocked, for Spain had produced great artists for centuries. The novelty of so many Jewish artists evoked much curiosity. In his notebooks, the French Jewish dealer René Gimpel reported a conversation with his colleague Léopold Zborowski, the dealer of Modigliani, Soutine and a dozen or so younger artists of the School of Paris. Gimpel, describing Zbo as "a person of great sensibility and a Christian," quoted him as ranking Modigliani and Soutine as the two greatest artists of the generation after Picasso and Matisse. "He thinks that there is a renaissance of spirit in the people of Israel," Gimpel wrote, "an evolution of the critical to the creative temper."

Yet the presence of so many Jews also aroused the vilest anti-Semitic attacks from others. In 1925, the same year that Warnod wrote his affirmation of the School of Paris, Dutch poet Fritz

Vanderpyl wrote an article for the distinguished French literary magazine *Mercure de France* with the mocking title, "Is There Such a Thing as Jewish Painting?" "In the absence of any trace of Jewish art in the Louvre," he said, " . . . we are nevertheless witnessing a swarming of Jewish painters." Invoking a common Jewish name, he complained that the galleries and salons were now full of painters called Lévy. In view of the Torah's prohibition, he went on, "where has this sudden desire to paint come from among the descendants of the twelve tribes, this passion for paint and brushes?" Vanderpyl concluded it was mainly greed—the avaricious Jews realized there was money to be made in art.

In a kind of reply, the Jewish painter Kisling tried to mock Vanderpyl's mocking by playing on his use of the name Lévy. When another art publication polled critics, collectors, dealers and artists in France to name ten living artists who deserved a place in a future museum of modern art, Kisling listed nine people named Lévy and himself.

Some of the most anti-Semitic diatribes came in the late 1920s in the commentaries of Camille Mauclair in the right-wing but highly respected newspaper *Le Figaro*. Mauclair was a novelist, poet and critic, and his pieces were collected later in a book starkly titled *The Métèques Against French Art*. *Métèques* is a slang word best translated as "dirty foreigners."

Mauclair described Montparnasse as "the filth of Paris," insisting that it was inhabited "by 80 per cent Semites and every one of them a loser." He urged police to raid the neighborhood and check the papers of all the residents to make sure they were legally in France. In his xenophobic view, the School of Paris was a deceitful term created by foreigners intent on teaching French artists how to paint. This kind of anti-Semitism would intensify as World War II approached, and Mauclair himself would collaborate with the Vichy government.

The Jewish artists were a varied lot. The largest number were Yiddish speakers from the Russian empire who were educated in Russian schools. But Kisling had been born in Krakow, a piece of Poland that was part of the Austro-Hungarian empire rather than the Russian empire, and therefore had attended German-language schools. Pascin, born in Bulgaria, moved to Romania as a child. Both countries were once part of the Ottoman empire, and his family sent Pascin off to Vienna, the capital of the Austro-Hungarian empire, for German-language education. It is not clear how much Yiddish, if any, Kisling and Pascin understood. Modigliani, the son of an Italian family descended from Jews expelled from Spain, knew Ladino, the Jewish language of southern Europe and North Africa with Spanish roots, rather than Yiddish, the Jewish language of Eastern Europe with Germanic roots. But his family spoke Italian, not Ladino, at home.

We do not know much about the religious attitudes of the Jewish painters, but most seem to have been secular Jews. Chagall and his wife would sometimes invite family and friends for a Passover seder, but the couple did not attend any synagogue regularly. No hint of religious observance shows up in the biographical material about Soutine, Modigliani or Pascin. Only two painters focused on Jewish folklore or scenes of Jewish life. One was Chagall; the other was Emmanuel Mané-Katz from Kremenchug in the Ukraine.

Of course, Jewish painters could express their ethnicity in ways other than folklore. In the catalogue for the 1950 Soutine retrospective by at New York's Museum of Modern Art, Monroe Wheeler attempted to attribute the artist's boldness and insolence—and presumably his wildness and distortions—to the sudden freedom felt by a Jewish painter in Paris. Wheeler wrote:

Whether by their own religious traditions, or by the repressions and injustices of others, Jews had previously been kept out of the

arts almost entirely. Suddenly, there they were in the vanguard, uprooted but quickly digging in everywhere, mixing in everything, playing a great role in civilization. It may be that for Soutine and for other of his fellow artists in Paris, the important thing was not the sense of race repression but the opposite, the rapidity of liberation . . . and its consequences. . . . It made them bold, even insolent, concentrated upon their advancement, indefatigable; but it kept them under continuous strain, ever insecure and perhaps incredulous.

This description, however, fits Soutine far better than Chagall and may not be helpful in differentiating a Jewish artist from any other in Paris.

Other tendencies seem to set members of the School of Paris apart from contemporary French artists. One is the lack of interest in cubism. That may be caused in part by the immigrant artists arriving in Paris too late to take part in the excitement over it. But in addition, the School of Paris artists may not have been sophisticated enough for cubism. Kenneth E. Silver, a professor of art history at New York University, has pointed out that the practice of cubism "usually presupposed a thorough grounding in artistic tradition along with . . . a willingness to defy the norms of standard practice." For the Eastern European artists, Silver wrote, it made no sense to defy the norms of a classic tradition that they had come to Paris to learn.

There was another difference. The first modern masters of the twentieth century tended to spend as little time as possible painting portraits. The prejudice against portraiture was so strong that critics demeaned a great portrait painter like John Singer Sargent for most of the century. Though their goals were far different from those of a society painter like Sargent, School of Paris artists like Soutine, Modigliani and Kisling made portraiture a vital part of their work.

The penchant for portraits could be carried too far. In 1929, a pair of impresarios arrived in Paris with a German movie actress named Maria Lani. They asked artists to produce portraits and sculptures of Lani for an exhibition at the Georges Bernheim Gallery on the rue de Faubourg-Saint-Honoré. Even in the early days of film, movie stars could stir up great excitement. Many artists complied with the request, including Soutine, Chagall, Chana Orloff, Foujita, Pascin, Zadkine, Kisling and other artists of the School of Paris. Henri Matisse joined as well. Soutine's portrait (now in New York's Museum of Modern Art) depicted Lani as tense and fragile. Jean Cocteau wrote an introduction for the catalogue.

The dealer René Gimpel was not impressed. "They are less interesting than might have been supposed," he wrote in his diary. "Here we have a woman painted by fifty artists, and it's rather pitiful; few painters stand up to the challenge." Gimpel pronounced the canvases by Matisse, Édouard Vuillard and Soutine as the three best.

All the hype deflated, in any case, when it was discovered that Lani was not an actress squired about by impresarios but a Prague stenographer partnered by a pair of hoaxers. The trio fled to the United States when their plot was exposed. According to some reports, they ran off with some of the paintings. But it is still not clear whether their subterfuge was aimed at defrauding the artists or embarrassing them.

Warnod's championing of the School of Paris as a special grouping of artists led to institutional and even government recognition. In 1928, for example, the organizers of the Venice Biennial set aside a room for the School of Paris separate from the room for French art. When the Jeu de Paume museum in the Tuileries Garden in Paris opened in 1932, room 14 was devoted to works of the School of Paris and included paintings by Soutine, Modigliani, Chagall, Pascin and Kisling. A museum announcement, noting that some of the artists were naturalized French citizens, said, "The 'School of Paris' is very

esteemed outside of France: It is indispensable that Parisians can see here, in their true place and carefully selected, the works of these leaders whose influence has been so great." For the Paris World's Fair of 1937, the Popular Front government of the Socialist and Jewish prime minister Léon Blum organized an exhibition of French art at the Petit Palais that included many works by Jewish artists of the School of Paris. This came at a time when the Nazi government of Adolf Hitler in neighboring Germany railed against Jewish and avant-garde modern art as degenerate.

Despite the enthusiasm for the idea of a school of Paris, attacks on foreign painters continued and, in fact, intensified during the 1930s. Some of the attacks seemed like blind rage against the people the protesters called *métèques.* Others reflected a venomous anti-Semitism that warned of the bastardization of French culture by Jews. Some comments came from critics uneasy about two different schools of painting coming from one country.

One of the most harmful attacks came from Waldemar George, who turned against the idea of a School of Paris a few years after supporting it. George, the same age as Soutine, was the model of an assimilated Jew, and the existence of a separate School of Paris for immigrants began to clash with his new hope that assimilated Jewish painters would someday take their place alongside French artists in a French school of painting. He was born in Lòdz in the Polish lands of the Russian empire, the well-educated son of a wealthy industrialist, and he arrived in Paris two years before Soutine, escaping Russian authorities angered by his book of patriotic Polish poems. Proficient in seven languages, including French, he obtained a degree in literature from the Sorbonne and then launched a career in French journalism, earning a reputation as a distinguished art critic.

Writing in 1931, George derided the School of Paris as a created title based on very little except an anti-French attitude. "This term, which dominates the world art market," he said, "is a conscious

example of premeditated conspiracy against the notion of a School of France." While it pretends to enrich painting in France, he went on, the existence of the School of Paris forces French painting to be dominated by foreign painting. He denounced this as "a rather subtle, hypocritical sign of the spirit of Francophobia" and concluded that the School of Paris was "a house of cards built in Montparnasse. It is a sterile movement. . . . It is not liable of any development."

George then called on the painters of the School of Paris to try to take their place in the French School of painting. "The French School is not a school made up only of French artists," he wrote. "It is a school that creates French painting. . . . France is a state of mind," he went on. "It represents a spiritual and intellectual order. French art welcomes and assimilates all those who adapt to its mode of feeling."

George's analysis ignored a major part of the story. The artists of the School of Paris came to France in a mass and rare migration, honed their art in the schools and museums of France, ignored the styles of French painters as young as themselves and produced a host of exciting and unique works of art. A good deal of great art would have been lost if they had come to Paris and did nothing more than mimic the bland work of young French painters. Even worse, George's arguments, though part of a plea for immigrant artists to assimilate to French ways, became useful ammunition for anti-Semites determined to prove that these foreign painters were besmirching the artistic honor of France.

SEVEN

ARTISTES JUIFS, REMBRANDT'S
CARCASS OF BEEF AND THE
DAUGHTER OF ELIE FAURE

IN THE LATE 1920S AND THE 1930S, SOUTINE SOLIDIFIED his place as one of the most distinguished artists of the School of Paris. The Paris publisher Editions Le Triangle issued a series of booklets, most in French, some in Yiddish, devoted to the leading *artistes Juifs* (Jewish artists) in France at that time. The list included all the obvious names: Marc Chagall, Amedeo Modigliani, Jules Pascin, Moïse Kisling, Jacques Lipchitz, Pinchus Krémègne and, of course, Soutine. Most of the booklet authors were Jewish as well, including novelist Sholem Asch and Waldemar George. George wrote the edition on Soutine, published in 1928. It is the first serious study of the painter.

George opened his booklet with a dark description of life in both an Eastern European shtetl and in an impoverished family in Smilovitchi. But George's view was rather general and remote—as if he were discussing Russian Jews in general, not Soutine especially.

Soutine, in fact, comes alive only as a youth pacing the sidewalk at dawn while waiting for the academy in Vilna to open for his entrance examination. The paucity of other detail indicates that George did not know the artist well. But he did know the paintings. Sixteen of the best, all from the gallery of Soutine's dealer Zborowski, are reproduced in black and white in the booklet.

"The story of Soutine is too true to be believed," George insisted. "It is a story for . . . Charlie Chaplin," a Cinderella story of transformation from darkness and poverty into wealth and recognition. George felt forced to set it down, he said, so that he could place Soutine "in his exact ambiance, this ambiance of deep despair that shapes his soul."

George described Soutine as a painter who "pushes aside all norms, transgresses the limits of logic, breaks all chains, tears all ropes. . . . What is the meaning of this art," George went on, "whose origin is impossible to establish, that knows no law nor national influence nor guiding principles, that is not linked to any tradition? Art of exile or even barbarian art? I defy anyone to discover the line of descent of Soutine." George acknowledged a resemblance to the work of van Gogh but denied that Soutine was a follower of the Dutch painter.

And then in probably the most persuasive words of his study, George concluded that Soutine painted without any "studies of style or plans for perfection. . . . Each of his works looks like a hemorrhage," the critic said. "Before portraying his soul, the painter spits out all his blood, and each rivulet of blood gives birth to a vision that is new, singularly intense, tragic and painful."

WHETHER OR NOT THE METAPHOR of blood fit most of Soutine's canvases, it certainly served for his series of still lifes of sides of beef bristling in carmine reds. Aside from portraits and landscapes, the still lifes took up a good deal of Soutine's time and energy, especially

in the 1920s. For the most part, he was obsessed with fish, poultry and meat, after their killing and sometimes butchering but long before they were ready for cooking. When he was impoverished, he painted emaciated herring. After Dr. Barnes enriched him, he painted beef.

After his first six months or so in Paris, Soutine gave up art classes and taught himself by studying paintings in the Louvre and other museums. He became obsessed with Rembrandt and was determined to try to match one of the Dutch artist's haunting canvases, "Le Boeuf écorché" (The flayed beef), in the Louvre. A friend, Hughes Simon, recalled sitting with Soutine on a bench in Montparnasse and hearing him praise the painting for more than an hour. "It was impossible to raise the slightest objection on this subject," Simon said, "because it would send him into an overexcitement that resembled an outburst of anger." The sculptor Chana Orloff said years later, "I can still see him gazing at the canvases of Rembrandt with respectful awe. He would contemplate them for a long time, go into a trance, then suddenly stamp his foot and explain, 'This is so beautiful it drives me mad.'"

Soutine had spent some time in the kosher butcher shop in Smilovitchi and kept at least one memory from those days. "Once I saw the village butcher slice the neck of a bird and drain the blood out of it," he recalled. "I wanted to cry out, but his joyful expression caught the sound in my throat. This cry, I always feel it there. . . . When I painted the beef carcass it was still this cry that I wanted to liberate. I have still not succeeded."

Soutine also said, "In the body of a woman Courbet was able to express the atmosphere of Paris—I want to show Paris in the carcass of an ox." (Soutine was probably referring to Gustave Courbet's erotic "The Origin of the World," now at the Musée d'Orsay in Paris.)

In 1925, Soutine rented a large studio on the rue du Saint-Gothard with high ceilings and a crumbling redbrick fireplace. Zborowski purchased a carcass of beef for him for 3,500 francs.

Soutine hung dead turkeys, hares, chickens and ducks in the studio as well. Zbo also sent a young employee, Paulette Jourdain, to serve as an assistant (and as a model for some very unflattering portraits).

Soutine wanted his beef bloody, and from time to time Paulette would go to the nearby abattoirs with a milk pot to buy blood. She would tell the workers she needed the blood for a very sick relative, and they would fill the pot with the purest blood available. Soutine was pleased with the results. "I have luck with you," he told her.

The blood and decay of the carcasses attracted huge flies and produced an awful smell, but Soutine was oblivious to these annoyances as he painted. The smell, however, made its way to other floors, and neighbors complained to the Paris department of health.

A knock on the door came soon afterward. City health workers announced they had arrived to remove the carcass of beef. "Soutine was white as a corpse," Paulette recalled. She pleaded with the health workers. "Be kind," she said. "You can see that he is painting the beef. He has need of the carcass to finish his painting." The workers relented and showed Soutine how to inject his dead animals with an ammonia solution to dissipate the awful smell.

While the health team returned the next day to disinfect the studio, Soutine rushed outside to buy a packet of syringes and needles. He proceeded to inject the beef carcass and other dead animals with ammonia. The awful smell dissipated, and Soutine completed an extraordinary series of still lifes of dead animals, the best known probably "Carcass of Beef" in the Albright-Knox Art Gallery in Buffalo, New York.

Soutine's painting was not an attempt to mimic the work of Rembrandt in any way. It was instead a modern Soutine variation on a theme by Rembrandt. The original masterpiece was still and orderly, the sinews of the carcass painted as delicately as Rembrandt painted lace. The Soutine paintings are unruly, feverish, as loud as the scream with which he struggled.

Abraham Mintchine, a Kiev-born painter five years younger than Soutine, came upon one of the Soutine beef paintings on the wall of a Paris dealer in 1929. According to the art dealer René Gimpel, Mintchine "turned pale, remained in front of it for ten minutes without saying a word, then left." He told his own dealer, "Soutine has robbed me. He has robbed me of something I shall never again be able to do." "For three days in Montparnasse," Gimpel wrote in his diary, "he was so haggard that his friends thought him demented." Mintchine was obviously suffering from admiration and envy.

Soutine's penchant for painting still lifes of dead animals, especially the carcasses of beef, has led to a good deal of speculation about the influence of Jewish shtetl life on his work. The kosher Jewish butcher, after all, was a powerful and important figure in the shtetl. But the ritual of kosher slaughter involves draining all the blood from an animal before carving, so Soutine's bloody carcasses were therefore not kosher. Of course, turning his youthful experience on its head could be cited as evidence that he could not shake off the memory of the Jewish butcher in the shtetl.

The critical fascination with Soutine's kosher butcher experience is part of a continual attempt by art historians to relate his work to his Jewishness. After all, he spent his entire childhood in the Russian Pale, always spoke French with a Yiddish accent, and, unlike some other contemporaries, never dropped his Jewish first name. Although many historians are certain that his Jewishness must have been a major factor in his work, it is very difficult to find any obvious evidence in his canvases.

Historians sometimes go far afield in their attempt. In the catalogue for the 1998–1999 exhibition in New York, Los Angeles and Cincinnati, the last major Soutine retrospective in the United States, Donald Kuspit, a well-known art historian at the State University of New York at Stony Brook, offered his readers a long and complex theory to tie up the art and the Jewishness.

Kuspit began by stating that all of Soutine's portraits, landscapes and still lifes show their subjects at the point of *shudder*. Kuspit called shudder "the subject's last defense against depression, a prelude to psychic death. . . . At their best," he went on, "Soutine's expression-ist paintings are nothing but shudder." In fact, this emphasis may be an insightful way to look at Soutine, for shudder—the convulsive shaking of the body when facing fear or danger—could explain the whirling and violence that mark so many of the artist's paintings. But Kuspit was not content with this contribution toward understanding Soutine's paintings. The art historian went on to obscure his theory with ludicrous elaboration.

Kuspit reached the startling conclusion that the shudder in Soutine's paintings "is Jewish." He based this on two facts: that Soutine came from a family that was the lowest of the low in the shtetl (his father was a mender of clothes trying to support a family with 11 children), and that Soutine broke with Jewish tradition by deciding to become a painter. "Soutine's shudder," Kuspit said, "is a sublimation of the trauma of being born a lowly shtetl Jew and becoming an absurd Jew—not a real Jew—by becoming a painter, which, after all, expressed the wish to escape the shtetl." Simon Schama, reviewing the show for the *New Yorker,* quoted this last conclusion of Kuspit and stated, "To which the only possible re-sponse is 'Oy!'"

DESPITE TITLING A SELF-PORTRAIT as "Grotesque," Soutine did not lack female companionship over the years, but most of his rela-tionships did not last very long. In 1925, Deborah Melnik, a Rus-sian music student whom he had first met in Vilna, gave birth to a daughter. Melnik insisted that Soutine had married her in a religious ceremony and was the girl's father. Melnik named the child Aimée Soutine. But Soutine denied the marriage and paternity. He did not deny their relationship but accused Melnik of sleeping with many

others in Montparnasse. Soutine never acknowledged or supported Aimée, who nevertheless carried his family name all her life.

In the late 1930s, he discussed the child with his lover, known as Mademoiselle Garde. "It would appear that I have a child," he told her. But he added quickly, "I don't know her. I don't want to know her. Besides, there isn't any proof. The mother is Russian. I detest her. She now lives with a Polish tailor who, I believe, has recognized the child as his own." When Garde suggested that he might like to see the child without seeing her mother, Soutine angrily replied that was not possible, that everything was over as far as he was concerned and that he did not want the matter raised again.

Someone told Garde that Melnik had come to Soutine's apartment once to ask for money for the child, but Soutine rejected her plea, declaring he would rather burn his money than give any to her. To demonstrate his contempt, he burned a banknote in front of her. When Garde met Aimée several years later, she found the girl's resemblance to Soutine striking.

THERE IS EVIDENCE that Soutine contemplated marriage just after 1929. That was the year when a second, far more important critical study of his work was published. The two events—proposal and publication—were linked.

Unlike the study by George, the new booklet was not a tribute to a Jewish painter by a Jewish critic writing for a largely Jewish audience. The author, Élie Faure, was a non-Jewish French critic regarded as the country's most eminent art historian of the early twentieth century, and the study was published as part of a series titled "The New Artists" that included Picasso, Renoir, Manet, van Gogh, Braque, Corot, Courbet, Zadkine, Chagall and Soutine. There could be no doubt now about Soutine's standing in contemporary art. Faure, a medical doctor who gained fame as both a political activist and an art historian, had written a four-volume history of art (*Ancient Art* in

1909, *Medieval Art* in 1911, *Renaissance Art* in 1914 and *Modern Art* in 1921) that would become the standard art text in France for many decades. Faure's art criticism became such a staple of French education that Jean-Luc Godard's 1965 movie *Pierrot Le Fou* opens with a scene of Jean-Paul Belmondo in a bathtub reading Faure's half-century-old words about Velázquez to his daughter. Soutine met Faure for the first time during preparation for the Soutine book, and the two men became close friends.

Faure was 20 years older than Soutine. He was born in 1873 to a Protestant family near the Bordeaux wine region. His father owned a Saint-Émilion winery. (When Picasso drew his portrait years later, Faure sent him a case of the family wine.) Both Faure's maternal grandfather and father-in-law were Protestant pastors. Faure attended a local Protestant school before going on to the Lycée Henri IV in Paris, where Léon Blum, the future Socialist prime minister, was a classmate. Faure, who obtained his medical degree from the Sorbonne in 1899, had many ties to leftist politics in France. His wife's uncle, for example, was regarded as the main theorist of the anarchy movement in the country.

Faure left no account of his conversations with Soutine, but their closeness tells us a good deal. Faure, bearded, stocky and professorial, was a renowned figure in France. Modigliani, Diego Rivera and Picasso had honored him with portraits. During the Dreyfus affair, he was a young and articulate defender of the persecuted army captain, even contributing a poem of support to *L'Aurore,* the newspaper that published Émile Zola's famous J'accuse essay that laid bare the lies of the army's general staff. Faure's political writing did not abate after he won fame as an art critic and historian. In the mid-1930s, he campaigned continually but in vain for France to help defend the Spanish republic against the insurgency of General Francisco Franco. It is obvious that Faure would not have spent so

much time with the young Soutine if he regarded him as a shtetl bumpkin.

Dr. Faure and his family—his wife, two sons and a daughter— embraced Soutine, treating him as a kind of third son. Faure was close to a number of renowned artists including Paul Signac, Picasso and Matisse, and the movie director Abel Gance. But he developed an even closer relationship with Soutine, who was often a guest at the Faure home in Paris and at their country home in the Dordogne. Soutine sometimes traveled to the Dordogne with them in the family Renault convertible. The distinguished historian and the young artist even toured Spain together.

The relationship raises several questions. What attracted Faure to Soutine? Why were they so close? What did they talk about? Faure was known as a garrulous man who liked to lay out his ideas in long monologues. But he also had great curiosity and varied interests. He could talk (and write) about medicine, the history of art, contemporary painters, French politics, European conflicts and, of course, Bordeaux wine. Friendship between the men would never have deepened if Soutine had simply listened timidly to Faure. Did Soutine comment on Faure's favorite subjects? Did he try to explain the twists and turns of his canvases? Did he talk about his childhood in Smilovitchi? Did he agree with Faure's leftist politics? We do not know. But we do know that he had mastered enough French and had enough poise and knowledge to serve as the favorite companion of the learned and very active Dr. Faure.

In his booklet on Soutine, Faure lavished image-laden praise on the young painter. "Here the mystery of the greatest painting shines forth," Faure wrote, "flesh more like flesh than flesh itself, nerves more like nerves than nerves, even if they are painted with streams of rubies, with sulphur on fire, droplets of turquoise, emerald lakes crushed with sapphires, streaks of purple and pearl, a palpitation of

silver that quivers and shines, a wondrous flame that wrings matter to its depths after having smelted all the jewels of its mines."

In an insightful passage, Faure admonished the public not to misread the violence in Soutine's paintings. "There are some who believe that Soutine deforms his paintings just to deform," the art historian said. "That is a grave error. He himself suffers in front of these formless canvases where his marvelous universe staggers like his own insides. At home, he lacerates his paintings in rage. At the dealers, he buys them back to take them away and destroy them." Faure said Soutine's work reminded him of the novels of Dostoevsky, one of Soutine's favorite authors, whose detractors complained that he filled his writings with "deformations." In short, Faure implied, Soutine could not prevent the violent turmoil on his canvases even as he suffered to see it and tried to destroy it.

This insight may have added an important insight to an odd habit of Soutine's. He was notorious for destroying or reworking canvases that displeased him, even many years after they had been sold. The dealer Gimpel said that his brother-in-law in 1930 bought an unsigned Soutine from another dealer and asked that it be sent to Soutine for a signature. Soutine decided to make some changes as well. "But, in repainting it," Gimpel said, "he literally destroyed it because he no longer liked it." The angry owner of the painting told Soutine, "You're a lunatic." But Gimpel told his brother-in-law, "It's you who are the lunatic to have sent Soutine the canvas, when everyone knows how many canvases he destroys." It was widely assumed that Soutine altered or destroyed canvases because they were too amateurish or because he now realized they were artistic failures. Dr. Faure added another possibility: Soutine could not face the inner demons that he had mirrored on the paintings. The paintings had become too personal.

Soutine fell in love with Faure's daughter, Marie-Zéline, who was known as Zizou, and hoped to marry her. In 1930, he was 37, and

she was 26. We know little about her. One published snapshot, taken from a side angle, shows her sitting between Soutine and Faure in the convertible at the family home in the Bordeaux country. She is wearing a bonnet, and it is impossible to make out her features. A bust, made by the French sculptor Charles Despiau, shows a young lady with the classic French features of high cheekbones and a prominent nose. In a memoir about her father, she wrote, "He bullied me, a little, not too much. He didn't put up with my friends, whether boys or girls. If he saw me crying over a school paper or homework, his remedy was to take me to the movies." She described him as "suspicious, jealous, straight-laced" but concluded, "We laughed a lot together, cried a lot and loved a lot."

For many years, little was known about Soutine's passion for Zizou. But Pascal Neveux of the Centre d'Art Contemporain of Paris put together much of the story in the 1990s with some intensive research and detective-like deduction. Soutine's shyness prevented him from pleading his case to Zizou. Instead, he confided in Faure and his wife that he would like to marry their daughter. The parents seemed agreeable, and Soutine, assuming that they would inform Zizou, began to search for an apartment and purchased some furniture.

According to Soutine's boyhood friend Michel Kikoïne, the Faures urged him to talk with Zizou, and Soutine, bolstered by his assumption that she knew all, mustered up enough courage to talk about their future marriage. But his words surprised her completely; she had heard nothing from her parents. According to Kikoïne, "she listened with kind attention and then broke into gentle laughter, telling him he should have spoken to her much sooner, for a few days earlier she had agreed to be the wife of her cousin," a pilot named Pierre Matignon. Soutine was devastated.

Soutine wrote an angry letter to Faure breaking their friendship. No copy of this letter has surfaced, but, judging by Dr. Faure's lengthy reply, Soutine's accusations of betrayal must have been bitter

and immoderate. Writing in March or April of 1930, Faure's reply began sharply. "You are atrociously unjust, something you will regret—I hope so, for your sake—when calm has returned to your heart. No one in my home has made sport of you, we have both been victims of circumstance and of a common imprudence in which I see nothing that can diminish the respect on which I hold you and that you owe to me as well. How can you judge us so harshly?"

Faure said that he would accuse Soutine of "wounded vanity" if he did not realize how much he had suffered, a suffering that made him "refuse to understand what happened." Without reciting the details of what had happened, Faure showed great resentment at accusations against both himself and Zizou. "And such is your estimation of my daughter, to say nothing of myself?" he wrote. "I would blame you even more than I do if you were to deceive yourself to this extent about her and about me.

"Yet you are not a base man," Faure went on. "I know you better than you know yourself. Even now your letter no longer exists in my memory. It is you, yourself, who would be 'offended' if you realized what it reveals about the present state of your soul. . . . It is within yourself that you will seek forgiveness for having written it, and I like to think that you will find it there." Faure said he did not want to feel that "there was only an exceptional painter where I thought I had found a man."

Faure concluded with a tinge of hope. "I will wait for you, then, with confidence, months and years if necessary," he wrote. "You were, you still are, aside from my two sons, the only man I love. I am fifty-seven years old. I could die without you having forgiven me for a wrong that no one in my home intended, and for which I, for my part, forgive you your ugly interpretation."

Soutine's response was curt and cold and written in someone else's hand. Ashamed of his poor spelling and grammar in a country that prized perfection in language, Soutine probably dictated the

letter to a friend or an amanuensis. It stated in its entirety: "I have thought and reflected much on your letter and I prefer her making sport of me to all this admiration you throw in my face. Just when I've been so offended it's wrong to talk about painting. And your feelings of friendship, what can you mean by them at such a time? Future conversation, then, no longer makes any sense. But rest assured I have wonderful memories of some moments."

Neveux, the researcher, published six letters of this correspondence, two from Faure, four from Soutine and a seventh from Soutine to Faure's widow. Several simply restate their positions. But a kindly letter from Faure in April 1931, a little more than a year after the bitter quarrel began, attempted to change the mood.

"I hope that you are doing well," Faure wrote. "I saw some beautiful recent canvases by you, which make me think that you remain the profound man that I knew and the first—far and away—among living painters. It would be a great joy for me to see you again. I hope you won't refuse me this. As of today the way is entirely open to you, and will remain so. Come whenever you like, write me whenever you can."

Faure evidently wrote other letters like this, and Soutine finally relented four years later in May 1935. This letter, written in Soutine's hand, said, "I received your very cordial letter, which touched me deeply. I thank you for it. I have been traveling. If you like, I could meet you in a café."

But, despite the calm and kindness in Soutine's words, they never met again, evidently because Soutine could not bring himself to reconcile so completely. Faure died at the age of 64 on October 29, 1937, more than two years after Soutine wrote that they could meet.

Soutine sent a brief note, in his own handwriting, to Mrs. Faure. "I was struck and very moved by the death of Dr. Faure," he wrote. "I have an impression of sadness that will stay with me for a long time. I also regret not having seen him again and spoken with him. Trust in my sincerity."

The standard biography of Faure by Martine Courtois and Jean-Paul Morel, published in 1989, tells us little about the conflict. In two pages, the biography notes that Soutine became one of the "rare friends" of Faure and that they broke up because of a "misunderstanding." The authors quote guardedly from the final correspondence but offer no hint that Soutine ever intended to marry Zizou. Perhaps their hesitation was due to the fact that she helped them put together the biography. The book itself is dedicated to her and one of her brothers.

Soutine's quarrel with Faure reinforces our images of his paralytic shyness, his foolish naiveté, his volatile anger and his sometimes-cursed relations with those who wanted to embrace him. It also makes clear that Soutine, despite all the turmoil inside him, despite all the turmoil on his canvases, yearned often for the calm of a staid, humdrum bourgeois life—even while failing to fathom how to attain it.

EIGHT

THE GREAT DEPRESSION, PASCIN,
THE DEATH OF ZBO AND THE
JUDGMENTS OF SOUTINE

IN LATE 1926, MARC CHAGALL SIGNED A CONTRACT WITH the Bernheim-Jeune Gallery to market his paintings. The gallery had just moved into new sumptuous quarters on avenue Matignon at the corner of the Faubourg Saint-Honoré, a few steps from the Élysée Palace, the official residence of the president of France. Chagall's paintings now hung alongside those of Cézanne and Matisse and, he boasted, were purchased by collectors soon after his signature dried. Three years later, in October 1929, when news of the disastrous stock market crash in the United States reached Paris, news that heralded the Great Depression of the twentieth century, Bernheim-Jeune immediately telegraphed Chagall that it had canceled the contract.

The depression that battered the United States and then wrecked the economies of the rest of the world did not crush France with full force until two or three years later, but the art market was one of the first economies to shatter. Paintings, after all, were not a necessity,

and collectors, bereft of their paper wealth by the incredible plummet of the value of stocks, started selling paintings for needed cash. The dealer Paul Rosenberg canceled a Picasso show in 1930 and stopped buying the artist's works for four more years. Picassos, once worth 100,000 francs, declined in value to 25,000 and less.

By that time, though, Picasso was a wealthy artist and could afford a few years of poor sales. The dealer Daniel-Henry Kahnweiler kept his gallery open, staffed by only his stepdaughter and himself, but no customers came. "We saw nobody," he said. He stood in the gallery out of responsibility for his painters, just in case someone might enter. "I did not want to abandon them," he explained. He did not worry so much about well-known artists. "Not so much the big ones," he said. "Picasso had no need of me. Nobody bought Picasso any more, but Picasso could wait." So Kahnweiler kept open in hopes of selling some works by poorer and lesser-known artists who might be devastated by the depression.

Soutine also escaped the ravages of the depression. A wealthy couple, Marcellin and Madeleine Castaing, long persuaded of his greatness, befriended Soutine, gathered him in, protected him, purchased whatever paintings he offered them. Chagall managed for a few years because of his lucrative contracts with the publisher Ambroise Vollard. Chagall had illustrated Gogol's *Dead Souls* and La Fontaine's *Fables* for Vollard and was now producing numerous illustrations for a massive Bible. But Vollard was forced to cancel the Bible project in 1934. Trying in vain to persuade others to assume publication, Chagall wrote a friend, "I have a great deal of moral success, but no one buys anything. It is quite discouraging."

Léopold Zborowski, who had launched the careers of both Modigliani and Soutine, expanded his stable of School of Paris painters. But the 1930s were the wrong time to do so. His problem was exacerbated when the businessman Jonas Netter, who had supplied the funds that kept Modigliani and Soutine alive and painting, severed

his financial arrangement with Zbo. The dealer's debts piled up as he sold little and tried to fulfill his promises to his painters. Isaac Antcher, a Russian-born immigrant subsidized by Zbo, was only 30 years old when the Wall Street market crashed. He spent five years during the 1930s as a laborer with little time for painting.

It took a few years for the French economy as a whole to succumb to the havoc of the Great Depression. The delay made France stand out, fostering the illusion that the country was the most powerful nation in Europe. When the bad times did come, France did not try to spend its way out. Befitting its self-image of a military power, the government budgeted for a single major project of infrastructure—the construction of the Maginot Line, the series of fortifications along the border that would make France, in theory, impregnable to a German invasion.

A few days after the start of 1934, when most French already felt the bite of the hurting economy, Serge Alexandre Stavisky, a Russian-born Jew, a swindler and a charlatan, was found dead, a bullet in his head, in a chalet in the ski resort of Chamonix in the French Alps. For weeks before, newspapers had published scandalous revelations about his escapades of fraud and cheating, always protected by friendly and corrupt politicians, judges and police. Police insisted he had shot himself, but many French suspected that police had killed him to protect themselves and their accomplices in the courts and the government. Bigots cited the fact that Stavisky was an immigrant and a Jew as evidence that foreigners were sucking away the glory of France.

The government had been run for many years by the centrist Radical Party, and right-wing parties exploited the mounting anger over the Stavisky affair by organizing public demonstrations against the government. Hoping to force the Radicals to quit, right-wing gangs, enraged by the Stavisky revelations and by the inability of the politicians to ease the depression, assembled in the Place de la Concorde

on February 6, then stormed the bridge that led over the Seine into the Chamber of Deputies. There were fears the rioters intended to overthrow the Third Republic. Armed police on the bridge barred the way. In the end, 15 demonstrators died while hundreds of demonstrators and police were injured. A few days later, centrists and leftists organized counterdemonstrations in defense of the French republic, and a new government was formed led by Premier Gaston Doumergue, a former president regarded as less partisan than the succession of Radical premiers who preceded him.

The Stavisky affair unsettled many Jews in France. As Jackie Wullschlager, Chagall's biographer, put it, "In a climate where foreigners were mocked as *métèques* and there was endless talk of 'the Jewish conspiracy,' the Chagalls felt less and less at ease." Jews, moreover, felt that their security depended on the strength of France, especially now that the anti-Semitic Hitler had taken over as chancellor of Germany. The images of right-wing gangs taking to the street to bring the government down weakened Jewish hopes for a powerful and protective France.

THE SCHOOL OF PARIS lost one of its most renowned artists at the start of the 1930s. When Dr. Barnes set out on the buying trip that led to his discovery of Soutine, he had intended to shower his attention on a much different immigrant artist in Paris named Jules Pascin—a popular, flamboyant, rich, derby-sporting painter and caricaturist born in a former territory of the Ottoman empire. Pascin was not unknown in the United States. In fact, he had spent the years of the world war in the country. When the 1913 Armory Show in New York introduced European modern art to Americans, Pascin was one of the less noticed Europeans on exhibit. Pascin returned to Paris after the war, and Barnes was determined to buy the best Pascins available. Despite all the excitement over the discovery of Soutine, Barnes did not forget his original quest. He was so successful that the

Barnes Collection in Philadelphia now contains almost five dozen of the best Pascin paintings, watercolors and drawings. Yet Pascin is now far less known and esteemed in museums and art journals than Chagall, Modigliani and Soutine.

Although a prolific artist, the legendary Pascin was best known in Paris as the host of all-night parties. He would invite friends to his studio or a restaurant for dinner and a *bombe,* French slang for a spree of fun in the cafés and nightclubs of Montparnasse. Aicha, one of his models, said people would show up without invitations, but he would never turn them away. Pascin's friend the artist Léopold Levy said there were guests at the nightlong parties "who did not give a hoot about him," but he did not care. Pascin sometimes gave away his artwork during the night and always tried to play an instrument or two in the nightclub bands. He wanted people around him all the time, but in the late 1920s, he and his wife lived in separate apartments, and his mistress refused to leave her husband and son, so his *bombes* might end at five in the morning with him taking breakfast alone at a café in the Place Pigalle.

Aicha described Pascin as "very charming, very sensitive, very handsome, very tormented." He was so generous that he would show up with many bottles of wine when invited to dinner. The poet and critic André Salmon, a close friend, described him as "an aristocrat, a prince." Salmon said Pascin knew there were not many others like himself. "He once told me," said Salmon, "'I would have liked to have founded a society of princes, but we would never have had a quorum.'"

Pascin was born Julius Mordecai Pincas into a Sephardic Jewish family on March 30, 1885, in the town of Vidin along the Danube River in Bulgaria. His father was a wealthy grain merchant who moved his family and business to Bucharest, the capital of Romania, when the boy was seven. Pascin's father sent him to Vienna for high school, and he later pursued art studies there and in Munich. The

popular German satirical weekly *Simplicissimuss* in Munich paid him handsomely for his drawings and continued publishing him for many years. His father, who wanted the young man to give up art in favor of the family business, complained about the family name appearing in a controversial magazine that often antagonized government officials. The son gave in to the pressure, changing the name Pincas into its anagram, Pascin.

Pascin arrived in Paris in 1905, earlier than most others in the School of Paris. He had enough money to stay in a small hotel rather than La Ruche. He soon met Hermine David, a tall, dark French artist whose eyes were slightly crossed due to an accident with a corset stay. They fell in love, and she often modeled for his nude watercolors and paintings. Pascin rented an apartment and studio a few years later on rue Joseph Bara in Montparnasse, the same building that housed the artist Moïse Kisling and the dealer Zborowski. The poet Salmon and the Norwegian artist Per Krohg lived on the same block. Krohg's wife, Lucy, would become Pascin's mistress in the 1920s.

When world war erupted in 1914, antagonizing alliances trapped Pascin. The government of Bulgaria, the land in which he was born but of which he knew little, was sympathetic to and would eventually join the Central Powers—the Ottoman empire, the Austro-Hungarian empire and Germany—the enemies of France. Pascin would be regarded as an enemy alien in Paris. So he fled to England, where he took the *Lusitania* ocean liner to New York.

The extroverted Pascin soon befriended Alfred Stieglitz, the photographer and gallery owner, who had helped organize the Armory show that included some of Pascin's work. Stieglitz suggested that he become an American citizen. Pascin remained away from Paris for six years, long enough to become a naturalized citizen of the United States, marry Hermine after she joined him in New York and travel extensively in the United States and Cuba.

Pascin and Hermine returned to Paris in October 1920, a month after he received his American citizenship papers. Pascin also returned to his role as the life of the parties in Montparnasse and Montmartre. Aside from his *bombes,* he liked to organize masquerade balls. Many photos of the era show Pascin, his derby at a jaunty angle, sitting at a table in a Montparnasse café drawing on a sketch pad. Friends organized a party for him at the Dagorno steak restaurant in 1925 on his fortieth birthday, presenting him with a golden derby. Thora Dardel, best known as the Swedish art student who sat for the last portrait painted by Modigliani, wrote an account of the party. "The small but noisy dinner party went on for a long time," she said. "Pascin himself seemed a little sad. Why? He said that he was getting old. The rest of us laughed, because for some of us, Pascin had always been old."

Pascin was a prolific producer of drawings, watercolors and oil paintings, and he sold well in the 1920s. The drawings were usually observant or satiric street scenes, the kind that *Simplicissimuss* liked. The watercolors and paintings had a shimmering, subdued look with weary, full-bodied women languishing almost completely nude on beds and sofas. A dark desperation hovered over his canvases. Though the palette was light, the mood was bleak, as if he were a Toulouse-Lautrec or a Degas exploring the brothels of Paris. Yet his scenes were not realistic, for the women were not prostitutes but lovers and professional models.

Pascin was a favorite of the contemporary art world. Even while back in Paris, his paintings sold at solo exhibitions in New York. André Warnod, the critic who first publicized the School of Paris, said that the work of Pascin, "due to its uneasy and perceptive sensitivity, due to its intellectuality, becomes a tremendous synthesis of our present era." Dr. Barnes heaped even more praise in the stilted prose of his book *The Art in Painting:* "In his sense for the compositional relation of masses, . . . Pascin ranks with the greatest of contemporary

painters." Barnes noted the shimmering: Pascin's outstanding characteristic, Barnes said, was "a short and wavy line which, in most of his work, evokes a sense of drama and a feeling of extremely animated movement." Barnes also noted the lightness of palette: "the lightness and freshness of his color contribute a quality of pastel which heightens the pervasive delicacy of all his work in oil." Just as in Goya and Daumier, Barnes went on, "we find illustration [by Pascin] brought to such a high level that it becomes great art."

Although Pascin was a philanderer, he had two great loves: his wife, Hermine, and Lucy Krohg. Yves Kobry, a French art historian, recently tried to contrast the two women. He described Hermine as "the neurotic intellectual, melancholic, a painter as well, who he [Pascin] was never able to decide to abandon." Lucy, Korby went on, "was the sensual muse that he left and rejoined again and again, indispensable to his inspiration, to his equilibrium, even to his life." In later years, Hermine lived in the Monparnasse apartment while Pascin lived in his Montmartre studio. He tried to persuade Lucy to leave her husband and son, but she refused. Yet she could never end their affair.

By 1930, Pascin was ill. According to one account, his doctor informed him that he had syphilis with little hope of recovery. Another report claimed he suffered from cirrhosis. In late May or early June, he sent Lucy a note that ended "You are too good. It is necessary that I take myself away so that you be happy. Adieu! Adieu!" On June 2, he slit his wrists and wrote a message in blood on the wall of his studio. "Adieu Lucy," it said. When the cut wrists did not kill him, he found electrical wire and hanged himself. He was 45 years old. "He did not die like a prince," Salmon said years later. "He died like people do in sentimental novels."

The galleries of Paris closed on the day of the funeral. Hermine, the widow, rode in a car with a rabbi. Everyone else walked in a long

procession to the cemetery at Saint-Ouen. Per Krohg walked at the side of his wife, Lucy. Pascin left his bank account, his belongings, his paintings and watercolors and drawings to both Hermine and Lucy. Lucy later opened a shop to sell Pascin's works; she also sold Hermine's paintings and etchings. Pascin's suicide darkened the mood of the School of Paris, but it was only the beginning of the awful 1930s.

THE PORTRAITS OF ZBOROWSKI by Modigliani and others always made the art dealer look saintly, ethereal, poetic. He seemed self-less as he nurtured Modigliani and Soutine and others, pleading for funds from Jonas Netter to keep them alive and hopeful. By 1929, however, Zbo had grown resentful that Netter had profited so much from the arrangement.

The financial brouhaha that cost Zbo Netter's support centered on an agreement covering the work of Isaac Antcher who liked to paint landscapes somewhat in the Barbizon tradition. Netter and Zbo had agreed that they would each contribute 1,000 francs a month for Antcher's support, and each would take two paintings by the artist each month.

But Zbo decided to contribute only 200 francs a month for the artist's support while still keeping two paintings for himself. He justified this by telling the 20-year-old Antcher that Netter's avarice had grown insufferable. Antcher, however, was sure Zbo was trying to make up for his business mismanagement. "He lacked order in his affairs," the painter said of Zbo years later, "but unfortunately his shortcomings always hurt others. . . . But he did this with so much elegance that he ended up charming his victims."

Netter discovered the fraud a year later and was not charmed. He sent Zbo a letter in December 1930 demanding 24 paintings and reimbursement for the fact that he had paid half of 2,000 francs a month when he should have paid only half of 1,200 francs. That

ended the long partnership between the Polish dealer and the French businessman.

The loss of income was not made up by the sale of Soutine paintings, since Soutine had slipped away into the embrace of his new friends, Marcellin and Madeleine Castaing, who purchased almost everything he produced. This was a great monetary loss but not a real personal loss to Zborowski, as he and Soutine had never been friends. Zbo took Soutine on at first only at Modigliani's insistence, and, though the discovery of Soutine by Dr. Barnes had enriched both and pulled them closer, the erratic Soutine—by moody turns from timidity to anger—always got in the way of friendship. Soutine, moreover, often felt that Zbo was mocking him. Yet he still owed the dealer much. "Although he was nasty to me and I did not like him," Soutine acknowledged years afterward, "I would not have accomplished my work without his help."

Zborowski considered filing some kind of lawsuit against the Castaings for stealing Soutine from his gallery but never did so. He collapsed and died of a heart attack in March 1932 at the age of 43. His entire collection of paintings was sold to settle his large number of debts. He was buried in a pauper's graveyard.

FROM 1918 UNTIL 1939, the dealer René Gimpel kept a diary about the French art scene that filled 22 large notebooks. Since most of Soutine's paintings were handled by Zborowski and later Marcellin and Madeleine Castaing, Gimpel sold only a few of Soutine's canvases, but he was a great admirer of the artist and referred to him fairly often in the diary.

Most references add colorful bits of information about Soutine. Gimpel, for example, liked to list the sales prices of paintings. This data showed that, despite all the acclaim over Dr. Barnes's discovery of Soutine, his paintings in 1926 earned no more than one tenth the price of a painting by the Impressionist Claude Monet.

The diary includes two vivid descriptions of Soutine in his early and mid-thirties. In 1926, when he met Soutine for the first time, Gimpel wrote: "He is small, sturdy, with a thick crop of hair whirling round his head. He has deep, round hooded eyes; they are of hard stone. Zborowsky told me he's a man in torment. He paints a great deal, but he will suddenly slash the canvas, tear at it, like one possessed."

Three years later, when he met Soutine for the second time, Gimpel added another word portrait into his notebook: "A clumsy man. A singsong voice rising from deep to shrill. The flattened face of a muzhik [Russian peasant]; his nose comes out in a rectangular cube and his nostrils move like wings; large sensual lips that speak as fish breathe out of water, with the same rapid tragic beating. He seems always to be looking into the air, the way large dogs do."

The most significant entry about Soutine came in 1938, when the dealer found the painter in an expansive mood. Soutine talked a good deal about what he thought of other painters. It's the best picture we have of Soutine's view of the world of art. Gimpel called on Soutine in his comfortable apartment on the street known as the Villa Seurat. His patrons, the Castaings, were there.

"Soutine understands nothing of modern art; he considers a Picasso pretty much a swindle; cubism means nothing, it's cerebral, can give no joy," Gimpel wrote. "Yes, Picasso knows how to draw, but Ingres drew better. The best painter is Matisse." Soutine praised Courbet and Corot but said, "Ah, the giant is Rembrandt. He's a god, he's god." Gimpel said that "for him, Rembrandt is the idol, excelling all painters. Velázquez is nothing beside him." Soutine insisted, Gimpel went on, that Rembrandt's "The Betrothed Jewish Maiden" "is probably the most beautiful canvas in existence, with its penetrating study of the clothing, and the hands, which are so beautiful."

"A painter who doesn't move me is Cézanne," said Soutine. "It's over, I've passed that stage; I believed in him. I don't think that a

great deal of him will survive in fifty years' time, he's too studied, too fastidious, difficult, too cerebral."

Gimpel, an Alsatian Jew, died in a German concentration camp toward the end of World War II. Excerpts from the diary were published after the war.

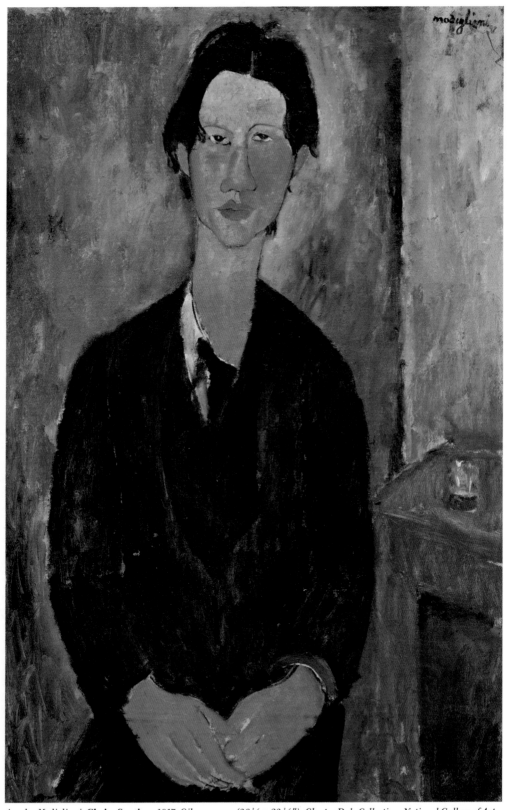

Amedeo Modigliani, **Chaim Soutine,** *1917. Oil on canvas (36 ⅛ × 23 ½"). Chester Dale Collection, National Gallery of Art.*

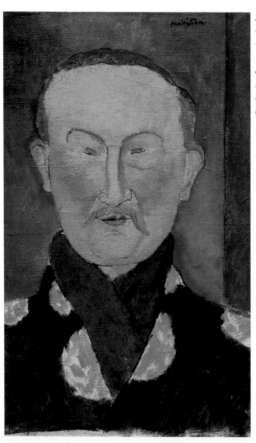

Amedeo Modigliani, **Léon Bakst,** *1917.*
Oil on canvas (21 ¾ × 13"). Chester Dale
Collection, National Gallery of Art.
* Bakst, a spectacular set and costume*
designer for the Ballets Russes of Serge
Diaghilev in Paris, was Marc Chagall's
teacher in St. Petersburg; Chagall followed
him to Paris.

Amedeo Modigliani, **Nude On a Blue**
Cushion, *1917. Oil on linen (25 ¾*
× 39 ¾"). Chester Dale Collection.
National Gallery of Art.

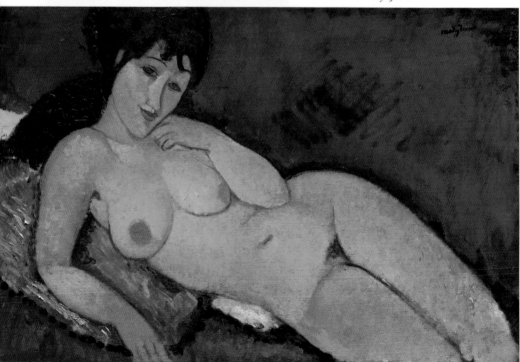

Chaim Soutine, **Le Pâtissier (The Pastry Chef aka Baker Boy),** *1919. Oil on canvas (26 × 20 ¹⁄₁₆"). The Barnes Foundation.*

This painting, which Dr. Albert Barnes noticed by chance, led to his discovery of Soutine and his realization that most of the best young artists of France were immigrants.

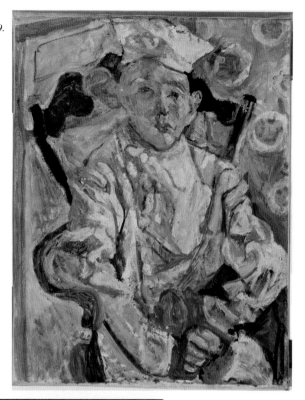

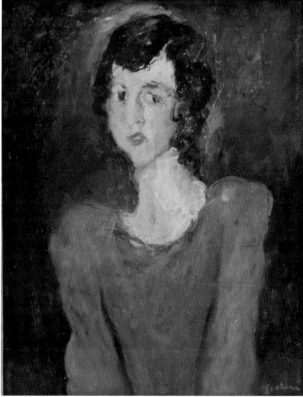

Chaim Soutine, **Woman In Red,** *1927–1930. Oil on canvas (25 ⁹⁄₁₆ × 19 ¾"). Louis E. Stern Collection, Philadelphia Museum of Art.*

This painting of an unidentified woman is, in many ways, a typical Soutine portrait of his mature years. The women's features betray wariness, apprehension, even fright.

Chaim Soutine, **Madeleine Castaing,**
1930. Oil on canvas (39 ⅛ × 28 ¾").
The Metropolitan Museum of Art.
 Madame Castaing was a great
friend and patron of Soutine.

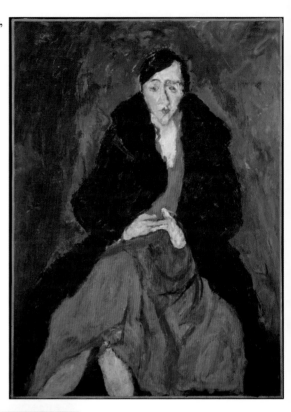

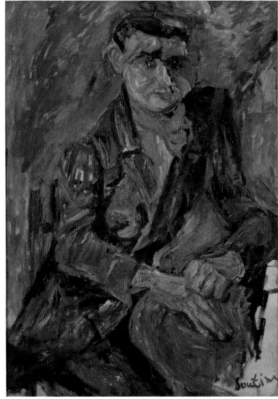

Chaim Soutine, **Portrait of Moïse
Kisling,** *1930. Oil on cardboard on
Masonite (39 × 27 ¼"). Philadelphia
Museum of Art.*
 *Although little known these days,
Kisling was regarded as one of the
leading painters of the School of Paris
in the 1920s and 1930s. Like Chagall,
he escaped to the United States during
World War II.*

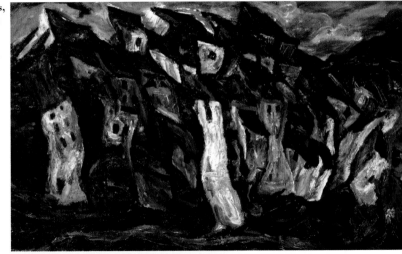

Chaim Soutine, **Houses,**
*1920–21. Oil on canvas
(22 ⅞ × 36 ¼"). Musée
de l'Orangerie, Paris.
Bridgeman-Giraudon/
Art Resource, NY.*
 *In one of his most
remarkable landscapes,
Soutine painted the
houses of Céret as
animate.*

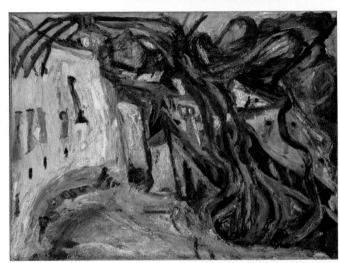

Chaim Soutine,
Landscape, Céret *1922.
Oil on canvas (26 ¼ ×
35 ¾"). Philadelphia
Museum of Art.*
 *As a young man,
Soutine spent three years
in this town near the
Pyrenees.*

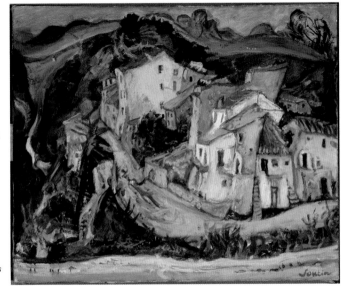

Chaim Soutine, **View of
Cagnes,** *1924–25. Oil on
canvas (23 ¾ × 28 ⅞").
The Metropolitan Museum
of Art, New York.*
 *At the suggestion
of his dealer, Soutine
sometimes painted in
the village of Cagnes
just outside Nice on the
French Riviera. But he
did not like to paint the
seaside, preferring the
French countryside with its
luxuriant trees.*

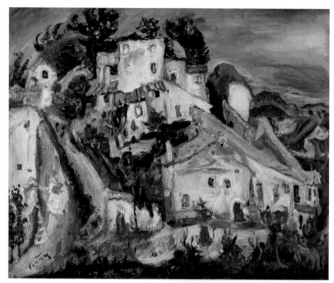

Chaim Soutine, **Landscape, Chemin des Caucours, Cagnes-sur-Mer,** *1924. Oil on canvas (21 ⅛ × 25 ½"). Philadelphia Museum of Art, Louis E. Stern Collection.*

Chaim Soutine, **Beef,** *1925. Oil on canvas (65 ⅜ × 45 ¼"). Stedelijk Museum, Amsterdam. Bridgeman-Giraudon/Art Resource, NY.*

Soutine was obsessed by the Rembrandt painting in the Louvre The Flayed Beef. *He was determined to create, in his own style, a masterpiece that would emulate and honor Rembrandt. Soutine painted a series of paintings of beef carcasses. This is one of the finest.*

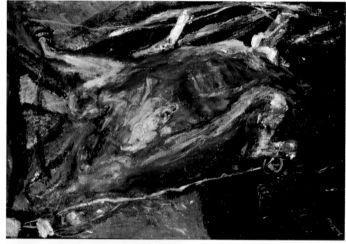

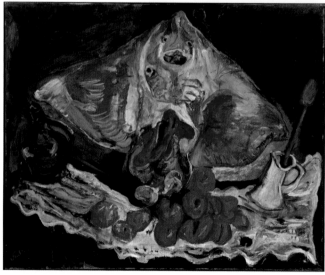

Chaim Soutine, **The Ray,** *1924. Oil on canvas (32 × 39 ⅜"). The Metropolitan Museum of Art, New York.*

This painting is an adaptation by Soutine of another of his favorite paintings in the Louvre, The Rayfish *by Jean Siméon Chardin.*

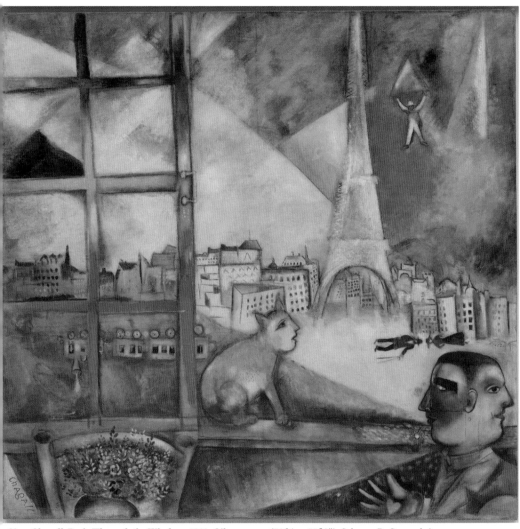

Marc Chagall, **Paris Through the Window,** *1913. Oil on canvas (53 9/16 × 55 7/8"). Solomon R. Guggenheim Museum, New York. Solomon R. Guggenheim Founding Collection, by gift. Art Resource, NY. © 2015 Artists Rights Society (ARS), New York/ADAGP, Paris.*

Chagall painted this from his apartment in La Ruche (the Beehive), the Paris residence for young artists. He actually could not see the Eiffel Tower from his window.

Marc Chagall, **Over Vitebsk,** *1915–1920 (after a painting of 1914). Oil on canvas (26 ⅜ × 36 ½"). Museum of Modern Art, New York. SCALA/Art Resource, NY. © 2015 Artists Rights Society (ARS), New York/ADAGP, Paris.*

 Chagall was trapped in Russia at the outbreak of World War I and remained there after the overthrow of the Czar and the Communist seizure of power. By the time he returned to Paris in 1923 he had developed a new style—his symbolic rendering of the life and traditions of shtetls like his own Vitebsk.

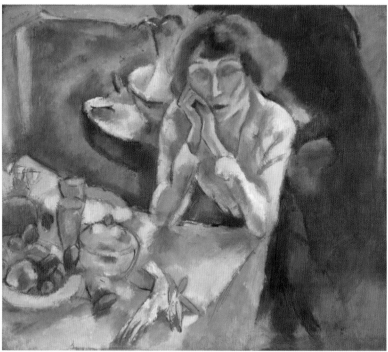

Jules Pascin, **Portrait of Madame Pascin** *(Hermine David), 1915–1916. Oil on canvas (21 × 24"). Philadelphia Museum of Art.*

 The Bulgarian-born Pascin was regarded as a leader of the social life of Montparnasse during his brief lifetime. Though his work was well known between the two world wars, he is largely a forgotten artist today.

ΠΙΠΣ

**IDYLL, MADELEINE AND MARCELLIN
AND THE PORTRAIT**

THE 1930S PRODUCED AWFUL, TENSE, ANXIOUS TIMES
for Europe, an era of rot and nationalist vitriol and hatred and in-
creasing poverty that brought forth another world war, the worst in
history. Yet many could not feel the fears and tremors around them.
Many French could not. Chaim Soutine certainly could not.

Soutine, in fact, spent much of the 1930s at peace in a wonder-
ful idyll, a long interlude of romantic if platonic love, a time when a
beautiful patroness and her lord pampered and protected him, when
she offered him space to work and then bought all that he produced.
The patroness, Madeleine Castaing, was a young, wealthy woman,
blessed with warmth and sensitivity and intelligence and vitality,
who wanted to fill her life with meaning and culture and, according
to her biographer, forget the humiliation caused by the philandering
of her older husband. She gave Soutine great calm.

Marie-Madeleine Magistry, a year younger than Soutine, was
born on December 19, 1894, in the town of Chartres, 60 miles

southwest of Paris. The town is best known for its cathedral, one of the finest achievements of Gothic art. Her father was a Paris engineer on assignment to oversee the restoration of the railroad station in the town. The area was home to her mother, whose family owned an estate in the village of Saint-Prest just outside Chartres. The patriarch of the family, Madeleine's grandfather, was a well-known publisher who was one of the founders of the popular daily newspaper *La Presse* and of the Havas news agency, which later became Agence France Presse, the French news agency.

Madeleine attended a boarding school in Chartres run by the White Sisters of the Sacred Heart and met the tall, blond, handsome Marcellin Castaing on a train while on a school vacation with her mother in southwest France. They were married five years later in February 1915 in the village of Saint-Prest. Madeleine was 20 years old; Marcellin, 34.

The Castaing family lived in the city of Toulouse in southwest France, not far from the Pyrenees, the mountainous border with Spain. The family derived its wealth from holdings in real estate and vineyards in the area. Marcellin had decided on a political career of some kind, and he followed the usual route in France, by entering the government's administrative system. Soon after the marriage, he was assigned as an assistant to the prefect of Nancy, a town in northeastern France. But Madeleine, after the birth of two sons, found the town lackluster and boring. The first volume of Marcel Proust's *In Search of Lost Time* had been published a couple of years earlier, and young Madeleine, enchanted by the magnificent book, longed for a life close to art and music and literature. She even took to calling her husband Marcel in tribute to the author.

The young wife persuaded her husband to give up his career in public administration and politics and through family connections to take up a post as the new literary and drama critic in Paris of the magazine *Floréal*. Marcellin did not seem to mind the turnabout. He

did not live off his work in any case; family wealth kept him and Madeleine in high style. Some friends looked on him as lazy. Madeleine smiled and described him years later as someone "who never lost a minute—to lie down and rest." But he obviously enjoyed satisfying the whims of his wife.

The Castaings entered the life of Montparnasse in the early 1920s in their own way. They did not even live in Montparnasse but in the elegant 16th Arrondissement on the Right Bank where their chauffeur and cook were not out of place. They did not set up a salon like Gertrude Stein. Nor did they join the *bombes* of Jules Pascin. They enjoyed a drink at the terraces of the Dôme and the Rotonde, but they were not habitues of these cafés. They began an art collection, but they did not try to buy paintings by everyone from Picasso to Pascin. They accepted invitations, of course. Picasso and his future wife, Olga, invited them to dinner at home. The painter pronounced Madeleine "the most attractive woman in Paris."

The Castaing approach to the cultural world of Paris was different from the approach of most others. The Castaings liked to focus on an individual, take him in, wine and dine him, listen to his stories, discuss the world of literature and art for hours on end. Their first significant find was Blaise Cendrars, the poet, playwright and critic who knew most of the artists in the School of Paris. He had once been the close friend of Chagall, but their relationship had cooled. Although Swiss, a citizen of a neutral nation in the world war, Cendrars had fought with the French and lost an arm. He wanted to make a movie version of *Madame Bovary* starring Madeleine in a screenplay written by Cendrars and Marcellin. "You will be the Mary Pickford of the French," Cendrars told Madeleine. But the project was abandoned when Flaubert's niece, who still had the rights, refused to approve it. Frequent guests at the Castaings' home also included the composer Erik Satie and the sculptor Constantin Brancusi. A lesser find was the strange, second-rate novelist and great gossip Maurice

Sachs, who liked to examine the Castaings as closely as they examined him. And, of course, there was Soutine.

One dark cloud hovered over the marriage. Madeleine began to suspect Marcellin of a penchant for amorous adventuring. She hired a private detective who confirmed her suspicions. Marcellin had liaisons with prostitutes and mistresses. On one occasion, armed with an address from the detective, she replaced a prostitute in a hotel room and shocked Marcellin when he opened the door for the assignation. Her biographer, Jean-Noël Liaut, believes Marcellin's Paris womanizing convinced Madeleine to move back to the countryside.

They bought and renovated an old, 4,000-square-foot mansion that had been used in the past as the summer residence for the bishops of Chartres. The house stood on 14 acres of land crossed by a river in Lèves just outside Chartres. But the separation from Paris was too limiting for Madeleine, and in any case life in the countryside had failed to cure Marcellin of his infidelities. The family returned to Paris after five years, moving this time into an elegant house—what the French call a hôtel—on the rue de Grenelle on the Left Bank of the Seine in striking distance of Montparnasse. From 1933 onward they resided in Paris with frequent weekend and vacation excursions to Lèves.

The long relationship between the Castaings and Soutine had a difficult beginning. Another artist, Pierre Brune, introduced them to Soutine at the Rotonde one evening. After they described themselves as collectors, Soutine agreed to meet them for dinner the next evening. They waited at the restaurant for several hours, but he did not show up. Later, after dinner, they found him walking in the street with two large canvases under his arm. Marcellin told Soutine they really were interested in seeing his paintings but no longer had the time to do so that night. Marcellin then handed Soutine a 100-franc note as a kind of deposit for what they intended to buy once they looked at his works in full. Soutine, irate, put the canvases down, threw away the note,

picked up the canvases and walked away. Handing him money before seeing any of his paintings was a form of charity, which he would not accept. He had no intention now of showing them his paintings.

In 1927, three years later, while browsing a gallery, Madeleine found a Soutine, a still life called "Dead Chicken with Tomatoes," that she felt she must have. By then the Castaings had assembled a small collection of works by Modigliani, Matisse, Picasso, Utrillo, Rouault, Juan Gris, Fernand Léger and André Derain. But the Soutine, though on display, was not for sale; it was owned by the novelist Francis Carco. Carco could not withstand Madeleine's pleas and finally agreed to give up the Soutine in exchange for a Derain. The Castaings owned their first Soutine.

Madeleine became obsessed with finding more Soutines and turned up in every Paris gallery looking for them. Word of her interest spread, and Zborowski soon phoned Marcellin with an offer. Soutine had just painted a portrait of a choir boy, which Marcellin could have for 30,000 francs (or $1,200 at the exchange rate in 1927, the equivalent, when adjusted for inflation, of 18,000 euros or $23,000 in 2011.) That was an enormous price for a painting in those days.

"We went to Zborowski's shop," Madeleine recalled in an interview more than a half century later, "and he showed us the wonderful portrait of the choir boy. My husband wrote out the check immediately, and we were very, very pleased to take the painting back with us."

The ease with which the Castaings paid so much for the painting redeemed them in Soutine's eyes. He was now ready to spend time with them. "A few days later, we made an appointment to meet Soutine at his atelier," Madeleine went on. "We arrived at six in the afternoon and talked with him until two in the morning. He asked if he could paint my portrait. I was flattered and, of course, agreed."

A remarkable and incredibly calm relationship developed that lasted more than a decade, wiped out only by the cruelty of war.

Soutine received undemanding loyalty from his new patrons. They, in turn, basked in the excitement of their new relationship to a great artist they admired without any doubts. While in Paris, they often accompanied him to the Louvre to hear his praise of Rembrandt and Courbet. Soutine was charmed by their wealth and admiration and enjoyed complete access to their country home. He loved to paint there and found exciting new subjects in and near Chartres. The Castaings learned never to interfere or even comment on his work, and he felt confident enough to sell all his paintings to them to keep or market. In fact, he gave Marcellin a new vocation as the part-time dealer in the work of a single artist of the School of Paris. There is a wonderful photo from this era of Soutine and Madeleine smiling happily not at the camera but at each other. Soutine, looking rather sporty in a fedora and a sweater, never looked happier in a photograph.

Maurice Sachs, the novelist, visited the Castaings' country home several times in the early 1930s and published indelible word portraits of the trio. He said that Madeleine "looked perhaps twenty-eight, though she had sons over fifteen; tiny, slender, vivacious, playful, her eyes black, her skin pale, her hair dark." He added more adjectives—"subtle, prejudiced, coquettish, chaotic, stubborn"— and said "she had a kind of creative genius for everything that had to do with houses." She "had made a dwelling full of whimsicality, invention and audacity," he went on, "and on the fallow land that surrounded it, she had produced a splendid little park that seemed to have been there always."

It was obvious that Madeleine was the mainstay of the relationship with Soutine, for she told Sachs that she "imagined happiness only by a succession of restrictions that permitted her to focus on a few persons or works the accumulated force of [her] feelings." Sachs called this "a reasoning quite astute in itself, but which she carried out to such extremes that I have never seen a comparable example."

As a result, Sachs said, "she was quite mad" about her husband, had only one friend (whom he did not identify), read Proust and Chateaubriand and little else and possessed only "one admiration in painting": Soutine. "She told me that was the way to savor people and things," Sachs concluded, "and almost managed to convince me of it."

Sachs pictured Marcellin as a rich man with little to do. "So here was a serious man, conscientious to a remarkable degree, without a serious object in life," the novelist wrote. "Consequently he decided to organize his leisure; he learned every game, and became the master of all of them: billiards, chess, cards, dominoes—everything served his skill. He developed a passion for Zola, read, reread, searched out his themes, studied his style, filled several notebooks with comments, locked them in a trunk and never mentioned him again. . . . Then he turned to detective stories; he read two a day, a Sherlock Holmes pipe in his teeth, until there was none left whose solution he hadn't divined by the tenth page."

Since leisure loses its charm, Sachs went on, Marcellin took up tennis, going so far as to make notes to himself when a thought about improving his game struck him at dinner. Sachs only alluded to one significant activity: Marcellin had become the exclusive dealer of Soutine, buying everything the painter finished, then selling what he did not want to keep for his collection. But Sachs did make clear that Marcellin discussed art "with the weight of an authority so evident that no one has ever questioned it, for painting to him is more than a pleasure, it is an enlightened passion, and it is by means of painting that my philosopher with his tennis rackets, his pipes and his detective stories, represents a treasury of wisdom and knowledge."

Sachs met Soutine at the Castaing home only twice. "I was moved by his gentle, wild expression," Sachs wrote. "He was, when I met him, a pale man of perhaps thirty-five, his flat, south-Russian face crowned with long, smooth black hair. He had both the nobility

and the hunted look of certain proud animals, horrified by the sound of a human footstep, but renouncing neither their secret laws nor the pride of their race.

"I had the greatest admiration for Soutine," Sachs said. "In the Castaings' home I saw his best work, and the more I saw the more I was convinced that Soutine was one of the only serious painters of our times and the one whose work would best sustain comparison with the masters of Impressionism." But Soutine did not say a word to Sachs on their first meeting and exchanged only a few words on their second. Sachs concluded that "my admiration embarrassed him."

Soutine would phone from Paris and announce, "Send the chauffeur. I'm arriving." The Castaings would dispatch their car and chauffeur to his apartment. He sometimes arrived uninvited and unheralded, but that did not bother the couple. Soutine was always welcome. In fact, they encouraged him to use the house and grounds even when they were away.

Clarisse Nicoïdski, a French biographer of Soutine, wrote that he seemed fascinated by "the beauty and authority" of Madeleine. He enjoyed taking long walks with her. He sometimes even accompanied her to mass at the cathedral in Chartres. They discussed the novels of Balzac, Michelet's *History of France* and the poetry of Baudelaire and Mallarmé. (She obviously read more literature that Sachs believed.) Soutine persuaded her to use a fiery red lipstick. Their closeness, their rapport, their ease has raised questions about their intimacy. But in later years Madeleine always denied that they had ever been lovers, although she acknowledged that it was possible Soutine had been in love with her. Despite an adulterous husband, she intended to keep her marriage whole. It was the source of her wealth, her collection of art, the fulfillment of her obsessions and her standing in the world of art.

Soutine often painted while staying in the country home. Marcellin found him working on a landscape one day and foolishly remarked that it reminded him of a new Renoir that he had seen recently in Paris. A furious Soutine pulled out a pocket knife and cut the unfinished canvas to shreds. It was a resounding lesson. From then on, the Castaings stayed far from Soutine and offered no comment while he worked.

The Castaing monopoly had diminished profits for Léopold Zborowski and Paul Guillaume. Zbo had been Soutine's dealer while Guillaume had arranged to show some of Soutine's work at his upscale gallery on the Right Bank. Zbo and Guillaume had threatened a lawsuit of some kind, and Guillaume showed up at the Castaing country home one day and proposed that the Castaings share some of the profits with his former dealers. Madeleine rejected the proposal completely. This incited Guillaume to spread rumors in Paris that the Castaings, after Madeleine seduced Soutine, detained the artist and forced him to paint only for them. The rumors received little credit, but the threat of a lawsuit remained until Zbo died in 1932 and Guillaume killed himself in 1936.

IN JANUARY AND FEBRUARY 1988, when she was 93 years old, I met with Madame Castaing on two occasions to discuss Soutine. We talked in her apartment next door to her fashionable antiques shop at the corner of rues Bonaparte and Jacob on the Left Bank of the Seine. Our first session was kind of introductory, the second more formal.

She had obviously worked at her appearance for the more formal session. She sat opposite me in a high chair that raised her level over mine, as if she sat on a throne. She wore red and black just as she did in the famous portrait of her now at the Metropolitan Museum of Art in New York, but she didn't try to mimic herself. She wore a red dress and black ocelot coat then; now she wore black tights and a

red wool coat. Her hair was not gray but a light brown. She still wore the fiery red lipstick that Soutine had favored. She had painted little black specks around her eyes, a trick that somehow made them seem youthful and vivacious.

There were many Soutines in the apartment. I noticed mostly the pulsating landscapes, more subdued than his younger violent landscapes, and his variation on Rembrandt's painting of "A Woman Bathing in a Stream," a prize holding of the National Gallery in London. Soutine made no attempt to capture the delicacy and beauty of Rembrandt's model. Soutine's woman was heavy and ugly and splashing through the water on thick legs.

"Soutine is a great painter," Madame Castaing said, "and he will someday take his rightful place. Modigliani said he was the greatest painter of the twentieth century. He comes out of a great tradition and belongs with painters like El Greco, like Cézanne. The Orangerie has very few good paintings. The Barnes Collection is abominable. These are paintings from his youth. When Soutine found his paintings of these years, he would rip them up. The great Soutines are the paintings of his maturity. My collection has many mature Soutines. I believe it is the greatest of all the collections of Soutine."

Madame Castaing's assessment was self-serving. I don't know of any art critic or art historian who would agree with her, although perhaps Soutine would have. There is no doubt that he did buy earlier paintings and either destroy them or attempt to improve them. But we do not know whether he was disappointed in many of the earlier canvases or just a few of them.

But all retrospective exhibitions of Soutine's lifetime have always depended heavily on the early paintings to demonstrate his mastery, innovation, excitement and unique flair. In the retrospective at the Orangerie in Paris in the fall of 2012 and winter of 2013, only 7 of the 62 paintings in the show were dated 1930 or later. And this was not due to the fact that Paul Guillaume's collection of early Soutines is

on permanent display at the Orangerie. Two-thirds of the retrospective's paintings came from elsewhere.

The best-known Soutines are the early paintings. A French postal stamp issued as a tribute to him in 2013 featured a landscape painted in 1922 or 1923. "Le Petit Patissier," which received the highest auction price ever for a Soutine, was painted in 1927. This work, which the auction house Christie's sold in New York for $16 million in 2013, was bought by the Castaings soon after they befriended Soutine.

There is no doubt that Soutine's paintings changed somewhat during the 1930s and early 1940s. One obvious change was that he simply did not paint as much. There were few all-day painting binges like the ones he forced on himself in Cerét. Soutine was now relatively well off, able to devote a few days to a single canvas, able, in fact, to spend time walking in the countryside with Madeleine Castaing between his assaults on canvas. In another obvious change, Soutine lost interest in his still-life paintings of butchered carcasses of beef and poultry. Instead he painted a few unimportant pastorals of live pigs, horses and donkeys.

The most significant shift in his approach to painting manifested itself in his landscapes. He now tried to fashion some kind of order to the wildness and fury of his canvases. He did so by concentrating on a tree or house or wall that stood fast in the turmoil. The compilers of his catalogue raisonné believe that he had been seduced by his experience with a new world of wealth and that its symbols now figured in his landscapes.

"The country homes, painted at or around the estate of his patrons, the Castaings, were symbols of a way of life, culture, and status to which he aspired," art historians Maurice Tuchman and Esti Dunow write in the introduction to their catalogue raisonné of the known works of Soutine. "His acceptance by the Castaings represented a larger acceptance and favor by the French upper class. Such approval was no small matter to Soutine. Similarly, Chartres

Cathedral provided a complicated emotional charge for him, a Jew from the shtetl, as a Christian religious symbol and as a monument to the French tradition—historically and artistically."

His new approach lost the sheer madness of the earlier landscapes and the churning rivulets of color that excited the abstract expressionists many years later. But he still fashioned animated canvases. These late landscapes were not gentle samples of representational art. The walls of Soutine's Chartres Cathedral pulsated with life. So did the massive trees that he painted again and again.

Soutine experimented a bit with his later portraits. He sometimes sketched in some detail—perhaps a door or a gate—to give the models some context. He also occasionally painted two figures in the same scene. But, in general, a Soutine portrait remained the same—a mysterious interchange of the tensions and turmoil of the painter and his model.

During our meetings, Madame Castaing brought up the portraits of herself. "Soutine told me when he painted me, 'You will never grow old,'" she said. What should be made of this portrait painter's cliché? The lithe and seductive Madame X, as far as the rest of the world can tell, will always remain the age when John Singer Sargent painted her. But Madame Castaing? The case is more complicated.

Soutine painted her three times in 1929, when she was 35 years old. The best known is the portrait that now hangs in the Metropolitan Museum of Art in New York. The evidence indicates that she looked younger than her years in those days, that Picasso complimented her beauty, that Cendrars thought she could be turned into France's "sweetheart" in the movies, that she was vivacious and brimming in youthful smiles. But that is not what Soutine painted.

Soutine's Madame Castaing looks like a stiff society lady approaching 50, her eyes troubled, her nose bent, her lips pursed. She looks haughty, authoritarian, saddened, anxious. It is hard to find beauty there or even warmth. Was Soutine trying to find all the

swirling sadness and trouble behind her joyful facade? Or was he predicting what might become of her in another decade and a half? Was he portraying what he thought she would be like? Madame Castaing knew the work of Soutine well enough not to expect a flattering portrait. But it is probably telling that none of the three portraits remained in the family collection at the time of our interviews.

TEN

CHARLES MAURRAS,
LÉON BLUM AND THE RESURGENCE
OF ANTI-SEMITISM

FOR A QUARTER OF A CENTURY AFTER THE END OF THE
Dreyfus affair in1906, anti-Semitism lost a good deal of its potency
in France. That did not mean that the main spewers of hate turned
themselves off. But few French listened anymore. Most had grown
weary of the incessant and enervating battling of the Dreyfus days.
Anti-Semitism was no longer a major factor in state policy. But all
that changed in the 1930s. The power and influence of the haters
seeped back and laid the groundwork for a Vichy government that
would eagerly help the Nazi German occupiers destroy a quarter of
the Jewish population of more than 300,000.

In the 1930s, the situation was far different and far more danger-
ous than the harping by art critics over whether immigrant artists
in Paris should be regarded as French or foreign painters. The new
surge in hatred would eventually threaten the lives of Soutine, Cha-
gall and the other Jewish painters of the School of Paris. While the

haters condemned all Jews, they condemned foreign-born Jews even more. For the health and purity of French culture and the French state, these *métèques,* whether artists or doctors or shopkeepers or laborers, had to be packed up and deported.

Charles Maurras, one of the chief journalists from the Dreyfus days, attracted attention again in the 1930s for his continual stirring of sentiment against Jews. In the past he had been so extreme that he persisted even when the case against Dreyfus fell apart. After the army general staff unjustly and publicly accused Captain Alfred Dreyfus of treason in 1894, the generals realized they did not have evidence to back up the charge. So Major Hubert-Joseph Henry forged a document that identified the Jewish Dreyfus as a spy. A few years later the document was exposed as a forgery. Colonel Henry, after confessing that he had written it, committed suicide. Nevertheless, Maurras regarded Henry as a national hero.

Henry had tried to salvage the honor of the French army and that, in Maurras's view, was far more important than the fate of a hapless Jewish captain imprisoned on Devil's Island. According to Maurras, Henry's deed was a "patriotic forgery."

Addressing the dead Henry in an article in the newspaper *La Gazette de France,* Maurras wrote, "We were not able to give you the great funeral that your martyrdom deserved. We should have waved your bloody tunic and the sullied blades down the boulevards; marched the coffin, hoisted the mortuary banner like a black flag. It will be our shame not to have attempted as much. . . . In life as in death, you marched forward. Your unhappy forgery will be counted among your best acts of war."

Maurras, born in the provincial town of Aix-en-Provence and deaf from the age of 14, founded a daily newspaper and a political party with the same name, Action Française. He was a royalist hoping to bring the monarchy back to France, a right-wing opponent of the parliamentary democracy practiced in the French Republic and

an anti-Semite eager to use contempt for Jews as a weapon in his causes. "Everything seems impossible or frightfully difficult without the providence of anti-Semitism," he wrote. "Thanks to it, everything works out, everything is smoothed over and becomes simpler. If we were not anti-Semitic out of patriotic determination, we would become so out of a sense of opportunity." Of course, the fact that Maurras used anti-Semitism cynically did not make him any less than a wholehearted anti-Semite.

Maurras and others like him had their perfect foil in the 1930s, for the head of the French Socialist Party and the prime minister for a year, Léon Blum, was a Jew. Blum, born in Paris in 1872, was fully assimilated. His parents spoke only French at home, and he was educated in France's elite schools. Esteemed as an intellectual politician, he also had a lively side career as a literary critic. He was not religious, attending synagogue only for family events, but he did not hide his origin. When jeered as a Jew, he said, "I will repeat as many times as I must that I take pride in it and no one wounds me by recalling my origin."

Emulating Hitler in Germany and Mussolini in Italy, some of the extreme rightist parties organized what they called "leagues," gangs of young toughs ready, if needed, to "restore order" or "reestablish French power" or some other ominous goal. They had also been exhorted metaphorically to lynch Blum, slit his throat, shoot him in the back and treat him like human garbage.

On February 13, 1936, a car driving Blum from the National Assembly to his apartment on the Île Saint-Louis came upon a demonstration by the Action Française on the Boulevard Saint Germain. When the young toughs recognized the 64-year-old Blum with his telltale thick gray mustache, they pulled him from the car and began to beat him. As he was pummeled and kicked, some in the crowd cried out, "Death to the Jew." Two policemen finally rescued Blum and led him into a secluded courtyard of an apartment

building. After he was treated in a hospital, Blum declined to press charges.

When the leftist parties staged a protest demonstration, Maurras mocked the marchers as "escaped prisoners, jailbirds, criminal weaklings, real scum, dregs of the slums, from Russia, the half-wild Levant, in which the Jews and the wogs have no trouble standing out."

The right-wing violence frightened leftist politicians into setting aside their own differences and forging a new unity. The Communists, under instructions from Moscow, agreed to join the Socialists and the centrist Radical Party in a leftist coalition known as the Popular Front. It won the election in 1936 and put Blum forward as the new prime minister. As he took office, he was challenged in the National Assembly by Xavier Vallat, who would become commissioner-general for Jewish affairs in the Vichy government during World War II.

"Your accession to power, Mr. Prime Minister, incontestably marks an historic occasion," Vallat began. "For the first time, this old Gallo-Roman country is going to be headed by . . ."

The presiding officer tried to head him off. "Take care, Monsieur Vallat," he warned.

But Vallat went on. " . . . by a Jew. I dare say out loud what the country is thinking in its heart; it is better to place at the head of this country a man whose origins lie in its soil rather than a subtle Talmudist!"

Maurras derided Blum as "this old Semitic camel" and called for his assassination if he tried to get France to enter the Spanish Civil War on the side of the Spanish Republic that was fighting a rightist rebellion led by General Francisco Franco and supported by Italy and Germany. "It shall be necessary to eliminate Blum physically only on the day he leads us into the godless war he dreams of against our Italian comrades-in-arms," Maurras wrote. "On that day, it is true, he should not be spared." This threat against the prime minister broke

French law, and Maurras was jailed for eight months. Nevertheless, he still was considered respectable enough to be elected to the Académie Française.

In the continual shifting coalitions that were the hallmark of the French Republic of those days, prime ministers came and left in dizzying succession, and within a year Blum was replaced by a Radical. But Blum did achieve three major legislative victories—guaranteeing collective bargaining, a maximum of a 40-hour workweek and paid vacations—for which he is still revered in France. He returned as prime minister in 1938 but lasted only a month. (And after World War II he had a third turn as prime minister, again of only one month.)

In their authoritative book *Vichy France and the Jews,* Michael R. Marrus and Robert O. Paxton add other root causes for the revival of anti-Semitism that enabled the French Vichy government to deport Jews to death so easily. The first was the faltering economy. Although the depression came to France late, it remained longer and caused more damage than in other European countries. "Rather than a cataclysm, the French Depression was a long, slow rot," they write. It was easy to blame the loss of jobs on the numbers of foreigners in the country.

After World War I, France had encouraged the immigration of foreign labor to make up for its losses in the trenches. But the numbers of immigrants were augmented in the 1930s by Jewish refugees from Germany and by Spanish Republicans fleeing the victorious armies of General Franco. By the end of the 1930s, France had a higher proportion of foreign-born residents than any other country in the world, including the United States. The Jewish population was estimated at more than 300,000 in 1940, about half foreign born.

The numbers provoked fears that the refugees were stealing jobs from Frenchmen. Two newspapers proposed that Jewish immigrants train as miners, a livelihood that did not attract enough French workers.

There also was a fear that the Jewish immigrants would subvert and sully French culture. The critic Robert Brasillach insisted that had happened already in the movie and radio industries. "The movie business practically closed its doors to aryans," he wrote in 1942. "The radio had a Yiddish accent. The most peaceable people began to look askance at the kinky hair, the curved noses, which were extraordinarily abundant. All that is not polemic; it is history." The novelist Louis Ferdinand Céline also claimed that the Jews had already overrun French culture. "Messrs. Kikes, half-niggers, you are our gods," he wrote in 1937.

There was yet another fear: That Jewish refugees would pressure France into dangerous byways in foreign affairs. This fear was expressed by left-wing pacifists as well as right-wing anti-Semites. The philosopher Simone Weil wrote a deputy in the National Assembly that she would prefer German domination to another war even though that would mean "certain laws of exclusion against Jews and Communists." As the war began in 1939, a writer for a pacifist periodical said, "Surely we are not going to war over 100,000 Polish Jews." Rightists were just as indignant. During the negotiations with Hitler over Czechoslovakia before the war, Maurras's Action Française warned that "it is the Jews who are pulling the strings."

Anti-Semites felt they had ample evidence for Jewish interference in foreign affairs in 1938 when Herschel Grynzpan, a 17-year-old Jewish refugee from Germany, shot a German diplomat to death inside the German embassy in Paris. The assassination set off Kristallnacht in Germany, when Nazi troopers burned several hundred synagogues, killed scores of Jews and pillaged more than 7,500 Jewish-owned shops. The killing and the bloody reprisals came a few weeks after the Munich accords that were supposed to guarantee peace between Hitler and the alliance of Britain and France. Many French agreed with anti-Semites who declaimed that the Jews had endangered the security of France.

It was easy to make the Jews scapegoats for all the perceived ills of French society. "France's international weakness, its economic decline, its parliamentary disorder, its diminished sense of national purpose, its declining birthrate, its flagging bourgeois culture," wrote Marrus and Paxton, "—all could be attributed to the Jews, so notoriously not French yet so evidently in so many spheres of French activity."

Blaming Jews for French troubles was even easier, as we have seen, when a Jew was prime minister. A Catholic deputy, who insisted he was not an anti-Semite, said during the first Blum administration, "When one hears Léon Blum, so destructive, one understands the pogroms, and one must resist the temptation to hate the Jews."

French intellectuals joined in the anti-Jewish campaign, though usually with less strident tones. Jean Giraudoux, a celebrated playwright and novelist, was named commissioner of information in the last democratic government before the fall of France in World War II. After the war, his translated plays delighted Broadway. In the 1950s, New York playgoers, many of them Jewish, enjoyed *The Madwoman of Chaillot, Ondine* (starring a little-known young actress named Audrey Hepburn) and *Tiger at the Gates.* The audiences would have been, at the least, disconcerted and uneasy if they knew what Giraudoux had written about Jews 15 years before.

In a popular book published in 1939, Giraudoux paid tribute to France as a generous country long open to refugees and other immigrants. With open immigration halted in the United States and some of the British dominions, he said, France had become the number one civilized goal for the world's immigrants. Yet there were negative sides to this. "The foreigner abounds in France," he wrote. " . . . Our land has become a land of invasion."

The problem, according to Giraudoux, was that France lacked a system for selecting immigrants. As a result, it often failed to attract those who would assimilate French culture and even enrich it. He

cited "hundreds of thousands of Ashkenazis who have broken away from their Polish or Romanian ghettoes" as an example of undesirable immigrants. Yet they were already in France and would get their naturalization papers. Giraudoux went on that a Jew like Sigmund Freud, if he decided to immigrate and become French, would have to wait until the others received their papers first.

Giraudoux concluded that "the country can be saved only temporarily by armed frontiers; it can be definitively saved only by the French race, and we are fully in accord with Hitler for proclaiming that a policy attains its highest form only when it is racial." He proposed the formation of a ministry of race, presumably to select immigrants who would not harm the culture of the French race.

The torrent of anti-Semitic rhetoric in the 1930s often excepted from its attacks French-born, assimilated Jews. But there was almost never an exception for foreign-born Jews, no matter what their accomplishments. No profession, craft, association or union in France was as dominated by foreign-born Jews as the School of Paris.

The threatening mood agitated Chagall. He was not in the business of offering lessons in painting to amateurs, but in the mid-1930s he began teaching the wife of the British ambassador to Paris. According to his biographer, he gave the lessons "partly because he believed gentile friends were especially valuable in anti-Semitic times."

More significant, the mood of his paintings sometimes turned cold and forbidding. In 1938, he painted "White Crucifixion" with the Christ figure depicted not as the son of God but as a persecuted Jew wearing a Jewish prayer shawl over the lower part of his body. There are scenes of pogroms in Russia and of marauding, murderous storm troopers in Germany. Jewish figures fly above the cross and lament while frightened Jews, wearing clothes from the nineteenth and twentieth centuries and carrying a Torah and bags of possessions, scurry in panic and terror. This painting, now in the Chicago Art Institute, was pronounced by Pope Francis as one of his favorites.

A tragic mood pervades Chagall's paintings even when the title sounds joyful. In 1938 he painted "A Midsummer Night's Dream," showing the comic scene when Titania falls in love with Bottom despite the fact that his head is that of an ass. But the model for Titania is Chagall's wife, Bella, who looks frightened and melancholy as Bottom, presumably a symbol for Chagall, clutches her. Élisabeth Pacoud-Rème, who is in charge of the collections at the Chagall museum in Nice, where this painting hangs, says it shows "the Chagalls at the eve of the Second World War preparing to close ranks against an ascent of perils."

At first the foreign-born Jewish community in Paris did not take the upsurge in anti-Semitism very seriously. One Yiddish newspaper analysis in 1936 said that survivors of the Russian pogroms looked on the young Jew-hating toughs of the right wing as "untalented shlemazels," using the Yiddish word for luckless bumblers. Even as evidence of the hatred mounted, most foreign-born Jews in 1935, according to the Jewish press, did not believe that the French would ever act with the same manic hatred of Jews that inflamed the Nazi Germans. In addition, Jews felt confident that the powerful French army and the impregnable Maginot Line would protect them from the Nazi tormentors. Chagall, despite his anxiety, evidently felt the same way, for he did not attempt to flee from France in the 1930s.

ELEVEN

LATE ONE AFTERNOON IN AUTUMN OF 1937, GERDA MI-chaelis Groth, a 27-year-old Jewish refugee from Germany, slipped into a seat near some friends on the terrace of the Café du Dôme in Montparnasse. A friend introduced her to someone she had never seen before: "The great painter Soutine." Gerda had never heard of him. She had no idea whether he was great or even competent. But she was intrigued by his features.

The 44-year-old Soutine had an olive complexion, very black hair and deep brown eyes. He smiled with thick lips. And through the cigarette smoke hovering over the table, she recalled, "his look shined with a kind of ironic gaiety." He spoke in French with a low voice in a Slavic accent. They barely said ten words to each other, but in the next few days Gerda could not put him out of her mind.

This meeting began a three-year relationship, the longest and most stable in Soutine's life. It played out against some of the most

terrible upheavals in the history of Europe. Soutine could not ignore them completely, for his new love, Gerda, was a living witness to Hitler's cruelty and sheer evil. As a bonus of their love, we also have her memoir, published more than 30 years later, which offers us many unadorned glimpses of Soutine as a man and almost nothing at all about him as a painter.

The memoir was put together in an unusual way. Gerda did not sit down and write it. She did not have that kind of self-confidence. Instead, the French literary critic Jacques Suffel, who had known her for 20 years, persuaded her to dictate her recollections to him. Suffel and Gerda than edited the transcript. The book revealed a good deal about Gerda as well as Soutine. She had been beaten down so much—the Nazis chased her from Germany and killed her family, the French failed to protect her but interned her instead, the war crushed her great love affair—that she became passive and accepting, unable even to cry out against her suffering. She was strong enough to care for Soutine's health but too weak to feel bitterness about the blows against her.

Gerda was born in 1910 in the medieval Saxon town of Magdeburg in eastern Germany. Her father was a Jewish dealer in leather and furs. After Hitler came to power in 1933, the new anti-Jewish laws deprived her father of his business and the family of their apartment. When rumors spread that the Nazis would soon round up Jews involved in politics, Gerda, who had belonged to a group of socialists, fled to Paris. Her brief marriage in Germany to a non-Jewish architect was floundering at the time, and she was divorced a few months later. She subsisted in Paris by washing clothes and cleaning homes. Her father would die in 1943; her mother and two sisters would disappear in Nazi extermination camps.

A few days after their first meeting, Gerda invited Soutine to join her and some friends for afternoon tea at her apartment. Although he accepted, Gerda did not have high expectations that he actually

would arrive. She was told that Soutine never remembered appointments, that he had no watch, that he might remember at midnight or three days later.

Soutine did forget, but only for a few hours, and showed up at seven in the evening. Since he was so late, he offered to take Gerda to dinner. But as they left for a restaurant, Soutine suddenly remembered that he had planned on seeing some bouts of catch boxing at the Vélodrome d'Hiver, the indoor Paris sports arena built mainly for bicycle races. Taking her along he explained that catch boxers were allowed to kick their opponents and use their heads to butt midsections. Soutine had seats close to ringside and shouted, clapped and laughed throughout the matches. But, before the final bout, he stood up in great pain. He told Gerda that he felt an unbearable burning in his stomach.

He begged her to come home and help him. At his apartment, he asked her to prepare a hot water bottle and a glass of lukewarm Vichy water, his long-standing home remedy. As the pain eased, he explained that alcohol and bad nourishment in his youth had ruined his stomach. He kept asking Gerda not to leave him, so she sat by his bedside as he slept. At 8 A.M. she started to leave for work that day, but he objected. He insisted she would not lose a great deal if she lost her work.

He rose from bed, held her arms and said, "Gerda, you were my guard this night, you are Garde [guard or nurse], and now it is I who will guard you."

She laughed at him. "It seems to me that you are getting better this morning," she said, adding later in her memoir, "It is thus that I was baptized Garde and began my affair with Chaim Soutine." From then on, he always called her Garde or Mademoiselle Garde.

She moved into his apartment at number 18 Villa Seurat, a new orange-red building on a quiet street offering apartments with studios for artists. American novelist Henry Miller lived in the same

building, and the sculptor Chana Orloff lived down the street. For most of his Paris life, Soutine had shifted continually from one apartment to another, but the Villa Seurat apartment, which he had rented recently and was more spacious, modern and expensive than the others, would remain his Paris address.

The apartment, a duplex, with a kitchen and studio on the ground floor and the bedroom upstairs, was disorderly and unkempt. Cigarette butts lay scattered on the floor. It was obvious that no maid had worked there for weeks. Garde, like a good German *hausfrau,* set out immediately to clean it up and impose some order. She found only a few books, including some Russian novels and, in French, several works by Balzac and the essays of Montaigne. Soutine did not keep copies of the monographs by George and Faure. Nor were there any catalogues from his exhibitions. No painting, by him or anyone else, adorned the walls. Instead he had tacked up a few tattered reproductions by Rembrandt, Courbet and Corot. Crumpled copies of newspapers were strewn throughout. Soutine liked newspapers and their changing headlines so much that he sometimes bought more than one edition of a paper on the same day. His favorite paper was the popular evening daily *Paris-Soir,* which was chock full of photos and advertised itself as the largest circulating paper in the world.

Eventually Garde got to the bottom of Soutine's supposed aversion to baths. She discovered that he had no phobia against hot water but lived in terror that the gas powering the water heater might seep out and explode. Soutine luxuriated in the bathtub when Garde watched over him, monitored the heater's every sound and movement and assured him again and again that no gas had escaped.

During her time with him, Garde did not see a single Soutine painting. He admonished her not to look at them, and she obeyed. Even after she realized he really was a celebrated artist, she still maintained her ignorance of his work. "Not for anything in the world,"

she wrote, "would I have allowed him to believe that I was attracted to him because of his celebrity. I loved him for himself, not for his painting." Even when she was alone in the apartment, she did not slip into his studio to glance at his canvases. She felt that would be a betrayal. Sometimes, when the studio door was open, she could see him stab at a canvas with a brush and then toss the brush on the floor, swiftly finding another to stab at the canvas again before tossing it away too. A mound of spent brushes soon grew on the floor. Soutine also pressed his hand against a canvas at times, pushing and squeezing the paint with his fingers.

He took several rail trips to Amsterdam on his own to study the Rembrandts at the Rijksmuseum, leaving in the morning and returning—"exhausted and delighted," according to Garde—by evening. He also made an overnight trip to London for the Rembrandts, especially "A Woman Bathing in a Stream," at the National Gallery. When he painted outdoors, Garde accompanied him, taking a book along to read. If her gaze wandered from the book, Soutine would stare in anger, sending her back to the book. For Garde, this refusal to share his work was more evidence of the inward, solitary nature of her lover. "He was a secret and solitary man, full of mistrust," she said, "and as little forthcoming as possible."

In the mornings, while Garde shopped for the day's meals, Soutine liked to sip coffee at a café with Russian Jewish friends from the School of Paris, such as Serge Gurevitch, Kostia Terechkovitch and his old schoolmate Pinchus Krémègne. In the evenings, aside from attending bouts of catch, he liked to go to the movies with Garde, but never in the large theaters of the Champs-Elysées and the grand boulevards, only in smaller neighborhood movie houses. If the main feature bored him, he would leave and shift to another neighborhood movie house that same evening. Soutine and Garde never attended live plays, though they did see Maurice Chevalier once in a music show at the Casino de Paris.

One morning an elegant and beautiful young woman, wearing a bonnet with ribbons tied under her chin, came to the apartment without calling ahead. She smiled, her black eyes shining. It was Madame Castaing, who seemed amused and surprised that Soutine had abandoned his bachelor ways. She was so close a friend that she stopped by once or twice a week without ever announcing her visit in advance. On one visit, she asked, "Tell me, Soutine, do you love Garde? You really love her?" "*Mais oui,*" he replied. Garde soon looked on Madame Castaing as her own friend as well.

Soutine never spoke to Garde about his family in Smilovitchi. In fact, many critics and collectors believed for years that he had turned his back on his parents and siblings. He never did return for a visit. But it would have been nearly impossible for Soutine to maintain a close relationship. A few years after his departure, the shtetl where the family lived became part of the Soviet Union, a closed society that rarely allowed travel in or out. A hint of the real relationship surfaced when Clarisse Nicoïdski found a family letter and published it in her 1993 biography of Soutine.

The undated later, written in Yiddish, was addressed to "my dear brother Chaim" from "your youngest sister Ertl." Ertl reported that their father and brother Yankeli were dead and that she, her husband and daughter Nahuma now lived near Soutine's mother.

"We are like blind sheep in the world," she went on. "Now, dear brother, it is you who is the light of the sun for us, who lights up our dark life, you who illuminates all. News of you gives us much courage to live."

Ertl said that her family had not forgotten his previous gift, adding that their mother had also helped with some cash. But now, Ertle said, "I myself have a serious illness, diabetes that cannot be cured but must be watched and treated strictly. Until now, I have not been able to do this."

In a final plea, she said, "Now, dear brother, I put my hope in you; I am addressing you because I have no other recourse. . . . It is you alone who can save us. I am very weak. I cannot see my daughter very easily, and she is very dear, the only one of my children still alive. Now, dear brother, it is very difficult for me to ask, but if it is possible to help me with a little amount of money, I would remember my whole life that you have been my savior."

We do not know how Soutine responded, but the letter tells us that he had sent funds to help Ertl in the past. Still, clearly he was not in close contact with his sister. Her plea sounds like a rare note, not part of a series of chatty correspondence. All else about Soutine's relations with his family, like much about him, remains conjecture.

We get an outside view of Soutine from Henry Miller. Miller, who was living upstairs at 18 Villa Seurat with Anaïs Nin, a French-born writer of Spanish descent, knew several painters in Paris, but he did not know his neighbor Soutine. Miller needed an apartment with a studio because he was trying his hand at watercolors. He set down his impressions of Soutine in a few sentences in a little-known book called *The Waters Reglitterized.*

Miller knew the oft-told tales of Soutine's wild days with Modi and describes Soutine as "the boon companion of Modigliani who, up until his third or fourth apéririf, is brilliant and entertaining—after that a madman, un exalté." But Soutine has changed a great deal. "Soutine is now living quietly below me," he writes, "with his new red-haired model, a 'Soutine' in every respect." It is not clear what Miller meant by a Soutine model "in every respect," especially since Soutine never painted Garde. But it is our first inkling of the color of her hair. No one else mentioned it, and the photos of her from those days are in black and white.

Miller goes on to say that Soutine "seems tame now, as if trying to recover from the wild life of other days. Hesitates to salute you in

the open street, for fear you will get too close to him. When he opens his trap it's to say how warm or how cold it is—and does the neighbor's radio bother you as it does him?"

Within the quiet, tame artist was a sick man. Garde worried that there was no letup of the recurrent pain, and she doubted that his remedy of lukewarm Vichy water and a hot water bottle did much good. She was sure that his avoidance of alcohol made sense, but she fretted over the rest of his regime. He refused to eat meat, poultry, fish or butter. She knew a Viennese doctor, a Dr. Tennent, who had fled Austria to escape the Nazis and was now staying in Paris while awaiting a visa to the United States, and she persuaded Soutine to meet with him.

Dr. Tennent ordered an immediate X ray of the stomach. Soutine grumbled about this but agreed, just to please Garde. A few days later, she met in private with the doctor.

Holding the X ray in his hands, Dr. Tennent told her, "Soutine suffers from a very deep ulcer of the stomach. I am afraid that the illness is too serious to be curable. His organism is weak and worn out. A well-regulated treatment could slow down the growth of the ulcer, but the threat will always remain. An operation would involve the removal of almost the entire stomach. At the moment we cannot think of that because the patient is too fragile. We are going to treat him, but in the present state of things it is necessary to have no illusions: I do not believe this man has more than five or six years to live."

Garde was crushed by this diagnosis, and asked, "Isn't there any hope?"

"Let's hope for a miracle," Dr. Tennent replied, "and let's not lose a minute to begin the treatment."

A few minutes later, Dr. Tennent informed Soutine of the diagnosis—without the doomsday prediction. He prescribed several medicines and lifted Soutine's self-imposed ban on meat, poultry,

fish and butter. Garde rushed to the pharmacy to buy the medicines and returned home to find Soutine in a fury.

Throughout his life Soutine burst into irrational fits of anger—a bane to his friendships, and this was another one. "Your doctor is a charlatan," said Soutine. "He claims that I have a stomach ulcer, and I know that is not true. He wants to frighten me to force me into a treatment that will never end and will be ruinous." Then he grabbed the package of medicines and threw it into the garbage pail.

For several days, Soutine adamantly refused to take anything for his pain but the lukewarm Vichy water. A desperate Garde finally conferred with Madame Castaing, who came up with a plan. She asked Dr. Gosset, a celebrated French specialist, to examine Soutine. Dr. Gosset's examination resulted in the same diagnosis as Dr. Tennent, and he prescribed the same batch of medicines. A subdued Soutine apologized to Garde. Her doctor was not a charlatan; he would take his medicines. The medicines began to alleviate his pain and restore his appetite, and he began to eat foods that he had sadly kept away from for years. When Garde roasted a chicken for him, he looked at it with delight. "I forbid you to touch it," Soutine told her. "It's for me alone. It's been a long time since I have eaten chicken." He began to gain weight, and Garde put out of her mind Dr. Tennant's dire prediction.

After Dr. Tennant left Paris for the United States, two renowned specialists, Dr. Guttmann and Dr. Abramy, took over Soutine's care. Dr. Abramy felt that a long spell of country air might improve the painter's condition even more, and, in the early summer of 1939, Soutine and Garde headed to the village of Civry-sur-Serein in Burgundy, about 100 miles south of Paris. The Lithuanian art critic Udi Einsild recommended Civry, a tranquil and picturesque village of 200 or so residents, as a wonderful place for artists seeking both rest and some hours for work. "A splendid little place," Einsild said. "Nothing phony about it, with absolute tranquility and incredibly

low prices. You can work there admirably, and you will encounter absolutely no one you know. And the scenery is delightful." Garde looked forward to this chance "to spend several weeks alone with him, far from the feverish atmosphere of Montparnasse."

Civry-sur-Serein was so small that its only street was the road to and from the town. There was one shop that sold groceries, milk, cheese, cold cuts, cigarettes, stamps and newspapers. It had a few tables and chairs for those who wanted coffee or an aperitif. The owner, Madame Michel, gave Garde directions to find the farm that sold eggs and a list of the hours when the butcher's wagon came to town. The couple rented a room at the home of Madame Galand, across the street from Madame Michel's shop. Although their room had electricity, Soutine and Garde had to go outside to a pump for water.

Civry was on a riverbank in a small valley at the base of a hill that ascended to a high plateau. The abundance of trees and the varied heights of the landscape made the scenery ideal for Soutine. Several artists had found the area just right for their work. American painter Morgan Russell bought a farm there in 1921, and Soutine's old schoolmate Michel Kikoïne bought some property nearby five years later. But Soutine met no one he knew during his stay at Civry.

Soutine and Garde had now been together for more than two years. Since they first met, Adolf Hitler had annexed Austria, unleashed the brutal Kristallnacht attack on the Jews of Germany, reached an agreement in Munich with Britain and France that allowed him to absorb the German-dominated Sudetenland from Czechoslovakia, mocked British prime minister Neville Chamberlain by then occupying the rest of Czechoslovakia and finally signed a pact with Stalin's Soviet Union that gave him more room to snub his nose at the Western democracies and threaten the rest of Europe.

Since Soutine read the newspapers every day, the couple knew what was going on. Yet, as Garde put it, "Soutine and I lived from day

to day, enjoying the hours that flowed, the pleasure of being together, the sweetness of precarious happiness. We had willingly abolished our past, and we closed our eyes on the future."

At Civry-sur-Serein, Garde wrote later, "several weeks passed in a delicious calm." After dinner, they would walk on the main road all by themselves, gazing at the stars, inhaling the smell of freshly cut hay. All they could see in the darkness below the sky were the red glows of their own cigarettes. Soutine found time and strength to paint in the daytime, completing some extraordinary landscapes, including "Windy Day, Auxerre" (now in the Phillips Collection in Washington).

But, said Garde, "this extraordinary tranquility, the isolation in which we found ourselves, did not prevent Soutine from closely following the escalation of political events." He pored over *Paris-Soir* as soon as it arrived in the village. The news was not good.

On September 1, 1939, Hitler's troops marched into Poland, a move that was the final straw for the two democratic governments of Britain and France. Their appeasement of Hitler had clearly failed. He was not bent only on uniting the German-speaking peoples of Europe; he intended to conquer all Europe. Britain declared war on Germany two days later, and France followed six hours after the British. The lives of Soutine and Garde were now overwhelmed by the maelstrom of World War II.

With France at war, Soutine felt that he must return to Paris, for him the center of all things. But he was quickly stymied. Garde, a citizen of Germany, was now an enemy alien. It did not matter that she was a refugee who had fled from the Nazis. He, a citizen of Russia, was an alien whose country was now allied to the enemy of France. It did not matter that he had fled the pogroms of the czar more than a quarter of a century ago and intended to live in France for the rest of his years. It did not matter that they were despised Jews in the lands of their birth. Orders came from Paris that German and Russian

aliens must not leave the French towns and villages in which they now resided.

Soutine had a recourse. The minister of interior, Albert Sarraut, was an art collector who owned several of Soutine's canvases, and he had once written the introduction to the catalogue of an art exhibition that included Soutine works. Soutine telephoned Sarraut's chief of staff, André-Louis Dubois, and explained his predicament. Within a few days, Dubois sent a laissez-passer that allowed Soutine to return to Paris for as long as he needed to consult his doctors and buy his medications. But there was nothing for Garde. Soutine told her that he would leave for Paris in a few days and arrange a laissez-passer for her. It was the first time they had been separated, and she was distraught.

"You are my wife," he told her, "have confidence. I will not abandon you. Above all, don't be discouraged."

For the next six months, Garde remained frightened and nervous in Civry while Soutine spent most of the time in Paris, writing sporadically about his hunt for a way to bring her back. He showed up several times with new papers or instructions for her that somehow failed. Finally, in December, he showed up with the coveted laissez-passer for her in her legal name: Madame Gerda Groth. In a joyful mood, they presented it the next morning to the mayor of Civry.

The mayor treated the laissez-passer from the ministry of interior with complete contempt. In time of war, he lectured the couple, it was the mayor, not the ministry, who took charge of police matters within his commune, and he had no intention of allowing Madame Groth, an enemy alien, to leave Civry. When Soutine demanded to know why the mayor accepted one laissez-passer and not the other, he replied, "I, Georges Sébillotte, mayor of Civry, in virtue of my discretionary power, have allowed Monsieur Soutine to leave for reasons of health. As for Madame Gerda, who is in good health, I refuse to give my permission." Soutine and Garde felt trapped,

depressed, more desperate than ever. Soutine headed back to Paris to see if more could be done, if some outside pressure could force the mayor to relent.

Soutine returned twice with nothing but finally showed up in March with a new laissez-passer for Garde. But this one also required the mayor's approval, and he remained adamant in his refusal. No one in the future could ever accuse him of endangering the security of France by permitting a suspicious German like Garde to wander from Civry unwatched.

Since the defeat of Poland, there had been no further fighting. Some historians would call these opening months of World War II "the phony war." In April, however, German troops seized Norway and Denmark, and the real war commenced. Soutine was certain that all Europe would soon be inflamed. Deciding the couple could remain in Civry no longer, he told Garde they would slip away at night like fugitives.

Garde was fearful they would be arrested, but Soutine insisted that no one would be suspicious of two people taking a train at night. Their only problem was avoiding the mayor. They packed in secret and left a little after 11 P.M., walking five kilometers to the train station in the village of L'Isle-sur-Serein. Garde wrote that "the darkness was deep and the silence absolute." They took the train to La Roche, where they changed for the train to Paris and arrived, exhausted, at dawn. The mayor did not try to track them down. Soutine told her, "You see, Garde. I am guarding you. You will never be away from me any more, I swear to you." Their joy lasted a few weeks more.

Once back home, Garde tried hard to restore the routines they had established before leaving for the countryside. She began cleaning the apartment at Villa Seurat. It was in as much disarray as she had found it almost three years before. Cigarette butts littered the floor once again. But her cleaning slowed down after she fell in a nearby café while making her way down the narrow staircase that led

to the toilets and telephone. Soutine feared that she had broken her arm, but a doctor assured them it was only sprained.

In early May, the Germans invaded Holland and Belgium, overrunning the countries in a few days. Hitler's forces now lined the northern borders of France. The French government began to fear the threat of a "fifth column" within France itself. This popular phrase, coming out of the Spanish Civil War, denoted a column of traitors within a city who helped the besieging enemy. To prevent this, French authorities pasted posters and published advertisements ordering all German nationals in Paris to report for relocation, the men to the Buffalo Stadium, the women to the Vélodrome d'Hiver.

Garde found the notice in a newspaper. When she read it to Soutine, he grabbed the paper from her, scolding, "You are crazy. You don't know how to read French. You understand everything completely the opposite." But she was right.

They rushed to the ministry of the interior the next day. Although the art collector Albert Sarraut had been transferred to another post, Dubois, the chief of staff, was still there. Garde showed him a certificate from the doctor describing the condition of her arm, but this did not help. Dubois told them that Garde had no other recourse but to report to the Vélodrome. Considering a Jewish refugee from Hitler a possible fifth-column traitor might seem absurd, but French officials did not have time now to study the details of each case. Dubois said the order to the German nationals was a matter of general security. Later, he said, when the situation cleared up, a special decision could surely be made in Garde's favor.

On May 15, 1940, Garde and Soutine took a taxi to the Vélodrome, where the two in the past had enjoyed bouts of catch boxing. They kissed, and Soutine promised to plead her case with Dubois until she was set free. There were four or five thousand women in the building. No beds were provided, and they slept on their suitcases for four nights. Police then herded the women to the Gare d'Austerlitz,

where they boarded a train for the Pyrenees in the south. They were destined for the village of Gurs, where a camp had been built a year or two before to house Spanish refugees fleeing from Franco, the fascist victor in the Spanish Civil War.

Soutine wrote to a friend, "Catastrophe is everywhere. . . . Everything that happens leaves me very unhappy. . . . To forget the nightmare, I paint, I draw, I read."

During her last night in the Villa Seurat, Garde had told herself that the war would not last forever, that she and Soutine would find each other again and would be happy together once more. But she could not shake off "dark premonitions that also told me that it was over, that I would lose Soutine, and that I would never see him again."

TWELVE

THE SWIFT CONQUEST OF FRANCE WAS THE MOST TRIUM-
phant moment in the reign of Adolf Hitler and the most humiliating
moment in the history of France in the twentieth century. In barely
three weeks, the German troops had trapped the French army and
sent the battered British forces scurrying back across the English
Channel in a procession of fishing boats and other small craft. In a
few weeks more, France, long hailed as the most powerful nation in
Europe, had surrendered and signed an armistice dictated by Hitler.

Hitler ordered that the signing take place on June 22, 1940, in
the same railroad car in the same clearing in the woods of Compiègne
in northern France where the French had forced the Germans to sign
the armistice that ended World War I. During the negotiations the
day before, William L. Shirer, the Berlin correspondent for CBS ra-
dio news, stood with binoculars 50 yards away, watching Hitler and
his aides pause before stepping into the railroad car. Hitler's face,
wrote Shirer, was "afire with scorn, anger, hate, revenge, triumph."

Then Hitler used his whole body to express his mood. "He swiftly
snaps his hands on his hips, arches his shoulders, plants his feet wide
apart," Shirer wrote. "It is a magnificent gesture of defiance, of burn-
ing contempt for this place now and all that it stood for in the twenty-
two years since it witnessed the humbling of the German Empire."

A block of granite nearby carried an inscription that proclaimed,
in French, "Here on the eleventh of November 1918 succumbed the
criminal pride of the German empire—vanquished by the free peo-
ples which it tried to enslave." Hitler ordered that his troops remove
the stone and obliterate it. After the defeated French generals signed
the armistice, Hitler stepped outside the railroad car and danced a
brief jig caught by worldwide newsreels.

A day after the signing of the armistice, Hitler embarked on
what he called an art tour of the conquered capital of France. The
visit, which lasted three hours, was his first ever to Paris. Accompa-
nied by three favored artists of the Third Reich—architects Albert
Speer and Hermann Giesler and sculptor Arno Breker—Hitler and
his aides flew into Le Bourget airport just north of Paris at 5:30 A.M.
They drove into the city in three Mercedes sedans through streets
empty of cars and people. Hitler and the three artists rode in the
first car.

The first stop was the Paris Opera house designed by Charles
Garnier in the nineteenth century. Hitler, an aficionado of op-
era houses, knew the plans of this one thoroughly and proudly
pointed out that an original salon was missing. An elderly atten-
dant soon confirmed that the room had been eliminated some time
ago. "There, you see how well I know my way about," said Hitler.
Speer wrote that Hitler "seemed fascinated by the Opera, went
into ecstasies about its beauties, his eyes glittering with an excite-
ment that struck me as uncanny." In those days, the ceiling of the
theater did not display, as it does now, a mural by Marc Chagall.
The French government asked Chagall to paint the ceiling after

the war, an act that would have infuriated Hitler, who looked on Chagall with contempt as both Jewish and a degenerate twentieth-century painter.

Hitler also stopped to look at the Arc de Triomphe, the Eiffel Tower, the Place de la Concorde and the Sacré-Coeur Church on Montmartre. He spent a good deal of time at the tomb of Napoleon in the Invalides, communing with another would-be conqueror of all Europe. He did not enter any museum to study any paintings. Afterward he ordered Speer to resume the construction that was designed to make Berlin a far more beautiful imperial city than Paris.

"In the past," Hitler told Speer, "I have often considered whether we would not have to destroy Paris. But when we are finished in Berlin, Paris will only be a shadow. So why should we destroy it?" Hitler never returned to the city.

The French cabinet resigned as soon as the French army foundered, and Marshal Philippe Pétain, an 84-year-old hero of World War I, was invited by President Albert Lebrun to head the government. Pétain called for an end of hostilities, ordered the generals to sign the armistice and declared himself chief of state of France. Under the terms of the armistice, German troops occupied most of the country, leaving the nonindustrialized Southeast under French control. The French government needed a new capital with space for its bureaucrats; it chose the town of Vichy, which had abundant hotel rooms usually filled by tourists who came for Vichy's soothing mineral waters.

The extreme right-wing Vichy government, one of the shames of France, proved itself a close collaborator of Nazi Germany. The Vichy ministers tried to build a cult of personality around Pétain to match those around Hitler, Mussolini and Franco—though, of course, the fact that German troops were on French soil left Pétain with far less power. Anti-Semites who had influential roles in the government believed the time had come to rid France of as many foreign-born Jews

as possible. Vichy decreed a law limiting the rights of Jews even be-
fore the occupying German army did and ordered some roundups
of Jews for deportation to death camps even before it received Ger-
man requests to do so. The hunts for Jews were carried out mainly by
French police, especially a new paramilitary right-wing police force
known as the *Milice*.

It has been difficult for many French to accept how closely the
Vichy government cooperated with Nazi Germany. For a quarter of
a century after the war, in fact, a myth prevailed that Vichy engaged
in a passive resistance that protected the French and that almost all
the heinous acts of oppression were the fault solely of the German
occupiers.

This myth was exposed as self-delusion in 1972 when Robert O.
Paxton of Columbia University published *Vichy France: Old Guard
and New Order 1940–1944*. The book was derided at first by French
historians but soon won acceptance in France as the classic study
of Vichy's eager cooperation with the Nazis. In 1981, Paxton joined
with Michael R. Marrus of the University of Toronto in publishing
a new book, first in French and then in English, detailing the Vichy
government's responsibility in helping to deport 80,000 Jews from
France to their deaths in Nazi extermination camps.

But some French researchers cite a paradox. Though a quarter
of the French Jewish population died during World War II, that per-
centage is smaller than the proportion killed in Holland, Belgium
and Norway. Some French scholars believe that policies of the Vichy
government or pressure from the French people may be responsible
for this low percentage. But Paxton, in a recent article in the *New York
Review of Books*, rejects both suggestions. He attributes the paradox
to the size of France, which made hiding in the countryside relatively
easy, to the humanitarian organizations that rescued Jews and to the
difficulty of distinguishing an assimilated French Jew from any other
French resident. As Paxton puts it, "the actions of the Vichy state and

its accomplices in the French population made the result worse than it would have been without them."

After Nazi Germany defeated the French army, all Jews in France had to register at police stations. Officials then stamped their identity cards with the word "Juif" (Jew). When Soutine presented himself, the policeman did a poor job with the stamp. The ink on a couple of letters was uneven. "Look," Soutine told Chana Orloff outside the station, "they have smudged my Jew." More than 20 years later, Orloff wrote that Soutine tried several times to obtain a visa for America from the U.S. embassy. "There were certainly no lack of Americans who would have saved Soutine," she said, "but he did not possess a single identity paper and his request was, therefore, turned down." Orloff evidently meant that he did not have documentation from Russia. Soutine maintained his apartment on the Villa Seurat in Paris during the German occupation but often slept elsewhere.

Soutine took refuge in a small hotel, telling the manager that, although his identity card listed him as a resident of Paris, he needed a room because the heating had broken down at his apartment. It was a desperate time for Soutine. He was now alone, far from his love, Garde. In normal times, the distance of 450 miles would not have been that great. But Paris was in German-occupied France and Garde was in unoccupied Vichy France, and travel between the two zones was forbidden without a special pass. Only an emergency, such as a death or illness in the family, was regarded as a valid reason for the pass. Soutine and Garde, two Jews, would have been foolish to come forward with some phony excuse and make themselves conspicuous. Soutine began an affair with a young French novelist and artist named Andrée Collié that ended quickly and badly.

Madame Castaing worried about him, fearing that his health would deteriorate without someone to care for him. Despite her admiration, perhaps even love, for Soutine, she could not devote her life to caring for him. In fact, she was busy during the occupation

running a shop on the Left Bank selling expensive antiquities. She
also had two young sons to care for. She knew that the restrictions
against travel between the zones were enforced strictly. Garde and
Soutine had no chance of meeting again soon. Madame Castaing felt
she had to do something.

In the late summer of 1940, Madame Castaing introduced Sou-
tine to Marie-Berthe Aurenche, the former wife of the German sur-
realist painter Max Ernst. The meeting took place at either the Café
de Flore or the Café du Dôme; memories are confused. But Madame
Castaing's intent was not confused. She believed that Soutine needed
the daily care of a woman to guard his health, encourage his painting
and protect him from arrest. The young and comely Marie-Berthe
knew how to cope with the temperament of an artist and, in Madame
Castaing's view, could care for Soutine much like Garde once did.
But the mordant Maurice Sachs, who witnessed the introduction,
thought the plan was a foolish and dangerous one. "You have signed
Soutine's death warrant," he told Madame Castaing. Soutine allowed
himself to fall completely into the hands of Aurenche, who had the
aura of a pixielike film star. Pierre Courthion, the Swiss art historian,
wrote: "Marie-Berthe, illogical, capricious, and feminine like a bird,
became a kind of dazzling fairy to Soutine."

When the armistice was signed, Garde was still in the detention
camp for enemy aliens near the Pyrenees in unoccupied France. A
notice was posted notifying all German women that they were free
to leave the camp for occupied France under the protection of Ger-
man troops. That was hardly an inducement for German Jewish
women, and Garde and a friend named Ruth remained in the camp.
Garde wrote several letters to Soutine in Paris and finally received a
reply dated July 10. He urged her to have courage and promised to
send her 175 francs soon and, if possible, a package. It was the last
letter Garde ever received from him. French authorities then said
that German refugees could remain in unoccupied France if French

residents sponsored them and offered them a place to live. Ruth had friends in the town of Carcassonne, and the two friends moved there in August, about the time that Soutine and Marie-Berthe began hiding together in Paris.

Life was pleasant in Carcassonne, a medieval fortress town. Their sponsor was Joë Bousquet, a surrealist poet who had been badly wounded and paralyzed during World War I. Friends would show up in the evenings, and Garde met distinguished French writers there like Louis Aragon and Paul Éluard.

In November 1940, several weeks after Garde had left the detention camp, Madame Castaing arrived by train in Carcassonne on her way to Toulouse. She had received official permission to travel to visit her husband's relatives because of a family illness. Madame Castaing told Garde about Soutine's liaison with Aurenche and acknowledged her own role in arranging it.

Madame Castaing explained that Soutine would be "exposed to the worst dangers if he remained isolated during this period of the Occupation when Jews were so threatened." She had decided that Marie-Berthe was the obvious choice as his protector. And although she did not discuss this with Garde, it would have been foolhardy for Madame Castaing to try to hide Soutine herself. The German Gestapo knew how close the Castaings were to Soutine and might call her in for questioning about his whereabouts. The wealthy couple's Paris apartment would not have been much of a hiding place for the artist.

The news about Soutine and Marie-Berthe upset Garde. "But what could I do?" Garde wrote. As Madame Castaing left Carcassonne, she advised Garde to wait patiently for the end of the war and not to lose courage. Garde, hardened by years of anguish, did not show any resentment at Madame Castaing for introducing a rival to her love. She evidently accepted Madame Castaing's rationale and even dedicated her memoirs to her.

With the help of a friend who was in the Resistance and knew specialists who forged official documents, Garde obtained a false identity card in the spring of 1943, almost three years after she had last seen Soutine. She was now Marie Dupas, a 33-year-old French citizen born in France. No one had stamped "Juif" on the document, for she was not Jewish in her new identity. Madame Castaing asked her to return to Paris. Soutine's health was deteriorating, and during her recent visit to his hiding place in the countryside he had implied that he had grown tired of Marie-Berthe. German troops had occupied the rest of France in November 1942, and there were now no restrictions on traveling from occupied France into Vichy France. Madame Castaing paid the rail fare for Garde to travel back to Paris. Garde said she had no intention of seeing Soutine unless he asked for her, but there was no doubt that she hoped he would ask.

THIRTEEN

TWO AMERICAN HEROES, THE ESCAPE OF CHAGALL AND THE FALL OF THE SCHOOL OF PARIS

MARC CHAGALL AND HIS FAMILY OWED THEIR ESCAPE FROM the Nazis and Vichy to a pair of young Americans who defied officialdom. The pair's heroism was not recognized and honored until many years later, but they reflected a burst of honesty and goodness in a generally gnarled American response to the oppression of dissidents and Jews in Europe. The two look similar in photographs—lean, studious, wearing suits, ties and spectacles. Both were easterners who attended prep schools and Ivy League colleges. They saved 2,000 or so victims—not a great number when the total of civilian casualties was counted at the end of World War II, but it took great bravery to accomplish what they did, and their short roll included many important writers, artists, intellectuals and politicians.

Thirty-two-year-old Varian Mackey Fry was a journalist and a graduate of Harvard University, where he and a classmate, Lincoln Kirstein, the future impresario of the New York City Ballet, had founded the literary magazine *Hound & Horn*. Fry later served as editor of *The Living Age*, a magazine that reprinted foreign articles, and then joined the Foreign Policy Association (a private organization founded in 1918 to encourage American interest in foreign affairs) as a writer of papers and pamphlets. His work took him to Nazi Germany and other parts of Europe in the 1930s, and he accepted a temporary job in 1940 as the agent in France of the Emergency Rescue Committee, a newly formed organization aiming to save refugees trying to escape from France. He reached Marseilles in unoccupied France soon after the armistice was signed.

Fry arrived with his pockets filled with lists. Influential sources, such as the German novelist Thomas Mann (already in the United States) and the Museum of Modern Art, had sent the committee names of people surely in danger of arrest by the Nazis if they were not whisked out of France as soon as possible. Fry assumed it would take him a few weeks to reach these potential victims and offer them funds to travel to the United States.

But he soon realized he had a massive refugee and emigrant crisis on his hands. Marseilles was teeming with Germans and French who wanted to leave for a haven in the United States. Not all were famous or on his lists. Fry set out to interview as many as possible, determined to rescue first those in most danger. He realized, of course, that a Jewish novelist hated by the Nazis probably had more to fear than a non-Jewish novelist hated by the Nazis. But in these first months of the war, Fry did not yet realize that all Jews, in the view of the Nazis, were deemed fit only for extermination. Fry was no Raoul Wallenberg intent on saving Jews, but he saved many Jews nevertheless.

Fry demonstrated great patience and resilience. His main escape route was by train to the Spanish border, across the border into

Catalonia and then Barcelona or Madrid, a flight to Lisbon in neutral Portugal and finally a flight or ship to America. He hired agents to watch over the escapees when they had to stop over in Spain. Sometimes he supplied his charges with Czech, Lithuanian, Polish or other passports, often with false names. The ease of the escape depended on the mood or orders of the French border police, who sometimes demanded difficult-to-obtain French exit visas, and on the mood or orders of the Spanish immigration officers, who sometimes issued visas to transit Spain and sometimes refused. The refugees, some elderly, some frail, might have to hike around recalcitrant French and Spanish border posts.

None of this mattered if Fry could not obtain American visas for his people, and the State Department had a policy of handing out very few visas, especially to Jews. State claimed that it feared the far-fetched possibility that these foreigners could turn into spies for Germany, but, in fact, the policy reflected its pervasive anti-Semitism. Fry's problem was solved, however, by Hiram Bingham IV, the vice consul in the American consulate in Marseilles, five years older than Fry and better known as Harry.

Bingham's father, a former U.S. senator, was renowned as the energetic explorer who first called attention to the Machu Picchu ruins in Peru. Harry Bingham, a Yale University graduate, seemed headed for a stellar foreign service career, serving in Japan, London and Warsaw before his posting in Marseilles. But he jeopardized his career when the refugee crisis erupted after the fall of France.

Despite State Department policy, Bingham issued a visa to everyone presented by Fry, and to others as well. In doing so, he was defying Washington. The United States, which was neutral, maintained an embassy in Vichy, and Secretary of State Cordell Hull wired the embassy that the country "can not repeat not countenance the activities" of Fry and his staff, "however well-meaning their motives may be," because these activities were "evading the laws of countries with

which the United States maintains friendly relations." Since Bing-
ham was Fry's chief enabler, the vice consul's mass issuance of visas
infuriated the department. But setting up the bureaucratic machin-
ery to stop Bingham would take time, for consular officers had a good
deal of discretion to issue visas under department regulations.

Shortly before the German onslaught against Holland, Bel-
gium and France began in 1940, Chagall had bought an abandoned
schoolhouse and transformed it into a studio and home in the vil-
lage of Gordes about 20 miles from Avignon in Provence in southern
France. It was a poor time to buy property in France, but the site had
the advantage, after the defeat of the French army, of being in unoc-
cupied France. That made it easy for both Fry and Bingham to drive
there and offer to help Chagall and his family flee.

But Chagall and his wife, Bella, were now citizens of France and
saw no danger to themselves if they remained in Vichy France. The
painter declined the offer, and the two Americans returned to Mar-
seilles to help others. In a few months, however, Vichy's anti-Semitic
laws and its plan to revoke recent citizenships frightened the Cha-
galls, and they moved to the Hôtel Moderne in Marseilles awaiting
departure with the help of Fry and Bingham.

In April 1941, the French police rounded up several hundred
Jewish men in Marseilles, including 40 at the Hôtel Moderne. Cha-
gall was among them. They were taken to police headquarters where,
according to Vladimir Visson, a Russian-born Paris art dealer, Cha-
gall did not behave heroically.

Visson, who was taken from the Hôtel Moderne with Chagall,
wrote in his memoirs that the painter sat aside from the others and
then, when a senior police officer arrived, addressed him in a ser-
vile manner. According to Visson, Chagall said, *"Monsieur le Com-
missaire,* please, I beg of you, don't lump me with all those people,"
gesturing toward Visson and the others. "I am not fleeing France.
I am not a refugee. I am going to America with an official *ordre du*

mission from Marshal Pétain." Chagall pulled some papers out of his briefcase as evidence that "I am a world famous painter." He showed the police officer lists of "just a few of the books and monographs published about me." The *commissaire* was not impressed.

"While sitting there in the *Sûreté Générale* (police headquarters)," Visson wrote, "I was certainly far from feeling like a hero, and I was just as scared as all the other Jews, but no one but Chagall had lost both dignity and decency."

When Fry found out about the detention of Chagall and others, he phoned police headquarters and berated a police officer for arresting "one of the world's greatest living artists." "If by any chance news of his arrest should leak out," Fry warned, "the whole world would be shocked, Vichy would be gravely embarrassed, and you would probably be severely reprimanded."

Chagall, Visson and others picked up at the Hôtel Moderne were soon released.

Chagall's detention was a revelation for Fry. He had thought Chagall was in danger because the Nazis regarded him as a "degenerate artist." The Nazis had staged a huge exhibition in Munich in 1937 of what they called "degenerate art." It included works from some of the best-known avant-garde artists of the early twentieth century. Hitler condemned all art that deviated from the classical realist tradition. The artists in the exhibition included Chagall and Max Ernst, both on Fry's lists of people to save. Now Fry realized that the Vichy police had detained Chagall not as a degenerate artist but as a Jew.

The departure of the Chagalls was accomplished without any major mishaps or delays. Fry's staff took them by train to the Spanish border, then the couple made their way to Madrid by train and flew to Lisbon on May 11. They waited a month before boarding the Portuguese SS *Pinto Basto,* arriving in New York on June 21, 1941. Their daughter, Ida, and her husband arrived on a Spanish ship several months later with a crate of Chagall's paintings.

Bingham continued handing out several dozen American visas a day. His boss, Consul General Hugh Fullerton, was astounded at Bingham's efforts to help Jews. "The Germans are going to win the war," he told Bingham. "Why should we do anything to offend them?" The State Department finally had enough of Bingham's antics and transferred him to Lisbon and then Buenos Aires in the autumn of 1941.

Bingham's departure crippled Fry's work. His replacement, according to Fry, "seemed to delight in making autocratic decisions and refusing as many visas as he possibly could." By the end of June, the State Department took the decision making out of the hands of the consulates. From then on, no consul in France could issue a visa without specific authorization from Washington. On top of this, Fry was pressured to leave by both the American consulate and the French police. When Fry's passport expired, the consulate refused to renew it until he promised to leave the country. The consulate also told him that the Gestapo had asked the police to arrest him. A high-ranking police official finally summoned Fry and warned that if he did not leave, he would be placed under house arrest in some small town "where you can do no harm." According to the official, the police complaint against Fry was the fact that "you have protected Jews and anti-Nazis." Fry succumbed to the inevitable and promised to leave France by mid-August 1941. When the police found him still in Marseilles in the last week of August, they expelled him, sending him to the Spanish border to take the same route that so many of his refugees had taken.

The list of European refugees in America who owed their safety during World War II and probably their lives to Fry and Bingham included German novelist Heinrich Mann (the brother of Thomas Mann), the German Jewish novelist Lion Feuchtwanger, the Prague-born Jewish novelist Franz Werfel and his wife, Alma (the former wife of Gustav Mahler), German painter Max Ernst, the Russian-born

Jewish sculptor Jacques Lipchitz, the French founder of surrealism André Breton, French Dada artist Marcel Duchamp, German Jewish philosopher Hannah Arendt, the Budapest-born Jewish novelist Arthur Koestler and, of course, Chagall and his wife. But if you review the names of all those Fry and Bingham helped, the celebrities are far outnumbered by unknown people escaping from Hitler and Vichy France.

A majority of those helped by Fry and Bingham were Germans who had taken refuge in France. Since the French had regarded them, like Garde, as enemy aliens, they were housed in detention camps in southern France after war was declared. When France was defeated and the armistice was signed, many of the refugees remained there, in the area that became unoccupied Vichy France. These refugees, now not far from Fry and Bingham in Marseilles, would be among the first to take advantage of the Americans' offer of help.

Fry and Bingham never again matched the derring-do of their adventures in Marseilles in World War II. Bingham's heroic flouting of authority ruined his career in the U.S. foreign service. No one honored the men's work until they were old or dead. In 1967, shortly before his death, France awarded Fry the Legion of Honor. In 1994, the board of Yad Vashem, the Israeli memorial to the Holocaust, named him a "righteous among the nations"—the Israeli term for a non-Jew who saved the lives of Jews during World War II. In 2002, fourteen years after Bingham's death, the American Foreign Service Association honored him as a "courageous diplomat." At the ceremony, Secretary of State Colin Powell said that Bingham "risked his life and his career, put it on the line" to do "that which he knew was right." Four years later, the U.S. Postal Service issued a stamp in his honor.

There is one glaring omission in the list of people Fry and Bingham saved. Chaim Soutine was not among them. The Museum of Modern Art evidently left him off its list of artists in need of help.

Alfred Barr, the director of the museum, sent a list to Fry with the promise that the museum would stage exhibitions of the works of those who came to the United States. That enabled Fry, if necessary, to persuade the Vichy government that the artist would be leaving for only a brief period. According to Jackie Wullschlager, Chagall's biographer, Barr's list included Henri Matisse, Pablo Picasso, Raoul Dufy and Georges Rouault, all of whom declined to leave, and Max Ernst, Jacques Lipchitz and Chagall, who accepted the chance to escape. (Explaining his refusal, Matisse wrote his son Pierre, a New York art dealer, "If everything of any worth flees, what will remain of France?") There is no evidence that Dr. Barnes sent the name of Soutine or anyone else to the emergency committee. It is unlikely that any other source handed Fry a list with Soutine's name on it. In fact, Soutine's name never comes up in any of the accounts of the work of Fry and Bingham.

Although Soutine was esteemed in Paris as at least the equal of Chagall, he was far less known in the American art world. Chana Orloff's claim that "there were certainly no lack of Americans who would have saved Soutine" was exaggerated. Soutine enjoyed a major place in Dr. Barnes's collection, but Barnes showed his private collection to few outsiders. Moreover, Soutine, unlike Chagall, was not adept at making and maintaining contacts with patrons and museum officials.

In any case, Soutine was hiding in Paris while Fry and Bingham were active. They would have had difficulty finding him even if they had tried. If word did reach him that some Americans in Marseilles were helping artists escape, attempting a journey that far south probably struck him as too dangerous. To a sick man afraid to walk the streets of Paris, Marseilles would have seemed very far away.

The fall of France and the occupation by German troops was a frightening time for the School of Paris. Not only did well-known artists like Chagall feel they were marked for arrest; every other Jewish

artist either hid within the city or fled. Mané-Katz, who dealt in Jewish themes, and Moïse Kisling, who liked to paint nudes with big black eyes, headed toward Marseilles and somehow made their way through Spain to Lisbon and the United States without Fry's help. Chana Orloff slipped across the border into Switzerland. France is a large country, and many artists, especially those who liked to paint landscapes, knew the countryside well and found familiar places in which to hide. Soutine's Vilna schoolmates, for example, rushed to the unoccupied zone of France, Pinchus Krémègne to the village of Céret (where the young Soutine painted so many landscapes) and Michel Kikoïne to the town of Toulouse.

The art scene was further depressed in Paris because a large number of collectors and dealers were Jewish. They, too, were forced to flee or hide, leaving their collections for German plucking. The Nazis stored the confiscated art in the Jeu de Paume museum just off the Place de la Concorde. Hermann Göring, who headed the German Luftwaffe, scoured the stolen goods there more than 20 times to see what was fit for his own personal collection and what was fit for Hitler's proposed new art museum in Linz. About 20,000 works of art were transported by train from the Jeu de Paume to Germany. Some works by Picasso, Joan Miró, Ernst and others—the kind of modern art that Hitler despised as degenerate—were burned.

In the summer of 1942, the fears of those who fled or hid proved justified. On July 16, French police, aided by young toughs, began a two-day roundup of Jews, mostly foreign born, in the Paris area. The police made no distinctions based on skills and professions. It did not matter if you were an artist or a doctor or a teacher or a housewife or a child. Almost 13,000 Jews were detained, most taken to the Vélodrome d'Hiver, where Soutine used to go to watch catch and where Garde had been detained. After five days, they were moved to a detention camp in Drancy outside Paris, where they awaited trains for deportation to almost certain death in the Nazi extermination

camp at Auschwitz in Poland. A month later French police began a roundup of more than 7,000 Jews in unoccupied France, also transporting them to Drancy for deportation. These roundups and deportations continued throughout France for two years until Allied forces liberated the camp at Drancy in August 1944. A reading of various lists makes it clear that at the very least, 20 artists of the School of Paris died in Auschwitz and other German death camps during the war. The actual number was probably much higher.

Despite the German occupation, the art scene in Paris during the war was lively, but without Jews. That, of course, pleased the anti-Semitic critics who had been warning the nation that these immigrants would judaize pure French art. Reviewing the latest art in the 1941 Salon des Tuileries, Lucien Rebatet of the Nazi-admiring *Je suis partout* newspaper, gloated, "Jews, *métèques* from the Orient and from Central Europe, have fled at last. . . . Disencumbered of their presence, the new Salon has now an air of probity and elegance."

The critic Camille Mauclair, who had spent many years condemning Jewish artists, tempered his own gloating with a warning that it was easier to eliminate the Jews than their influence. "All [Jewish] galleries are finally closed!" he wrote. "All the Jewish critics excluded from the newspapers. All of this is excellent! Yet the purge is far from over. The Jewish poison will only dissolve itself slowly."

The place of the immigrant painters of the School of Paris was soon taken over by their French-born contemporaries in the French School of painting. This did not include the old French masters of painting—Henri Matisse and Pierre Bonnard, both in their 70s at the fall of France. They continued their work but resided far from Paris. Pablo Picasso, known for his antifascist canvases during the Spanish Civil War, maintained his studio in Paris but did not show any work.

Although some young artists managed to produce modernist work for small brave galleries, most of the paintings produced under the German watch came from painters who had lost their creativity

and excitement, such as André Derain, the former fauvist ally of Matisse, and by a large contingent of little-known painters who had never been able to compete with the immigrant painters in the past. Their works were crafted to avoid any hint of degenerate art. The result was an abundance of mild art that did not offend the German occupiers and is little remembered today.

In 1941, eleven of the occupation-era painters and sculptors, led by Derain and Maurice de Vlaminck, traveled to Germany at the invitation of the Nazi government. Paul Belmondo, the father of the actor Jean-Paul Belmondo, was among the sculptors. The cubist painter Georges Braque refused to go. The guests spent two weeks at banquets and art tours in six cities including Vienna and Berlin. In Berlin, they viewed the models for Albert Speer's futuristic Berlin and visited the studio of Hitler's favorite sculptor, Arno Breker. French patriots looked on *Le Voyage,* as it became known, as a betrayal and an act of collaboration with the Nazis. After the war, French officials banned Derain, Vlaminck, Belmondo and several of the others from exhibiting their work in the official salons in Paris for one year. After so many hate-powered warnings about the *métèques* sullying France, it was the French-born artists who had stained the honor of their nation.

FOURTEEN

MARIE-BERTHE, HIDING AND
A DESPERATE DASH TO PARIS

THE GLAMOROUS AND CAPRICIOUS MARIE-BERTHE AU-
renche took care of Soutine about as long as Garde had, but she was
far different. Marie-Berthe "enthralled him," wrote Pierre Courthion,
the Swiss art historian. "She pampered him. . . . She reconciled the
Russian painter with the French milieu that he had chosen since his
youth but a milieu with which he was never much at ease. . . . Strange,
a little crazy, a woman of captivating beauty, she shared with her com-
panion an incurable aversion to cleanliness." She guarded Soutine
from the German Gestapo and the French *milice,* as the French se-
cret police were known, but she was less assiduous than Garde about
maintaining his health.

Marie-Berthe Aurenche was born in the little town of Pierre-
latte in the southeast corner of France in 1906. Her father, who soon
moved the family to Paris, was wealthy and filled with nostalgia for
the good old royalist days of emperors and kings. Her brother, Jean,
two years older, would become a screenwriter, best known for his

screenplay for Marcel Carné's 1938 film *Hôtel du Nord*. According
to Jean, she was an unexpected and unwanted child, and she felt this
lack of love throughout her life. She did poorly at school, and, when
she was 16, her parents sent her to a convent on the British island of
Jersey. Bouts of depression led to suicide attempts and, in later years,
alcohol and drugs. But she was regarded as an extraordinary beauty;
her first job was as a teenage model for the Chanel fashion house.

Bored and tired of modeling, she left Chanel to join the Van Leer
art gallery as a secretary and sales clerk. Van Leer specialized in sur-
realist paintings, and she met Max Ernst when the gallery staged an
exhibition of his work in 1926. The two fell in love, a coupling that in-
censed Marie-Berthe's father. He had contempt for Jews, for Germans
and for older men fooling around with his 20-year-old daughter. The
35-year-old Ernst, who was not Jewish, fit two elements of the profile.

The couple defied him by living together and hiding throughout
Paris. Marie-Berthe's father, hoping to persuade the government to ex-
pel Ernst, hired a posse of private detectives to find them. One after-
noon, when the couple arrived in a cab to join their friends at a café,
Marie-Berthe's father and his detectives suddenly appeared and circled
the cab. In the confusion, André Breton, the guru of the surrealists and
the author of their manifestos, suddenly stepped in front of the detec-
tives and shouted, "Max Ernst. That's me." The detectives grabbed
Breton, letting Ernst and Marie-Berthe rush away. The couple hid on
the islands of Ré and Noirmoutier off the Atlantic coast of France for
six months until Marie-Berthe reached the age of 21, which allowed
her to marry without parental consent. They were married in 1927.

Marie-Berthe became a favorite of the surrealists. Man Ray, the
American photographer, liked to shoot portraits of her. Luis Bu-
ñuel, the Spanish director, gave her a small part in his movie *L'Age
d'Or*. Breton evidently used her as a model for the main character of
his novel *Nadja*. After ten years, however, Ernst fell in love in Lon-
don with an English artist named Leonora Carrington. She was 20

years old, the same age Marie-Berthe had been when Ernst met her. In Paris, Marie-Berthe heard about the affair. When she arrived in London later to meet Ernst, she wore a dress slit from top to bottom with nothing on underneath. "This is a dress suited to an abandoned woman," she said. "She does not deserve better."

After Ernst left her, Marie-Berthe survived two suicide attempts in Paris, one by jumping into the Seine, the other by jumping out of a hospital window. Her brother believed her depression over the breakup was deepened by an illegal abortion forced on her several years earlier by Ernst, who did not want any children.

Marie-Berthe met Soutine in a Montparnasse café in 1940 when she was 34. According to a long newspaper article she wrote a dozen years later, her only published memoir of the affair,

> He was standing, drinking a lime tea, the only drink he was al-
> lowed. In spite of his forty-six years, he kept a great air of youth-
> fulness, much like the self-portrait of Rembrandt in the Louvre.
> Soutine reflected the same aspect of power, of kindness and of di-
> rectness in his own person—a round face . . . a full nose, a round,
> thick mouth with a singular expression of delicacy, a mouth dif-
> ficult to define, mobile like that of children, changing form with
> the mood of the moment, with curious and deep black eyes, with
> white hands that strike you at first with their beauty—fine and
> muscular at the same time. His voice had an accent of ardent sin-
> cerity. I was surprised by his tone of perfect politeness, stamped
> with reserve, and with his neat appearance, one and the other con-
> trasting with the legend that has grown up around Soutine. Was
> this the man they portrayed as brusque and wild?

Marie-Berthe accepted Madame Castaing's suggestion that she move in with Soutine, but she did not realize then how much he suffered from his illness. "When we ate together at cafés in the

Saint-Germain-des-Prés neighborhood," she wrote, "he succeeded in fooling me by breaking many of the rules of his diet. I would only discover little by little the constraints and sufferings that he endured for twenty years because of his stomach ulcers."

Soutine continued to live in Paris while the ordinances against Jews piled up. Jews could not own businesses, radios and bicycles; practice their professions; leave their homes after an 8 P.M. curfew; or attend concerts or see movies or walk into libraries. They were supposed to wear yellow stars and could be rounded up at any time for deportation from France. When a worried Chana Orloff urged Soutine and Marie-Berthe to slip into unoccupied France, the artist insisted that he would not find enough milk there for his ulcers.

Paris, of course, had changed a good deal since the fall of France. Black and red flags of the Third Reich with their Nazi swastikas billowed out from the façade of the Hôtel Meurice on the rue de Rivoli. The Germans had seized the hotel for use by the German army during the occupation. Foreign tourists no longer filled the outdoor cafés, their places largely taken by German army officers. As gasoline became expensive and in short supply, more bicycles than cars moved down the boulevards. The Louvre was closed, for all its paintings had been transferred to small museums throughout the countryside before the invasion. The Germans soon reopened the museum even though it displayed only sculpture.

Yet if you were not a Jew or communist in hiding or did not feel repelled by so many swastikas and German soldiers, you could still experience some of the old pleasures of Paris. After closing down for a few weeks, the theaters and music halls reopened. Some of the best-known singers—including Maurice Chevalier, Edith Piaf and Charles Trenet—continued to perform. Since a large number of the patrons of the cabarets were German, the singers usually offered a German song or two. One of the most popular was "Bei Mir Bist du Schön" (To me, you are beautiful), though neither the performers nor

the audience realized that the song was actually written for a Yiddish musical comedy in New York. The movie houses reopened, showing only French and German movies. The Paris Opera, known as a favorite building of Hitler, was one of the first to reopen. German army officers usually acquired a large number of tickets and clustered together during intermissions and moved in unison through the salons, their boots clanging.

Soutine and Marie-Berthe did not spend any time at these nighttime spectacles, but they did enjoy eating out at some of his favorite neighborhood bistros. Coming home from dinner one night, they were shocked to find that a police search had ended at 18 Villa Seurat only minutes before. They must have passed the plainclothes policemen walking away from the building. The police would surely return. The time had come to hide.

At first the couple took refuge in the apartment of Marie-Berthe's parents, but her father did not want them, and Soutine did not feel safe there, so they left in two or three weeks. Marie-Berthe then led Soutine to 26 rue des Plantes in the outer reaches of Montparnasse, where Marcel and Anne Laloë lived in a large apartment. Madame Laloë was a celebrated singer who used the stage name Olga Lucher, Laloë was a little-known painter, and the couple were old friends of Max Ernst. Marie-Berthe and Soutine arrived well past the curfew, and the Laloës were hesitant about opening the door. But they recognized Marie-Berthe's voice. She excused herself for arriving at that hour but whispered that her Jewish friend needed to hide from the German Gestapo and the French police. She pointed to a figure hidden in the shadows in the corridor.

The Laloës were astounded to discover that the figure was Soutine, a painter they admired a great deal. They agreed to harbor the couple in a guest bedroom. While Soutine and Marie-Berthe took refuge in the rue des Plantes in mid-August 1941, the French police rounded up more than 4,000 Jews and interned them at Drancy for

deportation to Auschwitz. Soutine and Marie-Berthe had decided to hide just in time.

Soutine remained in the apartment during the day but took a bit of air every day by accompanying Laloë on his evening walk with the dog. After a couple of months, however, the building's concierge, who had spotted the extra person at the walks, called on Laloë and asked him for an official list of guests staying in the apartment. The concierge did not threaten to denounce Laloë to the police, but that possibility was implicit in his request. It was a criminal offense to hide a Jew from the police. A new refuge had to be found for Soutine and Marie-Berthe.

THE LALOËS WERE FRIENDS of Fernand Moulin, a veterinarian who was mayor of the commune of Richelieu near the town of Chinon in the Loire valley. The area was not in unoccupied Vichy France, but it was heavily agricultural without many German troops. When asked if he could help, Moulin, who was a collector of paintings, replied, "Send your protégé. I'll find him a place to stay." Soutine and Marie-Berthe made their way to Richelieu, where Mayor Moulin welcomed them. Since Richelieu had a detachment of a few German troops, the mayor installed them a couple of miles away in Champigny-sur-Veude, a small village that was still part of his commune.

They went to Champigny for refuge, not for the scenery. But Soutine could not hide his disappointment at the countryside. "Oh, this flat country, these straight trees," he said. "I need bent and twisted trees." But his mood would change. He soon found his trees, and Marie-Berthe said that "little by little an accord was sealed between the painter and the landscape." He especially liked to see the wind bend a row of poplars, "creating the atmosphere of violence, anxiety and mystery that he needed."

According to the 1936 census, Champigny had a population of 838. Soutine biographer Michel Lebrun-Franzaroli says that, after

the defeat of France in 1940, that number was augmented by Parisians who fled to live with relatives in the countryside. It was a generally rural community, and Marie-Berthe and Soutine stood out as rather odd members of the crowd. Soutine, even when not painting, walked about in tattered and paint-smeared clothing, his work uniform for many years.

They were given a room at first at the Hôtel-Restaurant du Commerce on the road to Chinon, the largest town in the area. Owned by Madame Emilienne Coquerie, the Commerce had a bar and restaurant downstairs and rooms on the floor above. Soutine offered to pay for their room and board in paintings, but Madame Coquerie demanded francs. Despite this, the couple stayed at the hotel for more than a year, then rented rooms in various homes before settling in an even smaller hotel, the Café Saint-Louis. Soutine biographer Clarisse Nicoïdski claims they had to move often because landlords found them too slovenly as tenants.

While Champigny was a treeless village of nondescript two-story cement houses, nearby Richelieu boasted a palace built by Cardinal Richelieu in the seventeenth century and large public plazas with massive trees. Soutine sometimes painted the plazas and trees there, but the presence of the German troops frightened him. Luckily, he soon found the nearby forest of poplars by the Veuve River, and that kept him away from Richelieu.

Soutine would paint 10 or 12 hours a day, according to Marie-Berthe, working until nightfall. That was a return to work habits somewhat like those he had in Céret in his youth, habits he had given up when he became established and a friend of the Castaings. "When he came home he would have to change his shirt drenched in sweat even when he worked in the coldest weather," Marie-Berthe wrote. He would work in a storm, and she said, "I have seen him paint in a torrential rain." When he ran out of paints, Laloë supplied him with more.

According to Nicoïdski, the artist painted a portrait of Marie-Berthe while they lived in Champigny. But the beautiful and willful Marie-Berthe was upset with the result. He had turned her into an ugly woman. In fact, her features in the painting were monstrous. Unlike Mademoiselle Garde, Marie-Berthe did not obey his admonition to stay away from his paintings. One day, while alone, she took a brush and Soutine's palette and tried to alter the features. Soutine and Madame Laloë, who was visiting, suddenly walked into the room. Soutine's furious reaction was predictable. He picked up a large pair of scissors and cut the canvas into shreds. No Soutine portrait of Marie-Berthe is now known to exist.

Soutine also painted portraits of some of his neighbors. Christiane Delaunay, the daughter of a seamstress, posed for him when she was six years old. Recalling the experience 70 years later, she told a reporter for a local newspaper, "He was strict and said very little except to scold me for changing my dress between two sessions."

The Soutine Catalogue Raisonné, published in 1993, includes 22 paintings from the two years at Champigny. They continue the later style that Soutine developed while painting near the Castaings' country home just outside Chartres. There are no more still lifes of butchered meat; instead he painted a couple of canvases of live pigs. His landscapes are no longer in turmoil, no longer filled with houses churning and climbing. Yet they are still full of tension and impending danger. Some of the landscapes now show happy, playful children in the foreground. But it is hard not to fear that nature will soon turn on them. The portraits, however, continue in the same mood as the portraits of his youth, tense with fear, anxiety and unbearable mystery.

Soutine was not really hiding in Champigny. Local officials knew he was there. When the time came for Jews to wear a yellow star, the local rural police officer showed up at the couple's door, embarrassed. He had a form for Soutine to sign that would attest, if

signed, that the artist was not a Jew. Marie-Berthe wanted Soutine to convert to Christianity some day, but she knew she had failed so far to persuade him to do so. She took the form and ripped it up, and the police officer had to hand Soutine his yellow star.

"I believe that the moment he received the yellow star," Marie-Berthe wrote, "he realized that the universe he regarded as his own was different for a foreigner." Soutine hid the star in a pocket, avoided main roads and the village of Richelieu and tried to keep far from gendarmes. If he came upon a group of gendarmes, he would clip the star on himself. Once he left the gendarmes behind, he would slip the star back into his pocket.

Despite his nervousness, Soutine knew that he lived in Champigny under the protection of the mayor of the commune, and, as he discovered in Civry, the mayor can wield great power in the French bureaucracy. The French police rounded up Jews for the Germans to deport by trains to Auschwitz, and if the mayor did not order the police to arrest Soutine, the police would not arrest him. No one in Paris was likely to worry about the lack of Jews arrested in a rural hamlet as tiny as Champigny.

But cleanliness and health were problems. Neighbors said Soutine had the look of a *clochard*—the French word for tramp. Gone was the debonair air that he tried to cultivate after Dr. Barnes made him a relatively rich artist. Gone was the neat look, complete with a fedora, featured in photos with Madame Castaing. He had reverted back to the appearance of his old impoverished days. Neighbors also said they found Marie-Berthe lacking in cleanliness. Christiane Delaunay recalled that she was overcome by waves of nausea one day when Marie-Berthe handed her cocoa in a dirty glass. "Marie-Berthe was truly dirty," Christiane said, adding, "She must have been drugging herself because she was always so excited."

Although Soutine kept apart from most people in Champigny, he did befriend a cabinetmaker named Crochard, who owned the pigs

that Soutine painted. Even more important, he defied the German occupiers and listened to the radio news from London every evening. He was unusual in Champigny, an anticlerical leftist. Soutine visited often, and Crochard let him listen to the wireless radio to catch the latest news. When he heard the BBC begin by announcing the number of the days that had passed "in the battle of the French people for their liberation," Soutine would lean close to the set. The Voice of America reached them as well, and Soutine and Marie-Berthe were pleased one evening to hear the voice of André Breton.

"He had little sympathy for the Soviet regime," Marie-Berthe wrote about Soutine years later, "but he became very emotional about the sufferings or victories of the Russian people. He would stand up, sit down, in great agitation. He would talk about the Russian news constantly in the conversation that followed the broadcast."

Although Soutine avoided Richelieu and its German troops as much as possible, the troops came to Champigny one night. Soutine and Marie-Berthe, staying at the Saint-Louis, forgot to close the curtains of their room while a light was still on. Suddenly they heard a commotion in the street. They heard the cry "light" in French and then the thick, guttural sounds of a lot of words they did not understand. The hotel owner knocked on the door. "The Germans are here," he cried. Soutine and Marie-Berthe followed him downstairs to the lobby. Someone had reported their accidental violation of the nightly blackout. After the owner closed the curtains and persuaded the Germans that nothing else was amiss, the troops left Champigny.

The Castaings visited Champigny and were pleased when Soutine showed them his nearly completed painting of a large oak tree in Richelieu, which they agreed to buy. But, when Madame Moulin, the mayor's wife, delivered it in Paris, the Castaings discovered that Soutine had finished the work by cutting off a large strip of the canvas. They refused to accept it. Soutine proposed a painting of pigs in its place, but they rejected that as well. Madame Moulin then offered

the oak tree canvas to the dealer Louis Carré, and he bought it immediately. The incident angered the Castaings.

Soutine's health worsened. The most detailed description of his condition was put together later by art historian Pierre Courthion who interviewed the Laloës and read their letters from Marie-Berthe. The Laloës visited Champigny during the Christmas holidays of 1942 and found Soutine walking with a cane. He suffered spasms of pain and talked of returning to Paris to consult the specialist Dr. Guttmann. Laloë took walks with Soutine and found that the illness had not destroyed his attitude. "There was a great deal of allure in the anguished, painful ugliness that gave him his style," Laloë said later. Soutine asked Madame Laloë to sing passages of a Bach chorale. Later, Marie-Berthe wrote to the Laloës, "He has an appearance that worries me. He is all white. . . . For three weeks he has eaten only milk. Usually his attacks do not last as long as they do now."

Dr. Guttmann no longer lived in Paris; he had taken refuge in Montpellier when it was part of unoccupied Vichy France. That status, however, had changed a month before Christmas. When Allied forces invaded French North Africa in November, German and Italian troops marched into the rest of France. That meant it was no longer so difficult to travel from their zone to Vichy France. Soutine and Marie-Berthe began talking about leaving Champigny and settling in Montpellier near Dr. Guttmann. In the meantime, Dr. Guttmann had sent them advice by letter about diet and medicines. Marie-Berthe asked his assistant in Paris, Dr. Lannegrace, to visit them in Champigny, but Dr. Lannegrace said this was not possible. They would have to come to Paris for a consultation. By July 1943, Soutine was too sick to travel, whether to Paris or Montpellier.

About the same time, Garde, armed with her new false identity card, boarded the train from Carcassonne to Paris, her fare paid for by Madame Castaing. A room was set up for her at the home of Madame Castaing's brother. Madame Castaing told her that Soutine

wanted her back. "Only Garde knows how to take care of me," she quoted Soutine as telling her. "If I remain here, I will die soon."

There is no doubt that Madame Castaing was disappointed with her choice of Marie-Berthe as Soutine's protector. As Soutine's health worsened, she had to deal with her refusal to heed Maurice Sachs's warning that choosing Marie-Berthe would sign Soutine's death warrant. But she is the only source for the belief that Soutine had soured on Marie-Berthe and asked for Garde's return. That raises the question, which we cannot answer, of whether Madame Castaing exaggerated or misinterpreted Soutine's comments.

In any case, there was little Garde could do. She felt that she could not just barge into Champigny; Marie-Berthe would not allow it. Nor could she ask Soutine to travel to Paris alone, as the pace of roundups of Jews had accelerated there. She asked Madame Castaing to give Soutine her Paris address. If he wanted her now, he would let her know.

On July 31, Soutine was examined by a Dr. Renvoysé, who ordered him transferred immediately to the hospital in Chinon, 12 miles away. His problem with stomach ulcers was complicated by anemia. A town of 6,000 in the Loire River valley, Chinon was well known to tourists because of the Château de Chinon, a medieval castle. Marie-Berthe registered Soutine in the hospital as Charles rather than Chaim to hide his Jewish identity. She also placed a Catholic religious medal around his neck.

The doctors spent six days examining and testing Soutine. According to Courthion, when Laloë visited him in the hospital, he found Soutine "twisting like a worm, the covers hurled aside, hardly recognizable." A desperate Marie-Berthe asked the nursing nun if there was any water in the hospital from Lourdes. She had none but gave Marie-Berthe holy water from a nearby church.

Soutine drank a glass of the water and, according to Marie-Berthe, told her, "My God, this water is good. What is it?" She

replied, "Some serum that the sister brought to you." Soutine asked for more. In her description of the incident, Marie-Berthe added, "We had sometimes talked about the Christian religion, and I had the impression that Soutine wanted to know it better."

The doctor in charge of the case said surgery was necessary. The hope of a cure revived Soutine a bit, and he asked for café au lait and biscuits. The decision was made to transport Soutine to Paris for the surgery. Marie-Berthe, in her memoir, implied that the decision was made by Soutine himself. But a different story came from the doctor in Chinon. He told art historian Pierre Courthion in an interview that he allowed Soutine to leave the hospital only because he thought Marie-Berthe was his wife. If he had known they were not married, he would have overruled her and performed the surgery immediately in Chinon.

The journey to transport Soutine to Paris for an emergency operation turned into a rather relaxed affair. The most detailed account of the halting pace to Paris—and a defense of Marie-Berthe's role in it—comes from Michel LeBrun-Franzaroli, a recent biographer of Soutine.

According to LeBrun-Franzaroli, an ambulance picked up Soutine, Marie-Berthe and Dr. Guttmann's assistant, Dr. Lannegrace, at the Chinon hospital early on the morning of August 6. Dr. Lannegrace had interrupted a vacation with her family to join them. The ambulance carried a black and white banner—an old European symbol denoting a medical emergency—in hopes that would persuade German troops not to stop them.

The ambulance stopped off at Champigny first so that Soutine could put his studio in some order and Marie-Berthe could pick up some paintings in case they needed more money in Paris. Soutine wanted to spend some time alone with his palette, his easel and his canvases.

Chinon is about 175 miles south of Paris. Nowadays a car can make the trip in less than four hours. In those days, the trip, over

narrow roads, took twice that time or even longer. But it did not take more than a day. Yet the ambulance did not arrive at the Maison de Santé, a private clinic at 10 rue Lyautey in Paris, until the afternoon of the next day. Marie-Berthe wrote that they drove on roads "full of light, then of night." The surgeon, a Dr. Olivier, operated on Soutine, removing segments of his stomach, on August 8, the day after their arrival at the clinic. Soutine died at 6 A.M. on August 9 and was buried in Montparnasse cemetery on August 11. Marie-Berthe arranged to cover the grave with a slab of stone displaying a carved Christian cross.

Marie-Berthe was vilified for many years by Soutine's friends for three aspects of his death and burial. The first was the refusal to allow the operation in Chinon. The second was the inexplicably long road trip from Chinon to Paris.

The third, her worst offense in the eyes of his many Jewish friends, was the cross on his grave.

LeBrun-Franzaroli, one of her rare defenders, insists that she has been demeaned unfairly and is surely a scapegoat. He has speculated that, during the war, the Chinon hospital did not have the facilities or supplies to perform the operation. As for the lengthy road trip, LeBrun-Franzaroli assumes the couple spent several hours in Champigny before setting off for Paris and, to avoid arriving in Paris after curfew, stopped for the night at a hotel or friend's house somewhere along the way. Marie-Berthe's long newspaper article in 1952, "The Last Years of Soutine," failed to give detailed explanations that might satisfy her detractors. As for the cross, which even LeBrun-Franzaroli does not defend, she made no attempt to describe Soutine as a convert to Christianity but only as someone eager to learn more about the religion.

About 8 A.M. on August 11, Garde received a telegram signed "Marie-Berthe Aurenche-Soutine," listing a Paris phone number and asking for an urgent phone call. Garde called immediately and,

according to her memoir, their phone conversation followed this course:

"Madame Marie-Berthe Aurenche?"

"That's me."

"This is Garde. I received your message. Tell me the truth. Soutine is dead?"

"How do you know?"

"You would not have telegraphed me if he were still alive."

"That's true, but I have to tell you that in the last days he asked for you several times. I could not make up my mind to call you. They had to operate on him. No one could save him. He died the day before yesterday. The services will take place in a little while at the Monparnasse cemetery. Come at two o'clock. We are going to meet at the main gate."

Garde attended the funeral. There were only a few people there, including Picasso. Soutine's Jewish artist friends were too frightened to show themselves in public. To hide his religion from any French policeman or German soldier, Marie-Berthe listed Soutine's name on the funeral invitation as "Monsieur Ch. Soutine."

After the funeral, Garde accepted a proposal by Marie-Berthe that they travel to Champigny together to collect what was left there. In her memoir, Garde said this trip allowed her to look at Soutine paintings for the first time in her life. But she did not say what she thought or felt about them. Marie-Berthe proclaimed her right to full ownership of all the remaining paintings. All that Garde found for herself were a pair of leather suitcases that once belonged to her father. As a gift, Marie-Berthe gave her one painting, a gesture Garde greatly appreciated. A month later, however, Marie-Berthe berated Garde for accepting the gift and demanded its return. Garde refused.

In her memoir, Garde tried to moderate any bad feelings toward her rival. "I reflected with bitterness that she had taken my place," she wrote. "But that had happened at a moment when I was kept far

from him and found it impossible to rejoin him. I therefore had no reason to hold a grudge against my replacement, and his death made any idea of rivalry pathetic."

And yet, she went on, "I could not prevent myself from thinking that Marie-Berthe had not been the good genie of Soutine. She had hardly nursed him, let alone saved him. But it is fair to add that Soutine's health had been very fragile for a long time. Could I myself have achieved a miracle? I had once hoped so, but I could not now be reasonably sure." Dr. Tennent had once guessed that Soutine could live no more than another five or six years, and Soutine had died six years later. In any case, any chance for a miracle had been wiped out not by Marie-Berthe but by the German defeat of France and the hunt for Jews that followed.

In the late 1970s, Garde appeared on French television and continued to describe Soutine as "the love of my life." Marie-Berthe had died long before. She committed suicide in 1960 and was buried alongside Soutine under the stone slab and its cross.

FIFTEEN

THE AFTERMATH

WORLD WAR II OBLITERATED THE SCHOOL OF PARIS. HIT-
ler, the Nazis and the Vichy anti-Semites could count it as one of their
victories—though one not as awful and unspeakable as Auschwitz—
in their drive to rid the world of all things Jewish. It's possible, of
course, that the School of Paris would have petered out by the mid-
1940s anyway. In the history of art, brands and fashions often have
short lives. But trying to conjure what might have been is foolish. The
reality is that the Nazi Germans and the vicious French *Milice* sent
most Jewish artists fleeing from Paris. Those who remained either
lived a frightening life of evasion for more than four years or slept in
the wrong apartment on a fateful day and died in Auschwitz.

After the war, a surprising number returned to Paris. But they
were too small a group and too often away to become an obvious daily
presence in the cafés of Montparnasse. Michel Kikoïne, for example,
Soutine's old school buddy who had fought with the defeated French
army and then hid in Toulouse, returned to Paris, took several trips
to Israel but did not settle there and then lived in Paris until he died

in 1968. The sculptor Ossip Zadkine, who had escaped to New York during the war, also returned to Paris and resided there until his death in 1967. Both Mané-Katz, who had escaped to the United States, and Chana Orloff, who had spent the war years in Switzerland, returned to live in Paris but made so many trips to Israel that they died there during visits, Katz in 1962 and Orloff in 1968. There is a Mané-Katz Museum in Haifa, Israel.

Some returned to France but not Paris. Chagall, exiled in the United States, returned in 1947 and eventually settled in Saint-Paul-de-Vence outside Nice on the Riviera, where he died in 1985 at the age of 97. Moïse Kisling, who had enormous commercial success in both New York and Los Angeles during the war, returned to his ransacked Paris studio in 1946 but spent most of his time in Sanary on the Mediterranean, where he died in 1953. Pinchus Krémègne, the old schoolmate of Kikoïne and Soutine who took refuge in Céret in Vichy France during the war, remained there afterward, until he died in 1981 at the age of 90.

Others, such as the cubist sculptor Jacques Lipchitz, never returned to France except as visitors. Lipchitz, one of the artists rescued by Varian Fry and Hiram Bingham IV at the beginning of the war, decided to remain a resident of the United States. But he spent several months of each year in Italy and died in Capri in 1973 at the age of 81. He was buried in Jerusalem.

The story of the School of Paris became somewhat hazy after the war, especially in the United States, when the world capital of art moved from Paris to New York. Postwar Europe was too poor and dazed and involved in reconstruction to revive the vibrant and commercial prewar art scene. Soon Jackson Pollack, Mark Rothko and other Americans dominated contemporary art with their large abstract expressionist paintings. In all the excitement in New York over a new movement in art, it is not surprising that the School of Paris was mostly forgotten in America.

But America did embrace the school's three main individual artists—Chagall, Modigliani and, to a lesser extent, Soutine. Academic study of the artists, of course, led to some research into the School of Paris. But most museum goers came upon the subject rarely. The last major show devoted to the group—"The Circle of Montparnasse: Jewish Artists in Paris 1905–1945"—was presented by the Jewish Museum in New York in 1985, thirty years ago. In 2011, the innovative curator Michael R. Taylor, now director of the Hood Museum of Art at Dartmouth College, put together a small exhibition at the Philadelphia Museum of Art called "Paris Through the Window: Marc Chagall and His Circle." Aside from a good number of works by Chagall, the show included paintings and sculptures by Soutine, Modigliani, Lipchitz, Jules Pascin, Orloff and Kisling, making it clear that Chagall, far from being a solitary figure, came out of the School of Paris. But the show had little impact outside Philadelphia.

The French, of course, are more familiar with the School of Paris. French museums often identify the painters as coming from L'École de Paris. Publishers offer books on the phenomenon, and scholars devote a good deal of research into its history. A major exhibition on the school was mounted in Paris in 2001. The era—called the "Hot Hours of Montparnasse" in a 2006 television documentary—is a significant part of Parisian history.

The French treat Chagall, Modigliani and Soutine as the giants of the era and lavish far more attention on Soutine than he attracts in America. But they do not ignore the artists of the second rank. From time to time shows in small galleries and monographs are devoted to Pascin, Kisling, Kikoïne, Krémègne and others. Nadine Nieszawer, who comes from a family of dealers and is a specialist on the School of Paris, runs a Web site, ecoledeparis.org, that offers the biographies of 150 "Jewish artists of the School of Paris" in French, English and Russian.

When World War II ended, Chagall was the only School of Paris painter of international standing still alive. He would live for another four decades and become one of the most popular and beloved artists of the twentieth century. He was probably most loved for his surrealist paintings of shtetl life in old Russia. Some of his images became icons of Jewish life and history. Fiddlers on rooftops were his creation, and so were the wonderful scenes of him and his wife, Bella, kissing and floating upside down over their village.

He also turned to other media after the war, and the calm and hues of his stained glass windows delighted countless people throughout the world. In the early 1960s, he completed windows for both the Cathedral of St. Étienne in Metz in southeastern France and the synagogue of the Hebrew University Medical Center near Jerusalem. He called stained glass windows "the transparent partition between my heart and the heart of the world."

As a young man in Paris, he had never realized his dreams of designing sets and costumes for the great impresario Sergei Diaghilev and his Ballets Russes. While in exile in New York, Chagall finally had his ballet triumph, designing sets and costumes for Igor Stravinsky's "Firebird Suite" in performances at the Metropolitan Opera. An even greater triumph arose when André Malraux, the novelist who served as President Charles de Gaulle's minister of culture, commissioned Chagall to paint the ceiling of the Paris Opera in the 1960s, a great honor for an immigrant who escaped France during the war but still belonged nowhere else. Chagall completed the enormous work without charge, a gesture of gratitude toward his adopted country.

Time magazine soon wrote that "the history of modern art would seem vacuously cold without Chagall." Richard Brown, the director of the Los Angeles County Museum, said, "It's absolutely essential to have him." *Time* quoted a London dealer as insisting "The one painter sought by all museums is Chagall. He has already become an old master." John Russell, in his 1981 book *The Meanings of Modern*

Art, praised Chagall for using color and fantasy "to heal the hurt of living in a society which denied him certain fundamental human rights."

As he aged, Chagall grew more vain, avaricious, aloof and suspicious. But he still delighted his many fans. He was a short but handsome and dapper man with an appealing history. There was nothing bohemian or unsavory about his personal life. He had married his hometown sweetheart and lived with her, painting many portraits of her, until she died. There was no gossip about affairs with promiscuous models. No one ever found him drunk in the cafés of Montparnasse. He never made a disturbance in a public place.

There was a special appeal for Jewish admirers. Chagall still read the Bible in Yiddish. Most of his friends were Jewish. Though he was not a regular worshiper at a synagogue or fervently religious, he enjoyed most of the traditions, such as the Passover seder meal. He spoke very little English, but American Jews had no trouble identifying with him. Even when he tried his hand at ecumenical subject matter, no one ever doubted his identity.

Despite Chagall's enormous popularity and adulation, there was always a stubborn resistance among some in the art establishment who felt that there was not much worthwhile behind the sentimental façade of his work. Chagall himself fretted anxiously over his standing, fearing future verdicts of art critics and art historians. His fears proved justified. Yet neither his popularity nor the proliferation of Chagall exhibitions ceased. Long after his death, his name remained one of the most recognizable in twentieth-century art.

But he did not seem as original as he once had. In a lengthy article in 2013, Richard Dorment, the chief art critic of the *Daily Telegraph* in London, maintained that Chagall "became internationally famous without breaking new ground or attempting to renew his sources of inspiration." Dorment's conclusion was damning. "You could argue that his work has given more pleasure to more people than almost any

other 20th century artist," he wrote. "But in the final analysis, did he really contribute anything of significance to the history of 20th century art?"

When Pope Francis was elected in 2013, news stories reported that Chagall was one of his favorite artists and that Chagall's "White Crucifixion" was one of his favorite paintings. That 1938 painting, which hangs in the Art Institute of Chicago, depicts Christ on the cross, wearing a black and white Jewish prayer shawl for a loincloth, surrounded by scenes of later persecutions of Jews. Pope Francis's taste prompted James Elkins, a professor of art history at the institute's art school, to skewer the pope and the painter with one thrust. "Chagall is a common preference of viewers who are not interested in the art world," said the professor.

My own feeling is that Chagall painted some wonderful canvases in 1912 and 1913 when he lived in La Ruche in Paris. "Paris Through the Window" at the Guggenheim Foundation and "I and the Village" at the Museum of Modern Art (MOMA) always delight me. But the later rooftop fiddlers and floating Bellas and other fanciful scenes of shtetl life no longer seem exciting. Perhaps Chagall did so many of these scenes that he turned them into clichés.

Amedeo Modigliani achieved enormous popularity in the twentieth century—though not the same kind of love and adulation that fans showed for Chagall. But he was more prized. No work of a School of Paris artist ever sold for more than the $61.5 million paid for Modigliani's "Nu Assis sur un Divan" at a Sotheby's auction in New York in 2010. (The record auction price for a Soutine was $16 million in 2013. For a Chagall, it was $13.5 million in 1990.) Yet Modigliani, too, would probably fail the Dorment test of contributing something of significance to art history. John Russell does not even include him in his book on modern art. Perhaps critics like Dorment and Russell have set the bar too high. Can't we embrace great artists who have mesmerized us with the beauty of their works but contributed nothing

more to the history of art? Or, to put the rhetorical question in another way, isn't their beauty enough of a contribution? Admirers of Modigliani surely have good reason not to worry about the importance of their painter. In the first years of the twenty-first century, eight of his paintings sold at auction for more than $20 million each. He is linked in the public's mind with the great artists of the twentieth century.

In 2004 the Jewish Museum in New York organized a large Modigliani retrospective. The show, which went on to the Art Gallery of Ontario in Toronto and the Phillips Collection in Washington, was titled "Modigliani: Beyond the Myth." The title reflected the fear that Modi had become far better known for his antics than his paintings, that admirers were bidding more at auctions for a slice of his life than for a piece of his work.

There is no doubt that Modigliani's life was operatic. Suffering from tuberculosis, he rushed from café to café on Montparnasse every night, often with Soutine in tow, offering to draw a portrait on a napkin for a drink. And all through his short tormented life, Modi churned out wonderful portraits and nudes. His life story has been made into movies twice, in 1958 as *Les Amants de Montparnasse,* a French film starring Gérard Phillipe as Modi, and in 2004 as *Modigliani,* an American film starring Andy Garcia as the artist, though neither film made much of an impact.

It is true that Modigliani's café shenanigans pushed sales of his paintings in Paris soon after his death, but it is hard to believe than anyone bid $20 million to $61.5 million for one of his paintings in the twenty-first century because of his life story. I would guess that Modi's status depends on the appeal of his paintings, mostly his portraits, and here I detected another concern on the part of the curator of the 2004 exhibition.

Mason Klein, the curator, devoted some space to a discussion of the universality of Modigliani's portraits. "His art of portraiture balances a universal language of geometric form with the personal,

emotional, and political concerns of the individual," Klein wrote. By "universal language of geometric form," Klein meant Modigliani's habit in many paintings of omitting the pupils of the subject's eyes, lengthening the curvature of the neck and fitting the nose and mouth into an upside-down triangle. These habits may strike some viewers as gimmicky, repetitive and eventually tiresome. By calling them the geometric forms of a universal language, Klein struck a preemptive blow, cloaking what might seem like gimmicks in an aura of grand significance.

I think Modigliani will always be a great artist to admirers, like myself, and a charlatan to those who find him boring. I do not mean to contradict Klein. He may have come up with the key to understanding Modi. But I have never spent much time considering the universality of his subjects. I simply felt that his habits—habits, in fact, that make his portraits so striking—were carried over from his days as a sculptor. I have loved Lunia Czechowska, Modigiani's confidante, ever since I was a schoolboy without fretting over the length of her neck or her lack of pupils. Modi stamped a whole generation of the denizens of Paris for me. I can never read about Jean Cocteau without seeing Modigliani's portrait of a supercilious intellectual. The difference between the dapper, savvy dealer Paul Guillaume and the hopeless dreamer of a dealer Léopold Zborowski is set down starkly in their two portraits. At a time when many belittled the young Soutine as unwashed, unkempt and unmannered, Modigliani painted him as innocent and vulnerable.

Many contemporaries looked on Soutine as a great artist. Chana Orloff likened him to the Spanish master Goya. Dr. Barnes compared him to van Gogh. The renowned French art historian Elie Faure regarded Soutine as "the first—far and away—among living painters" and placed him on a level with Rembrandt. Jacques Lipchitz, praising Soutine for sometimes demonstrating the strength of Rembrandt and the "life" of Rubens, wrote, "He was one of the rare examples in

our day of a painter who could make his pigments breathe light. It is something which cannot be learned or acquired. It is a gift of God."

After World War II, Soutine's paintings were introduced to the American public in a 1950 retrospective at the Museum of Modern Art in New York. The dead painter evoked great excitement and enthusiasm, and many critics and artists extolled him as a pioneer of some of the latest trends in modern art. Soutine received the kind of accolades and status denied Chagall and Moldigliani for failing to change the course of art.

Soutine's portraits were acclaimed. Willem de Kooning, who called Soutine his favorite painter, said, "I've always been crazy about Soutine—all of his paintings. Maybe it's the lushness of the paint. He builds up a surface that looks like a material, like a substance. There's a kind of transfiguration." Francis Bacon praised the way Soutine laid down his paint on the canvas. Others regarded Soutine's painting as a forerunner of abstract art. Meyer Schapiro, the art historian, cited the Soutine exhibition as a factor in the development of abstract expressionism. Jackson Pollock painted one canvas as an homage to Soutine.

Yet Soutine failed to impress one of the most influential critics in postwar America: Clement Greenberg, often regarded as the guru of abstract expressionism. Greenberg did not know much of the work of Soutine, but he had heard so much praise that he attended the exhibition expecting to see the greatest expressionist painter since van Gogh. But these expectations, he said, "were disappointed."

Greenberg had great praise for the way Soutine "kneaded and mauled, thinned, thickened and rubbed" the pigment. "He was . . . one of those who succeeded best in converting the substance of pigment into signified emotion," the critic said before adding that Soutine "asked, perhaps, too much of painting" and what he intended "seems to belong too much to the provinces of poetry or music." Soutine, according to Greenberg, neglected the fact that painting was an

"art of space" that required the entire canvas to have a decorative unity of colors and shadows.

In what sounds like a direct contradiction, Jack Tworkov, the Polish-born American expressionist painter, said that Soutine's painting "contains the fiercest denial that the picture is an end in itself. Instead it is intended to have a meaning which transcends the dimensions and material. The picture is meant to have impact on the soul."

The excitement over Soutine dissipated in the decades after the MOMA show. My guess is that Greenberg's dissent did not have too much to do with that, for Soutine's work, in any case, did not fit easily into the role of a precursor to abstract expressionism. What matters in Soutine are the fierceness of his portraits, the turmoil of his landscapes and the darkness of his still lifes. The fact that some abstract painters mimicked some of his techniques does not add much to the power of his canvases.

The excitement over Soutine might have lasted longer if more of his work was available in American museums and private collections. But only Dr. Barnes had substantial holdings of Soutine, and he showed his collection only to his students and a few other lucky guests. Moreover, Barnes, adamant about his theories of art education, did not hang his Soutines together, a fact that diminished their impact.

On top of this, it was hard to identify and understand Soutine as a person. Biography should not count in appreciation of art, but it often does. Soutine did not have an operatic life like that of Modigliani nor a lovable public persona like that of Chagall. He was cripplingly shy and so lacking in the ways of commerce that he might have squandered his life if he had not been discovered by accident. His refusal to discuss his art made no sense. Perhaps his French and Russian were not, as he claimed, fluent enough to express his thoughts. Yet he was surrounded by native Yiddish speakers like himself, and none of them ever reported hearing him talk about his art.

One problem is that biographical tidbits about him usually emphasize that many Parisians looked on him as wild or mad, joked about him as unwashed and unkempt and gossiped about his fits of anger and failure to hold on to friends. Yet as we have seen in this book, there was another side to him. He would read and discuss Dostoevsky, Balzac and Flaubert. He spent months in continual conversation with Élie Faure, one of France's renowned intellectuals and political activists. He engaged in a lifelong study of Rembrandt in the museums of Paris, Amsterdam and London and could declaim about his idol at great length. And, despite his shyness, a succession of women found him gentle and charming.

A full understanding of Soutine and his work is often confused by the failure to find any sign of Jewishness in his paintings. This leads to disappointment in him and to a succession of convoluted theses by Jewish critics trying to find evidence of content that is not really there. These theories get in the way of understanding Soutine. No one tries to do this with the work of Modigliani, whose portraits and nudes also show no sign of Judaism. But Modigliani came from a sophisticated, assimilated Sephardic family in Italy. He could easily have assumed the role of a French painter in Paris. No one is surprised that his work does not seem Jewish. Soutine was different. He was the epitome of the impoverished, poorly educated shtetl boy who made his way to Paris and somehow became a great painter. Many Jews feel that he must have carried Jewish shtetl traditions to his work in Paris and are frustrated that they cannot find evidence for this.

Several art historians have worked hard over the years to maintain Soutine's stature in America. The most important is surely Maurice Tuchman, a curator of modern art at the Los Angeles County Museum of Art. Tuchman, Esti Dunow and the late Klaus Perls published a two-volume catalogue raisonné of Soutine in English, French and German in 1993. A third volume by Tuchman and Dunow is now in preparation. Though Soutine is hardly a household name in

the United States, he is regarded as a darkly original and significant avant-garde artist in the twentieth century. But his ranking and role are ill defined. There has not been a major exhibition of his work in the United States since 1998.

As might be expected, Soutine has much more standing in France. The interest, in fact, has intensified in recent years. There have been two major retrospectives in Paris in the twenty-first century, at the Pinacothèqe in 2007 and 2008 and at the Musée de l'Orangerie in 2012 and 2013. On top of this, the Pinacothèqe in 2012 exhibited the paintings that the businessman Jonas Netter received from the young Soutine and Modigliani in exchange for their stipends.

Even without special exhibitions, Paris offers a special bonus to Soutine's admirers. The Orangerie has a room chock full of Soutines, intensely colored spectacular canvases, wrought with emotion and surreal movement, all once the collection of the dealer Paul Guillaume. For Soutine admirers, it is the treasure trove. There is no greater concentration of Soutines anywhere else, not even in the Barnes Collection in Philadelphia. This collection ensures that Parisians cannot easily ignore Soutine.

The French treat Soutine as eccentric and special, an artist in need of great care and understanding. I have a feeling they are slowly trying to push him toward the pantheon of great French painters. They are not exactly sure where he belongs there, but they are right to push.

ACKNOWLEDGMENTS

I WAS HELPED IMMEASURABLY BY MY SON AND DAUGH-
ter-in-law, Joshua and Elodie Meisler, who acted as my research
associates and team managers in France while I wrote the book in
Washington. They contacted sources and kept me supplied with
recent catalogues, old news clippings, and obscure monographs to
make sure my archives on the subject, collected over many years,
were complete and up to date.

The book is based far more on textual material than on inter-
views. All the players in the story have died. I was able to interview
Madame Castaing in 1988 when she was 93 and wisely kept my in-
terview notes. A number of experts with special knowledge of the
era did take the time to reply to questions or help this book in other
ways. They include Barbara Beaucar, Elizabeth Kessin Berman,
Judith F. Dolkart, Anita Kassof, Michel LeBrun-Franzaroli, De-
borah H. Lenart, Charles Michaelson, Jan Rothschild, and Michael
R. Taylor. Institutions that proved invaluable include Archives Na-
tionales (Pierrefite-sur-Seine), the Barnes Foundation, Bibliothèque
Nationale, Musée d'art et d'histoire du Judaïsme (Paris), Musée de
l'Orangerie, Museum of Modern Art (New York), National Gallery
of Art (Washington), Philadelphia Museum of Art, Pinacothèque de
Paris and Princeton University Press.

My agent, Scott Mendel, placed the book in good publishing hands and came up with the felicitous phrase in the subtitle—*Outsiders of Montparnasse*—that sums up who this book is all about. My editor, Elisabeth Dyssegaard, took on the assignment after the book was already almost half done but had no trouble understanding the thesis completely and improving the work with insightful editing.

I had the usual family cheering section, augmented by two newcomers during the writing. Aside from Joshua and Elodie, it included Sam, Julie, Hunter, Sarah, Mike, Ronella, Jake, Luke, Claire, Michèle, John, Ava, Solal, Amiel, Gabriel, Patricia, Sophia, Penelope, Jenaro, Mallory and James.

The arduous government duties of my wife, Elizabeth, involve her in such international health crises as the Ebola outbreak. She is just as adept at dealing with crises at home. She helped me through the terrible losses of my sister and a nephew as I was writing the final chapters of the book. For this and much else, I owe her a great deal.

SOURCES

Introduction

"difficulty with Soutine": Clarisse Nicoïdski, *Soutine ou la profanation* (Paris: Jean Claude Lattès, 1993), p. 205.

1. La Ruche, Young Soutine and the Russian Jews

For the history of La Ruche, I have depended on Sylvie Buisson and Martine Frésia, *La Ruche: Cité des Artistes* (Paris: Éditions Alternatives, 2009). My account of Soutine's youth was informed by Pierre Courthion, *Soutine: Peintre du Déchirant* (Lausanne: Edita, 1972); Marc Restellini, "Soutine, Le Fou de Smilovitchi," in Restellini, ed., *Soutine* (Paris: Pinacothèque de Paris, 2007); and Billy Klüver & Julie Martin, "Chaim Soutine: An Illustrated Biography," in Norman L. Kleeblatt & Kenneth E. Silver, ed., *An Expressionist in Paris: The Paintings of Chaim Soutine* (New York: The Jewish Museum, 1998). The discussion of Jewish art in the Russian empire is based on Olga Litvak, "Painting and Sculpture," YIVO Encyclopedia of Jews in Eastern Europe, retrieved from www.yivoencyclopedia.org. Natan Meir's "Mendel Beilis," discussing that case, comes from the same encyclopedia. The discussion of pogroms is based on "From Kishneff to Bialystok: A Table of Pogroms from 1903 to 1906," first published in the 1906–1907 American Jewish Year Book of the American Jewish Committee, reprinted on the Museum of Family History Web site, museumoffamilyhistory.com. My summary of the Dreyfus case is based on Jean-Denis Bredin, *The Affair: The Case of Alfred Dreyfus* (New York: George Braziller, 1986).

Other references (note: throughout, page numbers cited cover not only quotations from the original source, but also subject matter to put the quotations in context):

"These ateliers were occupied by artistic Bohemians": Chagall, *My Life* (London: Peter Owen, 2011), p. 103.

"Portrait," by Blaise Cendrars, poem about Chagall, translated from the French by the author.

The descriptions of Smilovitchi, including Soutine's comment, come from Michel LeBrun-Franzaroli, *Soutine: L'homme et le peintre* (self-published, 2012), pp. 13, 19–20.

"an ugly, sickly child . . .": from Marevna's memoir, *Life with the Painters of La Ruche* (Dorset: Broglia Press, 2007), p. 9.

Zarfin's description of life in Smilovitchi comes from Courthion, *Soutine*, p. 11.

Butcher's beating of Soutine: in Sophie Krebs, "Soutine et les Debats de son Epoque," in *Chaim Soutine (1893–1943): L'ordre du chaos* (Paris: Orangerie, 2012).

Soutine's nervousness over the entrance exam to the academy in Vilna is described in Waldemar George, *Artistes Juifs: Soutine* (Paris: Editions Le Triangle, 1928), p. 12. There are more details in Alfred Werner, *Soutine* (New York: Harry Abrams, 1985), p. 17.

"always carried a suggestion of morbid sadness": quoted in Klüver and Martin, "Chaim Soutine," p. 97.

Kikoïne's description of Soutine's childhood and his schooling in Vilna and Krémègne's description of the battle against bedbugs come from Jean-Marie Drot, "In Search of Chaim Soutine," part of a DVD set titled *Les Heures Chaudes de Montparnasse* (Paris: Doriane Films, 2006). The incident is described as well in Courthion, *Soutine*, p. 24.

Metro emitted a strange metallic and acidic odor: from John Russell, *Paris* (New York: Abrams, 1983), p. 32.

"useless and monstrous" Eiffel Tower: described in Norma Evenson, *Paris: A Century of Change* (New Haven: Yale University Press, 1979), p. 132.

"He was not good looking": from Marevna, p. 12.

Soutine bursting into their home: Kikoïne's daughter describes the hungry Soutine in a DVD, Murielle Levy and Valerie Firla, *Chaim Soutine* (Paris: Reunion des musées nationaux, 2008).

"Please enroll M. Soutine in the class": Cormon's letter about Soutine's lack of French comes from Soutine's file Box # AJ/52/1155, Dossiers individuels des élèves, École Nationale Supérieure Des Beaux-arts [Archives Nationales, Pierrefite-sur-Seine].

"Soutine was never really part of the group": Czechowska's quote is in Courthion, *Soutine,* p. 33.

"a poor lover": Marevna, p. 106.

Marc Chagall's great-uncle Israel: Franz Meyer, *Marc Chagall* (New York: Harry N. Abrams, n.d.), p. 43.

The reactions of Herzl and Levinas's father to the Dreyfus affair are discussed in Adam Gopnik, "Trial of the Century," *New Yorker,* September 28, 2009 (retrieved from www.newyorker.com).

2. Modi, Montparnasse, Netter and Zbo

For biographical material on Modigliani, I have depended heavily on Mason Klein, ed., *Modigliani: Beyond the Myth* (New Haven: Yale University Press, 2004) and Marc Restellini, ed., *La Collection Jonas Netter: Modigliani, Soutine et L'Aventure de Montparnasse* (Paris: Pinacothèque de Paris, 2012). There is a useful survey of the changing role of Montparnasse as a haven for artists in Billy Klüver and Julie Martin, *Kiki's Paris: Artists and Lovers 1900–1930* (New York: Harry Abrams, 1989), pp. 10–11. For the love affair and deaths of Modigliani and Jeanne Hébutrne, I have depended on the Restellini book, *Le Silence Éternel: Modigliani-Hébuterne 1916–1919*; the Klein book, pp. 199–202; the Restellini book on the Netter collection, pp. 106–108; and the Klüver and Martin book, pp. 80–81, 90–91.

Other references:

Price for "Nude Sitting on a Divan": art prices throughout this book are taken from artprice.com.

Ehrenburg's description of the Rotonde: Klüver and Martin, *Kiki's Paris*, p. 63.

"scum of Greenwich": John Gnarowski's notes in John Glassco, *Memoirs of Montparnasse* (New York: New York Review Books, 2007), pp. 233, 235.

Hemingway-Pascin encounter: Ernest Hemingway, *A Moveable Feast* (New York: Scribner's, 1964), pp. 101–104.

Kikoïne's remarks about the cafés comes from the Jean-Marie Drot video, "In Search of Chaim Soutine." The Orloff quote about introducing Jeanne to Modi comes from the Drot video, "Enquête Sur La Vie, L'oeuvre et Le Destin de Modigliani," both videos are part of a DVD set titled *Les Heures Chaudes de Montparnasse* (Paris: Doriane Films, 2006).

"Despite the invisibility of Modigliani's Jewishness": Klein, *Modigliani*, p. 22. The discussion about Netter and his subsidies of artists is on pp. 9–16 of Restellini, *La Collection Jonas Netter.* The Hamlet letter is on p. 13.

Restellini's discussion of the supposed priestly benediction in Modigliani's portrait of Soutine: "Soutine, Le Fou de Smilovitchi," in Restellini, ed., *Soutine* (Paris: Pinacothèque de Paris, 2007), p. 11.

Modigliani's painting a portrait on a door in the Zborowski apartment: described in Billy Klüver and Julie Martin, "Chaim Soutine: An Illustrated Biography," in Norman L. Kleeblatt and Kenneth E. Silver, ed., *An Expressionist in Paris: The Paintings of Chaim Soutine* (New York: Jewish Museum, 1998), p. 101.

Zborowski "with his head in the clouds": Klein, *Modigliani*, p. 21.

Modigliani was twice as good as Picasso: Klüver and Martin, *Kiki's Paris*, p. 76.

Modi's letter to Zbo: Restellini, p. 13.

To figure out the inflationary value of the old francs in contemporary euros, I have followed the table in the publication of the French National Institute of

Statistics and Economic Studies, "Purchasing power of the euro and the French franc," February 15, 2012, www.insee.fr. I have used this table throughout the book to make the same kind of comparison.

Modi's affair with Hastings: discussed in Klein, *Modigliani*, pp. 84–85, 197–198; Restellini, *La Collection Jonas Netter*, pp. 103–104; and Klüver and Martin, *Kiki's Paris*, pp. 68–69. The Hastings quotes come from Marc Restellini, *Le Silence Éternel: Modigliani-Hébuterne 1916–1919* (Paris: Pinacothèque de Paris, 2008), p.40.

Berthe Weill gallery incident: discussed in Klein, *Modigliani*, pp. 56, 61–62, 199–200; Restellini, *La Collection Jonas Netter*, pp. 12, 106; and Klüver and Martin, *Kiki's Paris*, pp. 82–83.

The American expatriate role in making the Riviera fashionable is discussed in Jenaro Cardona-Fox, *Gerald and Sara Murphy: The Ideal American Expatriate Experience* (Princeton University, senior thesis, 2000), pp. 42–52.

"The baby is well" and "Modigliani was absolutely thrilled": Quoted in Meryle Secrest, *Modigliani: A Life* (New York: Knopf, 2011), p. 279.

"Modigliani was touchingly proud": Jeanne Modigliani, *Modigliani: Man and Myth* (New York: Orion Press, 1958), p. 94.

"Today, July 7, 1919, I pledge myself to marry": Jeanne Modigliani, *Modigliani*, p. 112.

Hoarding of Modigliani paintings while he was dying: discussed by Maurice Berger, "Epilogue: The Modigliani Myth," in Klein, *Modigliani*, pp. 80–81.

Modi's funeral procession is described by Secrest, *Modigliani*, p. 308.

"He was a son of the stars": Jeanne Modigliani, *Modigliani*, p. 114.

3. Midi, Landscapes in Turmoil, a Pastry Chef and Assaults on the Canvas

The catalogue for the 2000 exhibition in Céret, Esti Dunow et al., *Soutine: Céret 1919–1922* (Céret: Musée d'Art Moderne, 2000) covers this period of Soutine's life thoroughly. Picasso's stay in Céret is recounted in John

Richardson, *A Life of Picasso, Volume II: 1907–1917* (New York: Random House, 1996), pp. 183–195.

Other references:

Anonymous accuser complained that Soutine had made anti-French remarks: Pierre Courthion, *Soutine: Peintre du Déchirant* (Lausanne: Edita, 1972), p. 34.

"It is the first time that I have found myself": Soutine's letter to Zborowski from Cagnes can be found in Marc Restellini, ed., *La Collection Jonas Netter: Modigliani, Soutine et L'Aventure de Montparnasse* (Paris: Pinacothèque de Paris, 2012), p. 16. A photograph of the original letter, with misspellings, appears in Monroe Wheeler, *Soutine* (New York: Museum of Modern Art, 1950), p. 57. The letter, which bears no date in the original, is often described as written in 1923 rather than 1918 and, in fact, is dated both 1918 (p.16) and 1923 (p.149) in Restellini, *La Collection Jonas Netter*. But, judging by the contents of the letter, 1918 makes the most sense.

"Mecca of cubism": Dunow et al., *Soutine: Céret* catalogue, p. 36.

"He was raving mad": Dunow et al., *Soutine: Céret* catalogue, p. 38.

"completely unapproachable": Dunow et al., *Soutine: Céret* catalogue, p. 40.

"He was against Van Gogh": Dunow et al., *Soutine: Céret* catalogue, p. 40.

"He goes off to the countryside": Dunow et al., *Soutine: Céret* catalogue, p. 40, and amplified in Norman L. Kleeblatt and Kenneth E. Silver, ed., *An Expressionist in Paris: The Paintings of Chaim Soutine* (New York: Jewish Museum, 1998), p. 122.

"With delicate movements": Dunow et al., *Soutine: Céret* catalogue, p. 44.

"Everything dances around me": in Wheeler, *Soutine,* p. 42.

Examining a square inch of a Soutine canvas: Maurice Tuchman and Esti Dunow, *The Impact of Chaim Soutine* (Ostfildern-Ruit: Hatje Cantz, 2002), p. 63.

Soutine's remark about not speaking French or Russian well enough: Andrée Collié, "Souvenirs sur Soutine," *Spectateur des Arts* No. 1 (December 1944).

Photos of Zocchetto, the pastry chef: Dunow et al., *Soutine: Céret* catalogue, pp. 374 and 412.

"Soutine didn't just apply paint": Ellen Pratt, "Soutine Beneath the Surface: A Technical Study of His Painting," in Kleeblatt and Silver, *An Expressionist in Paris,* beginning on p. 119. Her quotes about his application of paint are on p. 124.

"I like to paint on something smooth": Kleeblatt and Silver, *An Expressionist in Paris,* p. 132.

"Death of his comrade": Courthion, *Soutine,* p. 45.

4. Dr. Barnes, the Discovery of Soutine and the Rise of the Foreigners

For the story of Dr. Barnes, I have relied mainly on Howard Greenfeld, *The Devil and Dr. Barnes* (Philadelphia: Camino Books, 2006). The quotes about his sessions with artists and critics in Guillaume's gallery come from pp. 99–100. The use of both Yiddish and German with Lipchitz is noted on p. 82.

Other references:

"*M. Barnes est dans nos murs*": in Billy Klüver and Julie Martin, *Kiki's Paris: Artists and Lovers 1900–1930* (New York: Harry Abrams, 1989), p. 122. (I have altered the translation.)

Guillaume's account of the discovery of Soutine: Paul Guillaume, "Soutine," *Les Arts a Paris*" (January 1923), pp. 5–6.

1950 letter to MOMA: Norman L. Kleeblatt and Kenneth E. Silver, ed., *An Expressionist in Paris: The Paintings of Chaim Soutine* (New York: Jewish Museum, 1998), p. 198.

"Leave us at least one Soutine": Klüver and Martin, *Kiki's Paris,* p. 122.

Dollar-franc exchange rate: "Financial Markets" column in the *New York Times,* January 6, 1923.

Barnes-Soutine meeting: Greenfeld, *The Devil and Dr. Barnes,* pp. 79–80.

"It is fairly certain that the dealers": cited in Marc Restellini, ed., *Soutine* (Paris: Pinacothèque de Paris, 2007), p. 29.

Anecdote about the appearance of Dostoevsky novels at the cafés: Clarisse Nicoïdski, *Soutine ou la profanation* (Paris: Jean Claude Lattès, 1993), p. 143; Pierre Courthion, *Soutine: Peintre du Déchirant* (Lausanne: Edita, 1972), p. 55.

"Everyone is running after Soutine": cited in Sophie Krebs, "Soutine et Les Débats de son Époque," a chapter in the catalogue *Soutine* (Paris: Hazan, 2012), pp. 17, 25.

"I was very frightened of him": Orloff's quote about Soutine come from the Jean-Marie Drot video, "In Search of Chaim Soutine."

Woman with the abscessed tooth: Roger Allard, "L'Europe Nouvelle," December 15, 1928.

Clip of the Jean Epstein film: can be seen in the Fabien Beziat documentary, "*Paris, Années Folles,*" 2013, presented on France3.

Miestchaninoff's gift: mentioned in Kenneth Silver and Romy Golan, *The Circle of Montparnasse: Jewish Artists in Paris 1905–1945* (New York: Universe Books, 1985), p. 46.

"his canvases . . . are sold these days": René Gimpel, *Diary of an Art Dealer* (New York: Farrar, Strauss and Giroux, 1966), pp. 309–310.

"painters of the Rotonde": in Greenfeld, *The Devil and Dr. Barnes,* p. 87.

"Slavs disguised as representatives of French art": in Krebs, "Soutine et Les Débats," p. 25.

Vauxcelles on Soutine, in Krebs, "Krebs, "Soutine et Les Débats," p. 25.

My description of the French Dadaists is based on Leah Dickerman, *Dada* (Washington: National Gallery of Art, 2005), pp. 308, 351, 357, 359, 374, 401.

The Tate Catalogue's entry on Picabia's "The Fig Leaf" discusses Picabia's friction with Signac, www.tate.org.uk/art/artworks/picabia-the-fig-leaf.

"*méteques* of Montparnasse": in Françoise Cachin, *Signac: Catalogue raisonné de l'oeuvre peint* (Paris: Gallimard, 2000), pp. 389–390.

Salon controversy: Marina Ferretti-Bocquillon et al., *Signac 1863–1935* (New York: Metropolitan Museum of Art, 2001), pp. 317, 318.

Protest withdrawals: *L'École de Paris 1904–1929: le part de l'Autre* (Paris: Musée d'Art moderne de la Ville de Paris, 2000), pp. 393–394.

"It seems the decision has caused the central European high society": in Romy Golan, *Modernity and Nostalgia: Art and Politics in France between the Wars* (New Haven, CT: Yale University Press, 1995), p. 140.

"School of Paris": cited in Krebs, "Soutine et Les Débats," p. 25.

Vauxcelles' solution: "School of Paris": Krebs, "Soutine et Les Débats," pp. 16–17.

In April and May 1923: Greenfeld, *The Devil and Dr. Barnes,* describes Barnes's exhibition of his recent purchases and the reaction to it, including all the negative press reviews, pp. 90–96, and the squabble with Lipchitz, pp. 82–83.

The rationale for the display of the Barnes Collection is explained in detail in Violette de Mazia, *The Barnes Foundation: The Display of Its Art Collection* (Merion Station, PA: Barnes Foundation Press, 1989).

"Soutine occupies a distinctive position": Albert Barnes, *The Art in Painting* (Merion Station, PA: Barnes Foundation Press, 1937), pp. 374–375.

I discussed Barnes's discovery of Soutine in "Soutine: The Power and the Fury of an Eccentric Genius," *Smithsonian Magazine* (November 1988), and the history of the Barnes Foundation in "Say What They May, the Feisty Doctor Had an Artful Eye," *Smithsonian Magazine* (May 1993).

5. *Marc Chagall, the Great Bakst, Paris and the October Revolution*

For Chagall's biographical details, I have depended a great deal on Jackie Wullschlager, *Chagall: A Biography* (New York: Knopf, 2008), augmented by Marc Chagall, *My Life* (London: Peter Owen, 2011), Franz Meyer, *Marc Chagall* (New York: Harry N. Abrams, n.d.), Julia Garimorth-Foray, ed. *Chagall Entre Guerre et Paix* (Paris: Musée du Luxembourg, 2013), and Michael R.

Taylor, *Paris Through the Window: Marc Chagall and His Circle* (Philadelphia: Philadelphia Museum of Art, 2011).

Other references:

Figures on Vitebsk's population, Jews and Yiddish speakers: *Demoscope Weekly,* June 17–30, 2013, demoscope.ru.

"my sad, my joyful town!": Chagall, *My Life,* p. 11.

"He lifted heavy barrels": Chagall, *My Life,* p. 12.

"Perhaps you ought to be a clerk": Chagall, *My Life,* p. 18.

"My uncle is afraid to offer me his hand": Chagall, *My Life,* p. 26.

His mother's successful effort to put him in art school: Chagall, *My Life,* pp. 61–62.

Encounters with Bakst: Chagall, *My Life,* pp. 90–95.

Chagall "walks on his head" and the importance of color: from Wullschlager, *Chagall,* p. 113.

"What I like best in your work": from Wullschlager, *Chagall,* p. 121.

"I can't be taught": Chagall, *My Life,* pp. 92–93.

"Tell me, can you paint scenery": The exchange with Bakst about painting scenery comes from Chagall, *My Life,* p. 93.

Chagall helped Bakst work on the sets for the Ballets Russes: Taylor, *Paris Through the Window,* p. 3.

"How crazy that you are going to go to Paris with 25 rubles": quoted in Wullschlager, *Chagall,* p. 122.

"Vitebsk, I am forsaking you": Chagall, *My Life,* p. 95.

Chagall in a boater: can be seen in Wullschlager, *Chagall,* p. 128; there are many photos of Chagall throughout the book.

"I even wanted to invent a holiday": Chagall, *My Life,* p. 100.

"So you came, after all?": in Chagall, *My Life,* p. 105.

Bella's letters are in Wullschlager, *Chagall,* p. 146.

"Chagall was emotionally alone": Wullschlager, *Chagall,* p. 146.

"He was the first to come and see me": Chagall, *My Life,* p. 111.

"a morbid expressionist": in Wullschlager, *Chagall,* p. 153.

Assessment of the friendship with Delaunay: Wullschlager, *Chagall,* p. 161.

"gentle Zeus": Chagall, *My Life,* pp. 111–114.

"*surnaturel*" and *surréel:* discussed in Wullschlager, *Chagall,* p. 164.

"Art seems to me to be a state of soul": Chagall, *My Life,* p. 113.

"Do you know what we ought to do": Chagall, *My Life,* p. 112.

The most beautiful painting at the salon: Wullschlager, *Chagall,* p. 177.

"the single most important exhibition of Chagall's life": Wullschlager, *Chagall,* p. 179.

"exuberant early masterpiece": Taylor, *Paris Through the Window,* p. 9.

"I didn't realize that, within a month": Chagall, *My Life,* p. 115.

"You'll ruin yourself for nothing": in Chagall, *My Life,* pp. 121–122.

"My Marxism was limited": His distancing himself from Marx is on p. 136.

Battles with Malevich: Wullschlager, *Chagall,* pp. 222–252. She uses the term "revolutionary correctness" on p. 243.

"Why is the cow green": Chagall, *My Life,* p. 137.

The story of the payments for the Berlin show, including the falling out with Cendrars, is covered in Wullschlager, *Chagall,* pp. 282-283, 301, 326.

Dead Souls deal with Vollard: described in Wullschlager, *Chagall,* pp. 302–303.

6. André Warnod, the School of Paris and the Jews

There is a short biography of Warnod in *L'École de Paris 1904–1929: le part de l'Autre* (Paris: Musée d'Art moderne de la Ville de Paris, 2000), pp. 396–397. Warnod's general comments about the School of Paris can be found in the opening section of his book, *Les Berceaux de la Jeune Peinture: L'École de Paris* (Paris: Editions Albin Michel, 1925), pp. 7–11. His comments on Pascin are on pp. 235–240, on Modigliani, pp. 233–234, on Soutine and Chagall, p. 246. The book *L'École de Paris 1904–1929: le part de l'Autre* served as the catalogue of the 2000–2001 exhibit in Paris, while Kenneth Silver and Romy Golan, *The Circle of Montparnasse: Jewish Artists in Paris 1905–1945* (New York: Universe Books, 1985) served as the catalogue of the Jewish Museum exhibition in New York. Nadine Nieszawer's count of School of Paris artists comes from her Web site, www.ecoledeparis.org. The prevalence of Yiddish in Eastern Europe is detailed in David Katz, "Language: Yiddish," in the Yivo Encyclopedia of Jews in Eastern Europe, www.yivoencyclopedia.com.

Other references:

"the Mahdi of modern art": John Richardson, *A Life of Picasso: Volume II, 1907–1917* (New York: Random House, 1996), p. 14.

Return "to his Spanish roots" and "beautiful country of my birth": Richardson, *A Life of Picasso,* p. 153.

Chagall on surrealism: Wullschlager, *Chagall,* p. 322.

"He thinks that there is a renaissance of spirit": René Gimpel, *Diary of an Art Dealer* (New York: Farrar, Straus and Giroux, 1966), p. 349.

"Is There Such a Thing as Jewish Painting?": in Romy Golan, *Modernity and Nostalgia: Art and Politics in France Between the Wars* (New Haven, CT: Yale University Press, 1995), pp. 138–139; Kisling's reply is on p. 138.

"the filth of Paris": Mauclair's quotes come from Golan, *Modernity and Nostalgia,* pp. 151–152, and Silver and Golan, *The Circle of Montparnasse,* p. 85.

"Whether by their own religious traditions": Monroe Wheeler, *Soutine* (New York: Museum of Modern Art, 1950), pp. 35–36.

"usually presupposed a thorough grounding": Silver and Golan, *The Circle of Montparnasse,* p. 23.

Maria Lani incident: Jon Lackman, "Maria Lani's Mystery," *Art in America* (June/July 2014); Silver and Golan, *The Circle of Montparnasse,* p. 44; and Gimpel, *Diary of an Art Dealer* p. 409.

Venice Biennial and the confused London exhibition: *L'École de Paris 1904–1929,* p. 36.

Jeu de Paume museum placement: pp. 387–388.

Paris World's Fair of 1937: Golan, *Modernity and Nostalgia,* p. 154.

There is a short biography of Waldemar George in *L'École de Paris 1904–1929: le part de l'Autre,* pp. 379–380; it also includes long excerpts in French from a 1931 magazine article by Waldemar George, "Ecole Francaise ou Ecole de Paris," pp. 402–403. I have followed Romy Golan's translation on p. 153 of her book but used my own for sections that she did not translate.

7. *Artistes Juifs, Rembrandt's Carcass of Beef and the Daughter of Elie Faure*

Waldemar Georges's essay on Soutine: Waldemar George, *Artistes Juifs: Soutine* (Paris: Editions Le Triangle, 1928), pp. 7–24.

Pacing the sidewalk at dawn: George, *Artistes Juifs,* p. 12.

"story of Soutine": George, *Artistes Juifs,* p. 13, 15–17.

The titles in the *Artistes Juifs* series are listed in *L'École de Paris 1904–1929: le part de l'Autre* (Paris: Musée d'Art moderne de la Ville de Paris, 2000), p. 382.

"It was impossible to raise the slightest objection": in Pierre Courthion, *Soutine: Peintre du Déchirant* (Lausanne: Edita, 1972), p. 73.

"I can still see him gazing at the canvases": in Julia Weiner, "Chaim Soutine: The Artist who Fell Foul of the Hygiene Police," October 19, 2012, on the *Jewish Chronicle* Web site, www.thejc.com.

"Once I saw the village butcher": in Maurice Tuchman, Esti Dunow, and Klaus Perls, *Chaim Soutine: Catalogue Raisonné* (Cologne: Benedikt Taschen Verlag, 1993), p. 16.

"I want to show Paris in the carcass of an ox": Alfred Werner, *Soutine* (New York: Harry Abrams, 1985), p. 94.

Foul-smelling carcass of beef and the health inspectors, and Soutine's comment to Paulette: in Courthion, *Soutine,* p. 76.

"Soutine has robbed me": René Gimpel, *Diary of an Art Dealer* (New York: Farrar, Strauss and Giroux, 1966), p. 365.

Kuspit's theory about Soutine and Jewishness: in Norman L. Kleeblatt and Kenneth E. Silver, ed., *An Expressionist in Paris: The Paintings of Chaim Soutine* (New York: Jewish Museum, 1998), pp. 77–86.

"To which the only possible response is 'Oy!'": Simon Schama, "Gut Feeling," *The New Yorker,* May 25, 1998.

Gossip about the birth of a child: in Kleeblatt and Silver, *An Expressionist in Paris,* p. 200; Clarisse Nicoïdski, *Soutine ou la profanation* (Paris: JCLattès, 1993), pp. 35, 165–166, 168; and Garde (Gerda Michaelis), *Mes Années avec Soutine* (Paris: Editions Denoël, 1973), pp. 63–65.

Important critical study of Soutine's work: Elie Faure, *Soutine* (Paris: Editions G. Crès, 1929). The other books in the series "Les Artistes Nouveaux" are listed on the back cover.

Details of the life of Dr. Faure come mainly from Martine Courtois and Jean-Paul Morel, *Elie Faure* (Paris: Librairie Séguier, 1989), pp. 18–21, 33, 39, 59, 64–65, 119, 169–170, 193, 252–256. Zizou's quote about being bullied is on page 59.

Godard's use of Faure in *Pierrot Le Fou:* cited in Richard Brody, *Everything Is Cinema: The Working Life of Jean-Luc Godard* (New York: Metropolitan Books, 2008), p. 245.

"Here the mystery of the greatest painting": Faure, *Soutine,* p. 4.

"There are some who believe that Soutine deforms": Faure, *Soutine,* pp. 6–7.

I have used the translation in Kleeblatt and Silver, *An Expressionist in Paris,* p. 151 for the first quotation; the second is my own.

"in repainting it, he literally destroyed it": Gimpel, *Diary of an Art Dealer,* p. 374.

Soutine's love for Soutine Faure's daughter, Marie-Zéline: Pascal Neveux, "Elie Faure and Chaim Soutine: The Story of an Ill-Fated Friendship," which includes the Faure-Soutine correspondence, appears in Kleeblatt and Silver, *An Expressionist in Paris,* pp. 150–158.

"she listened with kind attention": memoir of Kikoïne in *Soutine* (Musée de Chartres, 1989), p. 78.

8. The Great Depression, Pascin, the Death of Zbo and the Judgments of Soutine

Chagall's contract with Bernheim-Jeune, its cancellation after the Wall Street crash, and the cancellation of a Picasso show are covered in Jackie Wullschlager, *Chagall: A Biography* (New York: Knopf, 2008), pp. 326, 342–343. Chagall's quote about a moral success is on p. 355. Kahnweiler's quotes about keeping his gallery open come from John Richardson, *A Life of Picasso: Volume III 1917–1932* (New York: Knopf, 2007), pp. 384–385. I have based my brief discussion of the French depression and the Stavisky case on Alfred Cobban, *A History of Modern France: Volume Three* (London: Penguin Books, 1965), pp. 137–146), Wilfrid Knapp, *France: Partial Eclipse: From the Stavisky Riots to the Nazi Conquest* (London: Macdonald, 1972), pp. 5–10, 15–26; and J. P. T. Bury, *France: The Insecure Peace: From Versailles to the Great Depression* (London: Macdonald, 1972), pp. 131–144. For the life of Pascin, I have consulted Dina Vierny et al., *Pascin: Le magicien du réel (*Paris: Musée Maillol, 2007); Jean-Marie Drot, "Pascin, l'oublié," part of a DVD set titled *Les Heures Chaudes de Montparnasse* (Paris: Doriane Films, 2006); and François Lévy-Kuentz, director of the video *Pascin: L'impudique* (Paris; Doriane Films, n.d.). The quotes of Aicha, Salmon and Levy come from the Drot video.

Other references:

Paintings sold soon after his signature dried: Wullschlager, *Chagall,* p. 326.

"The small but noisy dinner party": in Billy Klüver and Julie Martin, *Kiki's Paris: Artists and Lovers 1900–1930* (New York: Harry Abrams, 1989), p. 146.

"a tremendous synthesis of our present era": André Warnod, *Les Berceaux de la Jeune Peinture: L'École de Paris* (Paris: Editions Albin Michel, 1925), p. 240.

"In his sense for the compositional relation of masses": Albert Barnes, *The Art in Painting* (Merion Station, PA: Barnes Foundation Press, 1937), pp. 33, 375–376.

Pascin's two great loves, Hermine and Lucy: Dina Vierny et al., *Pascin: Le magicien du réel,* p. 23.

Photos of the "You are too good" note to Lucy and the adieu to Lucy in blood: in Klüver and Martin, *Kiki's Paris,* pp. 204–205.

"He did not die like a prince": Drot video.

The argument between Zborowski and Netter, including extracts from their correspondence, is covered in Marc Restellini, ed., *La Collection Jonas Netter: Modigliani, Soutine et L'Aventure de Montparnasse* (Paris: Pinacothèque de Paris, 2012), pp. 23–25. The downfall and death of Zbo is covered on pp. 25–26. Antcher's description of Zbo is on p. 24.

"Although he was nasty to me": in Restellini, *La Collection Jonas Netter,* p. 24.

One tenth the price of a painting by the Impressionist Claude Monet: from Michel LeBrun-Franzaroli, *Soutine: L'homme et le peintre* (self-published, 2012), p. 307.

Gimpel's descriptions of Soutine and Soutine's estimates of other artists: René Gimpel, *Diary of an Art Dealer* (New York: Farrar, Straus and Giroux, 1966), pp. 310, 374, 436–437.

9. Idyll, Madeleine and Marcellin and the Portrait

Details of the life and marriage of Madeleine Castaing: Jean-Noël Liaut, *Madeleine Castaing: Mécène à Montparnasse Décoratice à Saint-Germain-des-Près*

(Paris: Petite Bibliothèque Payot, 2008). Liaut discusses Marcellin's philandering on pp. 41–42, 75, 93.

Marcellin "never lost a minute—to lie down and rest": in Liaut, *Madeleine Castaing*, p. 94.

Picasso quote in Liaut, *Madeleine Castaing*, p. 34.

"You will be the Mary Pickford": in Liaut, *Madeleine Castaing*, p. 50.

The story of the first meetings of the Castaings and Soutine is covered in Liaut, *Madeleine Castaing*, pp. 63–69, and in my interviews with Mme. Castaing on January 29 and February 16, 1988.

The photo of the smiling pair can be found in Marc Restellini, ed., *Soutine* (Paris: Pinacothèque de Paris, 2007), p. 20.

Maurice Sachs's descriptions of the Castaings and Soutine: Maurice Sachs, *Witches' Sabbath* (New York: Stein and Day, 1964), pp. 254–261.

"Send the chauffeur": in Liaut, *Madeleine Castaing*, pp. 88–89.

Soutine fascinated by "the beauty and authority" of Madeleine: Clarisse Nicoïdski, *Soutine ou la profanation* (Paris: Jean Claude Lattès, 1993), pp. 194–201.

Madeleine's denial that they had ever been lovers: Liaut, *Madeleine Castaing*, pp. 79–80. Liaut also reveals more about the relationship, including the books they discussed, on p. 91.

Soutine's work reminded Marcellin of a new Renoir: Liaut, *Madeleine Castaing*, p. 88.

Argument with Guillaume: Liaut, *Madeleine Castaing*, p. 90.

Discussions with Mme. Castaing about Soutine's later paintings and his portrait of her came up in our 1988 interviews.

"The country homes": Maurice Tuchman, Esti Dunow, and Klaus Perls, *Chaim Soutine: Catalogue Raisonné* (Cologne: Benedikt Taschen Verlag, 1993), pp. 98–99.

10. Charles Maurras, Léon Blum and the Resurgence of Anti-Semitism

For the story of the resurgence of anti-Semitism that led to Vichy's harsh policies against Jews, I have depended a good deal on Michael R. Marrus and Robert O. Paxton, *Vichy France and the Jews* (New York: Basic Books, 1981). I also talked with both authors while I covered these issues for the *Los Angeles Times* in the 1980s.

Other references:

The story of Maurras and his praise of the forger Henry: Jean-Denis Bredin, *The Affair: The Case of Alfred Dreyfus* (New York: George Braziller, 1986), pp. 337–338.

The Maurras quote about the need for anti-Semitism comes from Zeev Sternhell, "The Roots of Popular Anti-Semitism in the Third Republic," in Frances Malino and Bernard Wasserstein, eds., *The Jews in Modern France* (Hanover, NH: University Press of New England, 1985), p. 115.

"I take pride in it": in Jean Lacouture, *Léon Blum* (New York: Holmes and Meier, 1982), p. 526.

The leagues and their young toughs: discussed by Alfred Cobban, *A History of Modern France, Vol. 3: 1871–1962* (London: Penguin Books, 1965), pp. 137–146.

"Death to the Jew": in Lacouture, *Léon Blum,* p. 187.

"escaped prisoners, jailbirds, criminal weaklings": in Lacouture, *Léon Blum,* p. 227.

"Your accession to power, Mr. Prime Minister": in Lacouture, *Léon Blum,* p. 271.

"this old Semitic camel" and Maurras's arrest for threatening Blum: Alan Riding, *And the Show Went On: Cultural Life in Nazi-Occupied Paris* (New York: Knopf, 2010), pp. 19–20.

"French Depression was a long, slow rot": in Marrus and Paxton, *Vichy France and the Jews* on p. 35.

"The movie business practically closed its doors to aryans" and "Messrs. Kikes": in Marrus and Paxton, *Vichy France and the Jews*, p. 38.

"certain laws of exclusion": in Marrus and Paxton, *Vichy France and the Jews*, p. 39.

"not going to war over 100,000 Polish Jews": Marrus and Paxton, *Vichy France and the Jews*, p. 40.

"it is the Jews who are pulling the strings": in Marrus and Paxton, *Vichy France and the Jews*, p. 40.

Assassination in Paris and Kristallnacht: described in Marrus and Paxton, *Vichy France and the Jews*, pp. 25–26.

"France's international weakness": in Marrus and Paxton, *Vichy France and the Jews*, p. 41.

"When one hears Léon Blum": in Marrus and Paxton, *Vichy France and the Jews*, p. 39.

Jean Giraudoux quotes: Jean Giraudoux, *Pleins Pouvoirs* (Paris: Gallimard, 1939), pp. 58–76.

Chagall and the British ambassador's wife: Jackie Wullschlager, *Chagall: A Biography* (New York: Knopf, 2008), p. 362.

"the Chagalls at the eve of the Second World War": in Julia Garimorth-Foray, ed., *Chagall Entre Guerre et Paix* (Paris: Musée du Luxembourg, 2013), pp. 66–67.

"untalented shlemazels": in David H. Weinberg, *A Community on Trial: The Jews of Paris in the 1930s* (Chicago: University of Chicago Press, 1977), p. 104.

11. Mademoiselle Garde, Trapped Aliens and Roundup in the Vélodrome

For the story of the relationship between Soutine and Mademoiselle Garde, I have depended heavily on her memoir, Garde (Gerda Michaelis), *Mes Années avec Soutine* (Paris: Editions Denoël, 1973). She discusses the start of the romance and his naming her as his garde on pp. 19–27; she outlines her

background on p. 9–17; she describes Soutine's everyday life and habits as a painter, 29–42; the exchange between Madame Castaing and Soutine is reported on p.45. Mademoiselle Garde's story about the illness of Soutine and the recommendations of the doctors is told in her memoir, pp. 47–54; her comment about closing their eyes to the future comes from p. 34; their stay at Civry is described on pp. 68–76; Einsild's description of Civry in on page 69; the difficulty of obtaining papers for Garde to leave Civry after the war begins is described on pp. 77–91; Soutine's promise that "you are my wife" is on pp. 81–82 (his words could be translated as "you are my woman" but the context indicates that he means more than that); the defiant pronouncement of Mayor Sébillotte is on p. 86; their clandestine flight to Paris is recounted on pp. 90–96; the detention of Garde as an enemy alien is described on pp. 99–106.

Other references:

"your youngest sister Ertl": translated into French in Garde, *Mes Années avec Soutine,* pp. 200–202, and reproduced in Yiddish in Clarisse Nicoïdski, *Soutine ou la profanation* (Paris: Jean Claude Lattès, 1993), pp. 267–268.

Henry Miller's description of Soutine: Miller, *The Water Reglitterized* (London: Village Press, 1973), p. 49.

Civry is described in Michel LeBrun-Franzaroli, *Soutine: L'homme et le peintre* (self-published, 2012), pp. 359–362.

"Catastrophe is everywhere": in Pierre Courthion, *Soutine: Peintre du Déchirant* (Lausanne: Edita, 1972), pp. 134–6. (LeBrun-Franzaroli, *Soutine,* pp. 370–372, believes this letter is a fake, but I did not find his argument strong enough to contradict the many French historians who accept the letter.)

12. *The Fall of France, Vichy and a Death Warrant*

For my summary of Vichy France's policies, I have again depended on Michael R. Marrus and Robert O. Paxton, *Vichy France and the Jews* (New York: Basic Books, 1981). Paxton's conclusion comes from his article "Jews: How Vichy Made It Worse" from the *New York Review,* March 6, 2014. The

description of Hitler at the signing of the armistice after the fall of France comes from William L. Shirer, *20th Century Journey: A Memoir of a Life and the Times. Volume II: The Nightmare Years 1930–1940* (Boston: Little Brown, 1984), pp. 530–534.

Other References:

Hitler's art tour of Paris: described in Albert Speer, *Inside the Third Reich* (New York: Macmillan, 1970), pp. 170–173.

"they have smudged my Jew": Chana Orloff, "My Friend Soutine," *Jewish Chronicle*, November 1, 1963.

Madame Castaing's decision to anoint Marie-Berthe Aurenche as Garde's successor: Jean-Noël Liaut, *Madeleine Castaing: Mécène à Montparnasse Décoratice à Saint-Germain-des-Près* (Paris: Petite Bibliothèque Payot, 2008), pp. 117–118.

"You have signed Soutine's death warrant": in Liaut, *Madeleine Castaing,* p. 117.

"Marie-Berthe, illogical, capricious, and feminine": Pierre Courthion, *Soutine: Peintre du Déchirant* (Lausanne: Edita, 1972), p. 142.

Madame Castaing and Garde's meeting in Carcassonne: Garde (Gerda Michaelis), *Mes Années avec Soutine* (Paris: Editions Denoël, 1973), pp. 118–120.

Garde obtained a false identity card: Garde, *Mes Années avec Soutine,* pp. 130–131.

13. Two American Heroes, the Escape of Chagall and the Fall of the School of Paris

I have based the story of the two American heroes of Marseilles mainly on two sources: Varian Fry's memoir, *Surrender on Demand* (Boulder: Johnson Books, 1997), and a magazine profile by Peter Eisner, "Saving the Jews of Nazi France," *Smithsonian* (March 2009).



Other references:

"can not repeat not countenance the activities": in Eisner, "Saving the Jews of Nazi France."

Chagall's meeting with Fry and Bingham and his eventual escape from France to the United States: in Jackie Wullschlager, *Chagall: A Biography* (New York: Knopf, 2008), pp. 386–394.

"don't lump me with all those people": in Vladimir Vissson, *Fair Warning: Memoirs of a New York Art Dealer* (Hermitage, 1986), pp. 82–84.

"one of the world's greatest living artists": Fry, *Surrender on Demand,* pp. 206–207.

"The Germans are going to win the war": in Eisner, "Saving the Jews of Nazi France."

"delight in making autocratic decisions": Fry, *Surrender on Demand,* p. 215; the police warnings and his expulsion: pp. 221–224.

"righteous among the nations": Fry, *Surrender on Demand,* p. ix.

"courageous diplomat" and Secretary Powell's remarks: in Eisner, "Saving the Jews of Nazi France."

"If everything of any worth flees": in Alan Riding, *And the Show Went On: Cultural Life in Nazi-Occupied Paris* (New York: Knopf, 2010), p. 179.

Riding also describes the shipment of art from the Jeu de Paume to Germany, pp. 166–167.

1942 Vélodrome d'Hiver roundup of Jews and the first Vichy roundups of Jews: Michael R. Marrus and Robert O. Paxton, *Vichy France and the Jews* (New York: Basic Books, 1981), pp. 250–252, 255–260.

"Jews, métèques from the Orient": in Monica Bohm-Euchen, *Art and the Second World War* (Princeton, NJ: Princeton University Press, 2013), pp. 108–109.

"All [(Jewish]) galleries are finally closed!": in Bohm-Euchen, *Art and the Second World War,* p. 108.

Le Voyage of the French artists to Germany: in Bohm-Euchen, *Art and the Second World War,* pp. 110–111, and in Riding, *And the Show Went On,* pp. 175–177.

French officials banned Derain, Vlaminck, Belmondo: described in Herbert R. Lottman, *The People's Anger: Justice and Revenge in Post-Liberation France* (London: Hutchinson, 1986), p. 254.

14. Marie-Berthe, Hiding and a Desperate Dash to Paris

Marie-Berthe Aurenche's article, "Les Derniérs Années de Soutine," appeared in the weekly newspaper, *Arts, spectacles,* August 15–21, 1952, p. 7. It is the most personal account of those years. While it helped us put together this chapter, we also depended upon the accounts of Pierre Courthion, *Soutine: Peintre du Déchirant* (Lausanne: Edita, 1972); Garde (Gerda Michaelis), *Mes Années avec Soutine* (Paris: Editions Denoël, 1973); Michel LeBrun-Franzaroli, *Soutine: L'homme et le peintre* (self-published, 2012); and Clarisse Nicoïdski, *Soutine ou la profanation* (Paris: Editions Jean-Claude Lattès, 1993).

All of Marie-Berthe's quotations in this chapter, unless otherwise noted, come from her article. The biography of the young Marie-Berthe is based on Michel LeBrun-Franzaroli, pp. 375–377. Garde's description of her return to Paris, her phone conversation with Marie-Berthe, the funeral, and the visit to Champigny come from her memoir, *Mes Années avec Soutine* (Paris: Editions Denoël, 1973), pp. 133–144. Garde's summing up is on pp. 138–139.

Other references:

Marie-Berthe "enthralled him": Pierre Courthion, *Soutine: Peintre du Déchirant* (Lausanne: Edita, 1972), p. 142.

Some of the old pleasures of Paris: description based on Alan Riding, *And the Show Went On: Cultural Life in Nazi-Occupied Paris* (New York: Knopf, 2010), pp. 90–102.

Paris Opera: described by Jean Guéhenno, *Diary of the Dark Years 1940–1944: Collaboration, Resistance and Daily Life in Occupied Paris* (Oxford: Oxford University Press, 2014), p. 58.

LeBrun-Franzaroli, *Soutine,* describes Champigny and the life of the couple there on pp. 384–393.

Had to move often: Nicoïdski, *Soutine ou la profanation,* p. 255.

Portrait of Marie-Berthe: Nicoïdski, *Soutine ou la profanation,* p. 257.

"He was strict": "Champigny-sur-Veude n'a pas oublié Soutine," lanouvellere-publique.fr, October 19, 2013.

"Marie-Berthe was truly dirty": in LeBrun-Franzaroli, *Soutine,* p. 387. LeBrun-Franzaroli, *Soutine,* also describes the incident over the sale of a painting to the Castaings, p. 389.

Detailed description of his condition: Courthion, *Soutine,* p. 142.

"He has an appearance that worries me": in Courthion, *Soutine,* p. 142.

"twisting like a worm": Courthion, *Soutine,* p. 142.

Thought Marie-Berthe was his wife: Courthion, *Soutine,* p. 165.

One of her rare defenders: LeBrun-Franzaroli, *Soutine,* describes the last few days of Soutine and puts down his defense of Marie-Berthe's actions, pp. 406–409; he also summarizes the details of the operation and the burial in Paris, pp. 408–412.

"the love of my life": in Jean-Marie Drot, "In Search of Chaim Soutine," part of a DVD set titled *Les Heures Chaudes de Montparnasse* (Paris: Doriane Films, 2006).

15. The Aftermath

"transparent partition between my heart and the heart of the world": in Jackie Wullschlager, *Chagall: A Biography* (New York: Knopf, 2008), p. 491.

"history of modern art": *TIME* magazine and Richard Brown quotes are in Wullschlager, *Chagall,* p. 500.

"to heal the hurt of living in a society": John Russell, *The Meanings of Modern Art* (New York: Harper & Row, 1981), p. 144.

"became internationally famous": Richard Dorment, "Was Chagall Actually Any Good?" www.telegraph.co.uk, June 6, 2013.

"Chagall is a common preference": in Menachem Wecker, "Understanding Pope Francis's Surprising Affinity for Jewish Art," forward.com, April 8, 2013.

For auction prices, I have followed the prices carried on artprice.com.

"His art of portraiture": Mason Klein, ed., *Modigliani: Beyond the Myth* (New Haven, CT: Yale University Press, 2004), p.10.

Spanish master Goya: in Jean-Marie Drot, "In Search of Chaim Soutine," part of a DVD set titled *Les Heures Chaudes de Montparnasse* (Paris: Doriane Films, 2006).

Van Gogh. Barnes, *The Art in Painting,* p. 374.

"the first—far and away": Faure's estimate of Soutine comes from Norman L. Klechblatt and Kenneth E. Silver, eds., *An Expressionist in Paris* (New York: The Jewish Museum, 1998), p. 156.

"make his pigments breathe light": in Alfred Werner, *Soutine* (New York: Harry Abrams, 1985), p. 46.

The de Kooning quote comes from Mark Stevens and Annalyn Swan, *de Kooning: An American Master* (New York: Knopf, 2005), p. 562.

"kneaded and mauled": Clement Greenberg, *The Collected Essays and Criticism. Volume 3: Affirmations and Refusals* (Chicago: University of Chicago Press, 1995), pp. 72–78.

The Tworkov quotes are in Maurice Tuchman and Esti Dunow, *The Impact of Chaim Soutine* (Ostfidlern-Ruit: Hatje Cantz, 2002), p. 121.

"denial that the picture is an end in itself": in Tuchman and Dunow, *The Impact of Chaim Soutine,* p. 121.

INDEX